CHICKS WITH GUNS

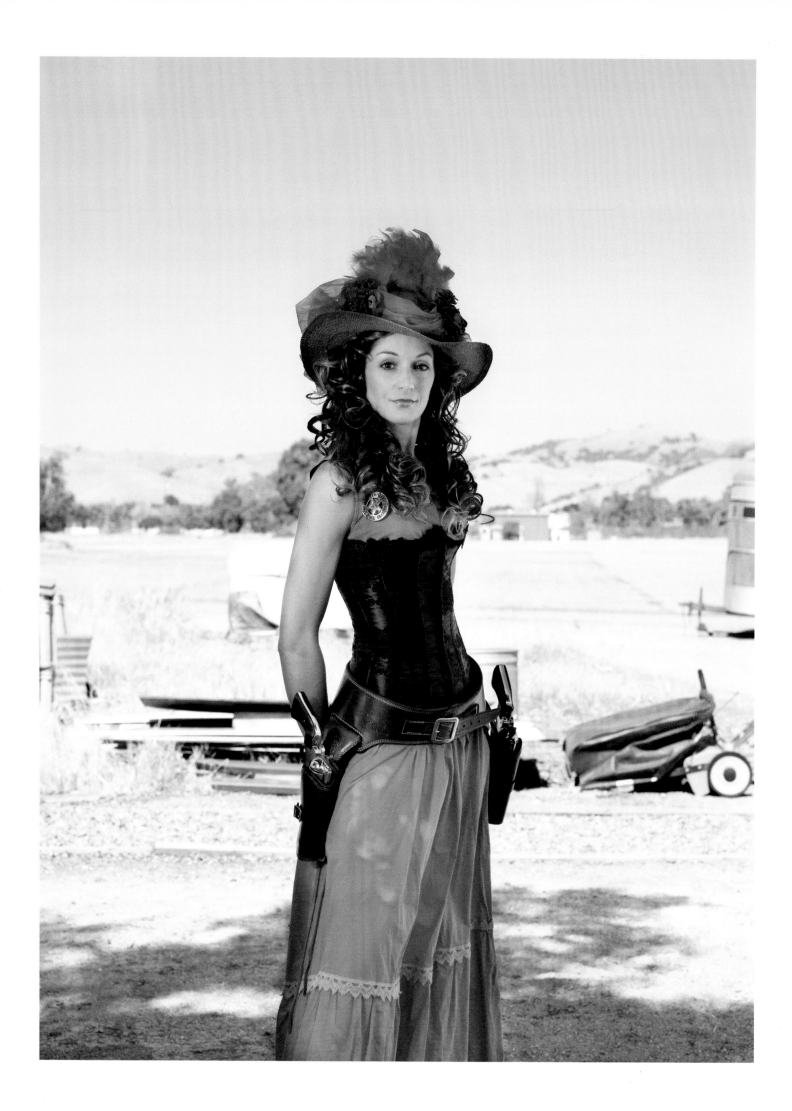

CHICKS WITH GUNS

LINDSAY McCRUM

THE VENDOME PRESS

NEW YORK

CONTENTS

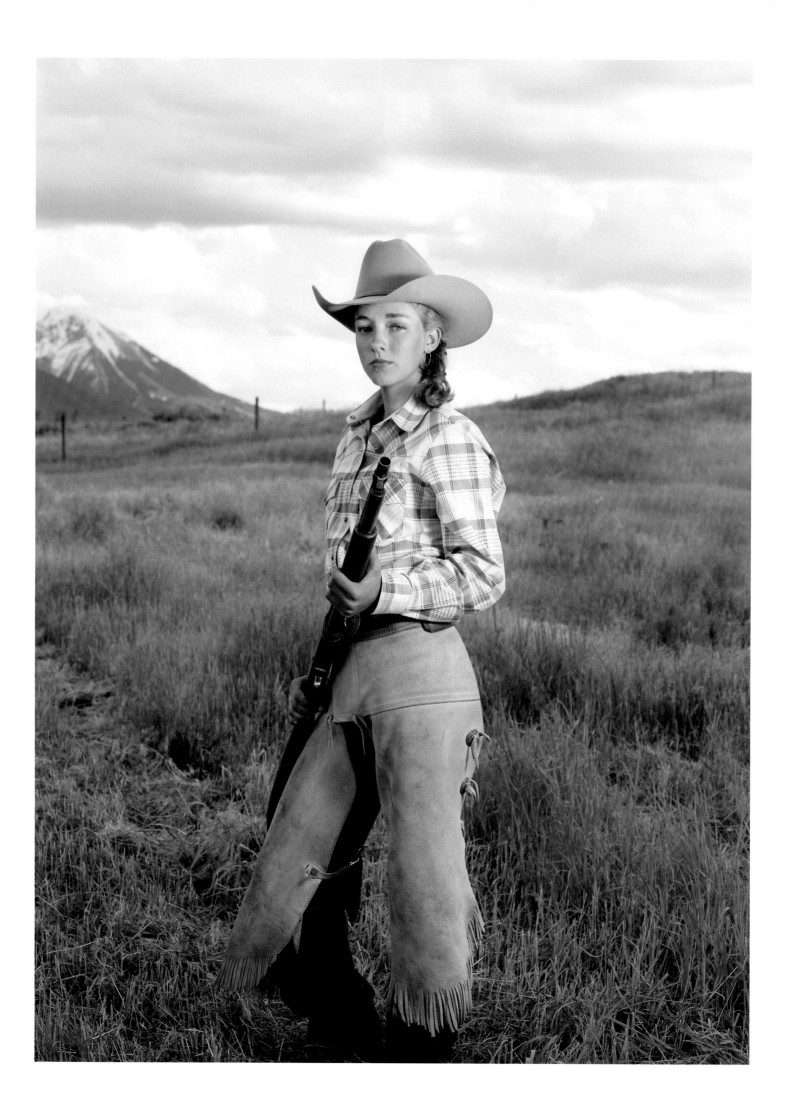

AN EXQUISITE SHOT

STEPHEN L. MEAGHER

There could be some incongruity between the words *beautiful* and *unsettling.* If there is, Lindsay McCrum has managed to reconcile it in her compelling book. *Chicks with Guns* is filled with images that are strikingly beautiful, yet often have a haunting or unsettling quality. Sometimes the photographs convey a graceful wit as well. This work is a collection of seventy-eight cultural portraits of women gun owners from a cross section of American society, with a narrative by each subject about how guns influence her life. Some are artfully posed in intricate surroundings with precious antiques, others outdoors with their hunting rifles, and still others with their guns obviously intended for self-protection. They represent the remarkable diversity of women who own guns, crossing all boundaries of age, culture, wealth, and geography. The result is an arresting exploration of a world rarely seen or even considered in some parts of the country.

In our time, few subjects provoke the range of emotions that guns do. Thoughts as varied as policies to prevent violent crime, the romance of the Old West, and even the implications of children playing with toy guns come to mind. No matter what images are evoked, the reality is that in this country, fifteen to twenty million women own guns.

ELIZA
Livingston, MT
Remington 20-gauge pump-action

The sight of women with ostensibly deadly weapons (they are actually unloaded) challenges our preconceptions about the female or maternal role. The vernacular has long reflected society's view. The musical *Annie Get Your Gun* popularized the line "You can't get a man with a gun." Similarly, the phrase *shotgun wedding* conjures up anything but romance—or even peaceful coexistence—between the sexes. It's possible that evolution has bequeathed to us the idea that the role of hunter or protector, or maybe even violence itself, is the province of the masculine, not the feminine. Perhaps that is the source of a vaguely unsettling quality of some of the images.

In the modern world, the subject of guns seems to be an inherently political issue. All too often, it provokes exaggerated polemics rather than revelations. One of the achievements of this book is that it remains true to the photographer's neutrality. It offers insight rather than advocacy, an exploration not an agenda. It is obvious that McCrum is humane and treated her subjects with respect and dignity, but they are neither glorified nor vilified. Still, in tacit tribute to the photographer, one can often sense she inspired both trust and affection in her subjects.

Lindsay McCrum first became interested in the subject of guns after reading an article in *The Economist* in 2006. She was struck by the immense size and scope of the gun business in the U.S. as well as by the contrasting political views on the subject in Europe and America. Given the breadth and significance of gun ownership here, McCrum thought it might have potential as an engaging project. At the time she was working on two series of portraits. The first, "Commando Squad," dealt with the roles and self-image young boys adopt while playing in military costumes with toy guns. The second, a project titled "Dress Up," was an examination of how contemporary notions of beauty and fashion were developed in young girls. With that gender-based prism, she decided to focus her attention (and lens) directly on women gun owners in the U.S.

She approached this controversial subject through the formal and classical visual language of portraiture. Her aesthetic was informed by her background and training as a painter and her love of art history. Velázquez, Giovanni Bellini, Gainsborough, and Balthus are four painters she mentions frequently when speaking about portraiture. Many of the formal aspects of her compositions and lighting are inspired in part by Velázquez, especially his military portraits. The attention to detail, particularly in the dignified poses, gestures, and self-presentation of

the subjects, is evident in the work. Many of the painterly background landscapes in *Chicks with Guns* are inspired by Gainsborough. That may be unsurprising, given that McCrum was a landscape painter before becoming a portrait photographer.

Among the photographers who have influenced this series of portraits are August Sander, Sharon Lockhart, and Elena Dorfman. McCrum seeks to explore a social subject writ large through a series of individual portraits. She aspires to develop that sense of individual connection with her subjects through immersion in their community. *Chicks with Guns* is a community, though not in the geographic sense. It is a diverse community surrounding a social phenomenon. McCrum succeeds in illustrating that diversity as well as the commonalities of her subjects.

One of the most interesting aspects of the project was finding the subjects. As it turned out, a surprisingly large number of women were excited to be photographed and tell their stories. Interest spread quickly by word of mouth. Enthusiasm for the project crossed economic, geographical, and social boundaries. When McCrum began the series four years ago, she started with women primarily interested in competitive shooting and hunting. As the project developed, women involved with law enforcement, those interested in self-defense, and collectors of antique firearms joined as well.

Photographic shoots were arranged throughout the country. Since McCrum was shooting with a medium-format camera on a tripod with off-camera lighting, each photograph had to be carefully planned in advance. Encouraged to participate as much as possible, the subjects themselves would often suggest ideas and locations for the shoot. Those collaborative efforts resulted in a unique collection of memorable images revealing the relationship between the women and their guns. The narratives were also important in providing the context, history, and achievements of each woman.

Taken as a whole, this is a powerful and elegant portrait of a group of women whose numbers are large but whose profile is often low. *Chicks with Guns* is an accomplishment reflecting years of thought, creative work, and the vision behind it. An exquisite shot.

PLATES

CYNTHIA
Stamford, CT
Beretta 20-gauge over-and-under

When you're field hunting, you're always paying attention to your gun. You know it's loaded, the barrels are pointing toward the sky, the safety is always on. You're ready at all times and walking very carefully so you don't trip or fall. You're listening to where the dog is moving through the corn. You're using your peripheral vision and also turning your head, looking to see where everybody else is to make sure you're all in the same line. If someone's ahead, you move up, if someone's behind, you might slow down a little. Your adrenaline is pumping and all your senses are really acute. Your vision is clear, your mind is clear; you're totally focused on what you need to do. All of a sudden a dog flushes a bird, a big pheasant flies up, the gun goes to your shoulder—it all kinda happens at once, it's a smooth thing—and boom!, you bring the bird down.

You always shoot at blue sky. That's an expression that means you must see the sky behind the bird, because if you're not seeing blue sky, you're shooting too low, you're shooting down at the brush or cornrows.

When I field shoot, I have two guns that I like to use. One is my Beretta 20-gauge over-and-under, and I also have a 28-gauge Parker. Field guns tend to be a little bit smaller and lighter because you're walking, walking, walking, carrying this gun all day, and it gets heavy when you're going through the woods or fields. Years ago I used to hunt American grouse in Maine. You'd be in full rain gear, carrying a big monster gun, schlepping through the woods and climbing over rocks and trees trying to hear the thumping of a grouse and track it down. I mean, it's tough, tough going. I wouldn't do it now, but it's a lot of fun and is another type of walk-up hunting people like to do.

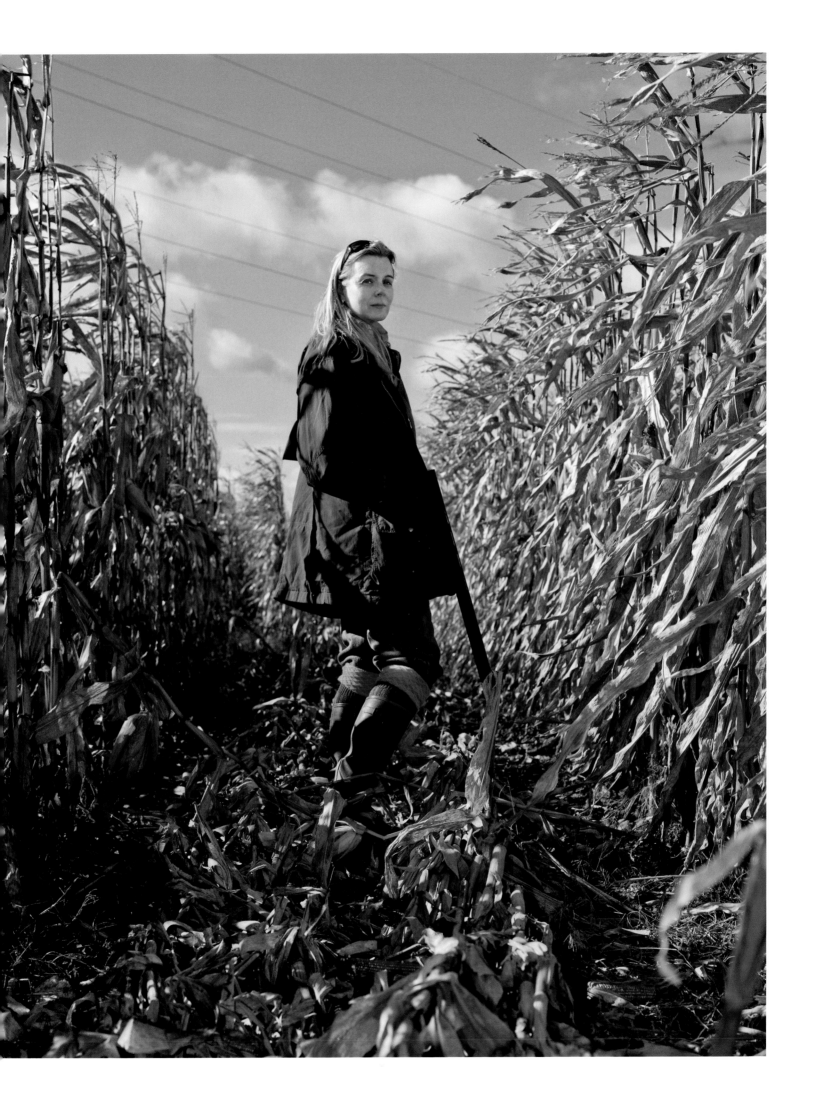

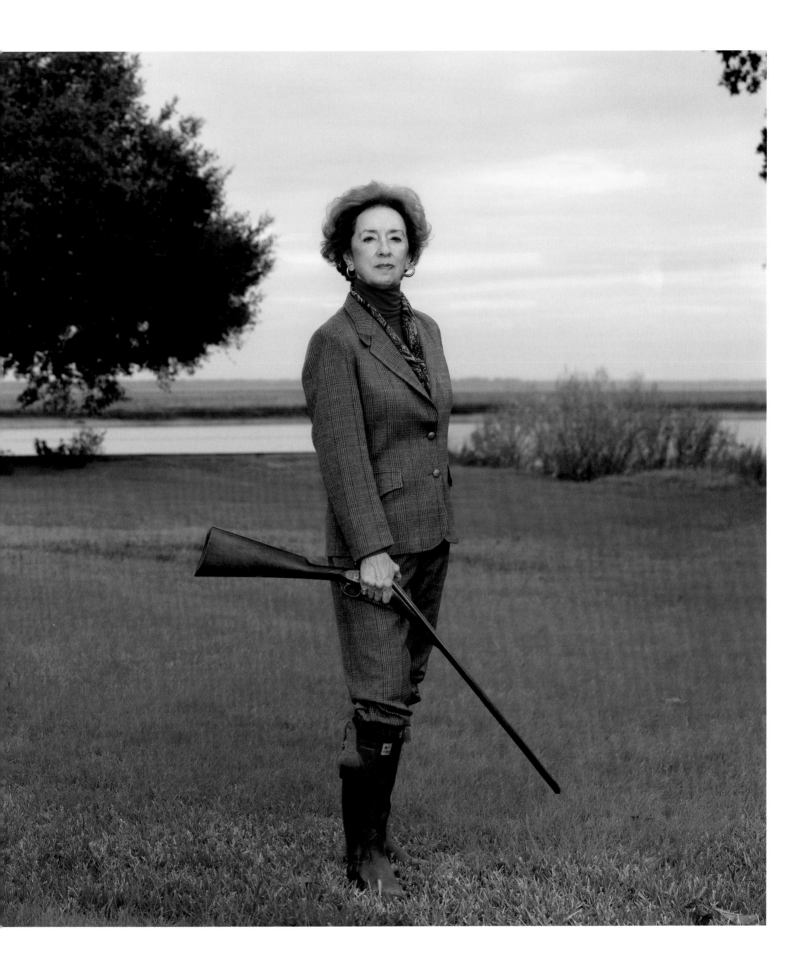

LEE
Ridgeland, SC
Boss 20-gauge side-by-side

Hunting and shooting are the foundations of a complete
and very special world. My first shooting lesson was at
the Campfire Club (founded by, among others, Teddy
Roosevelt) under the baleful glances of Boone & Crockett
and Rowland Ward record trophies. Further instruction
came from a cheroot-smoking Cornishman (according
to my husband, the divorce courts are full of men who
tried to teach their wives to shoot) who fueled his coffee
(and my lessons) with an endless supply of Scotch.

The first driven bird I shot was a cock jungle fowl,
glorious flaming tail streaming behind him, driven by
Sental beaters through one of the few remaining jungle
patches in a rather remote Indian state (Bihar). My next
hunting adventure was driven snipe, shot standing on
a high (and dry) Indian rice paddy as the Sental tribesmen
worked up and down the streams. Frankolin and guinea
fowl in South Africa followed rapidly. Walked-up partridge
through wildflower-strewn meadows in Outer Mongolia
was a particularly memorable hunt. What possible excuse
could I have had to be in all of these amazing places if I
didn't shoot?

As for the guns, once you've held the work of art that
is a best-grade London side-by-side in your hands—espe-
cially if made in the 1930s (the golden age of English gun
making)—you will never forget that miracle of balance and
weight. It seems so natural to swing and hit the bird that
you're endlessly surprised when you miss. Its fine engrav-
ing rivals any jewelry in workmanship and detail. And
each gun's unique history, its family owners before you,
makes it all the more precious.

RACHEL
Livingston, MT
Ruger 10/22 carbine

I got interested in hunting because my dad is a hunter,
and ever since I was little I knew that I was going to be a
hunter too. My sisters and my dad taught me how to
shoot a .22 when I was very young. My favorite gun is the
.250 Savage, because that's the gun I used when I killed
my first elk. That's all.

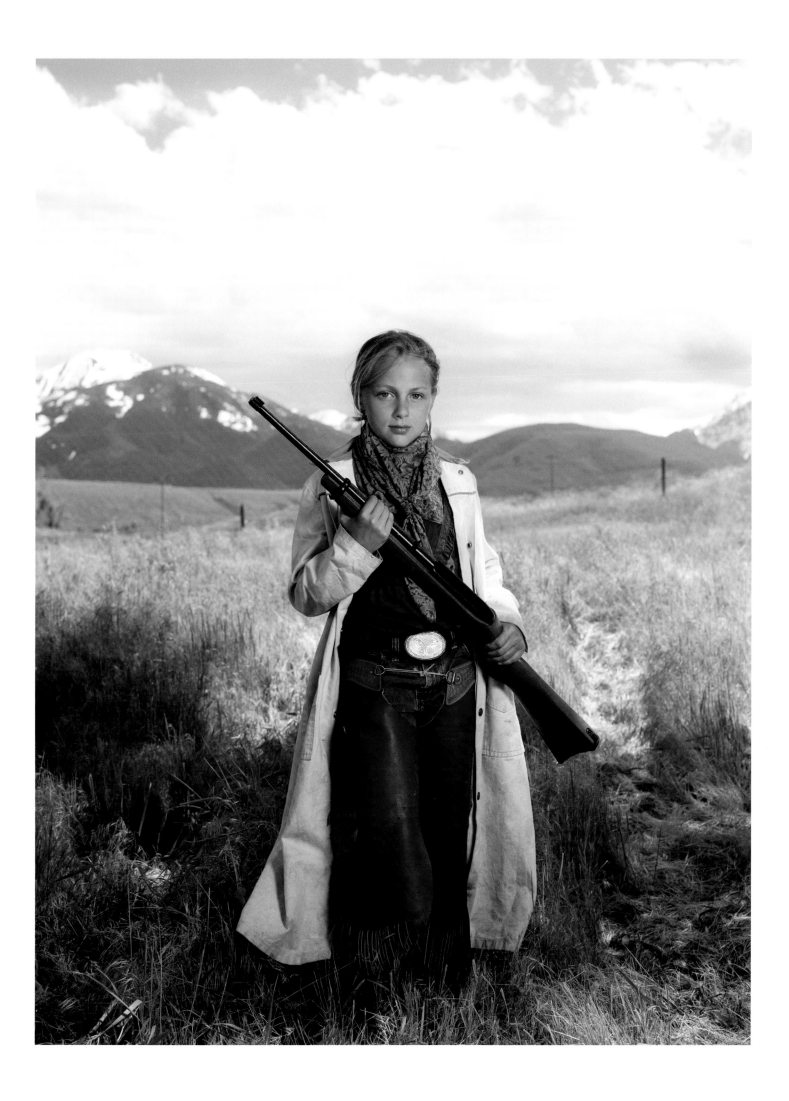

PAMELA
Monte Sereno, CA
Freedom Arms .454 Casull

My father was a subsistence hunter. Every year he harvested a deer and butchered it himself. We stored it in the freezer and consumed it throughout the winter. When I was first dating my husband, he invited me to go dove hunting. I was so flattered that he had asked me to join him on his hunt that I said yes. That was the beginning of a lifetime love of the outdoors and hunting. My husband and I have been hunting for thirty-five years.

He taught me to shoot rifles and shotguns and a bit with light pistols. When I chose to use a hunting handgun, we called the local competitive police shooting team and asked for their assistance. I met the team's coach at the local police shooting range and he showed me how to shoot my new hunting pistol, a Freedom Arms .454 Casull. The .454 Casull is a five-shot revolver and mine has a 10-inch barrel with a Leupold fixed 4× scope on it.

I first looked into handgun hunting when I found my .375 rifle was heavy to carry while climbing a mountain, and its recoil was too punishing. I am 5'2" and weigh about 110 lbs. When I switched to a hunting handgun, I found it challenging and fun to shoot. I'm comfortable shooting it up to about 150–175 yards. I typically use 300-grain soft bullets when hunting. I've tried the 240- and 260-grain but the recoil is sharp and I can feel it in my wrist. The 300-grain is heavy and has more of a rolling recoil. It's less punishing on the hands.

I've had several men mention to me that the .454 Casull kicks too much for them. My response is they're fighting it too much. Men seem to want to control the recoil but can't, so they hold on too tight. I know I can't beat it so I just go with the recoil and it doesn't give me any trouble.

In 1997 I was the third woman to be honored by Safari Club International with the Diana Award. Until 1995, only men had received such prestigious awards. SCI and other organizations had previously awarded women for their conservation but never for their hunting or the two categories combined. When I learned that I was to be the third "Diana," I was thrilled and honored. Named for the huntress of Roman mythology, the award honors SCI's female hunter of the year, a woman who has excelled in international big game hunting. A Diana must also have shown exemplary ethics in the field, remained committed to the mission statement of SCI, and given personally of her time and energies to enhance wildlife conservation and education. Conservation and hunting remain my passions.

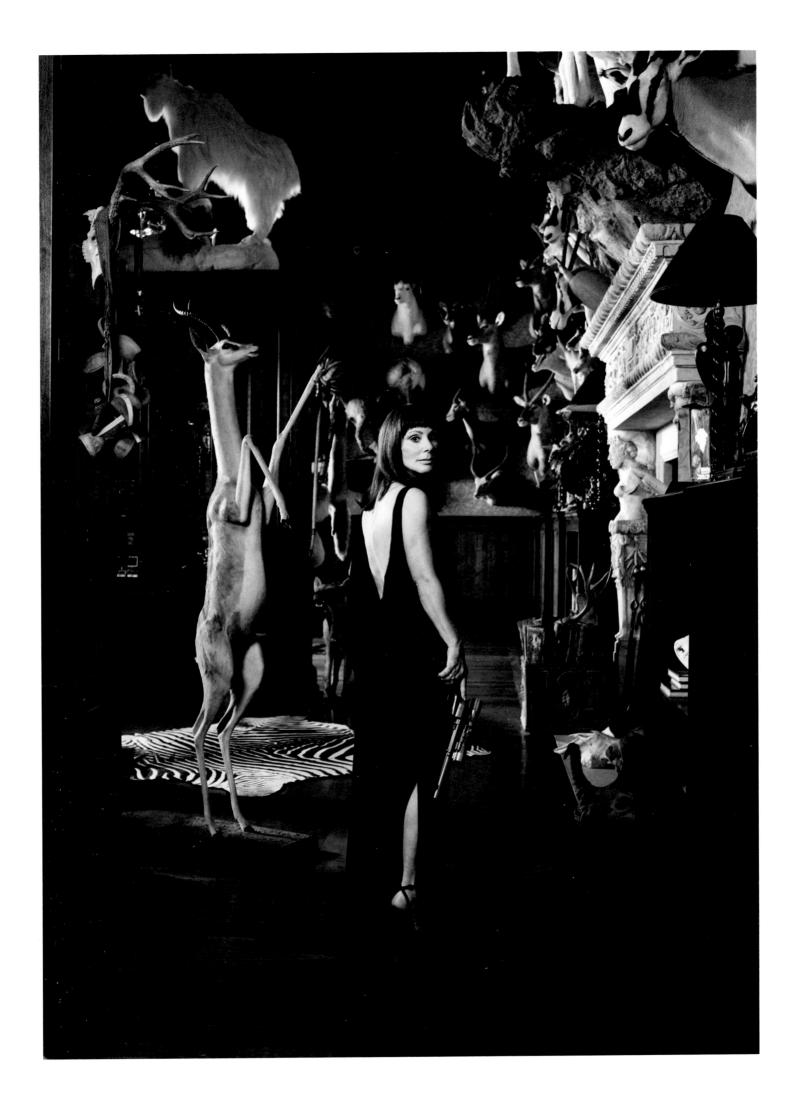

ANITA
St. Paul, MN
Glock .40-caliber & Remington 11-81 Police Model

I was pushing middle age the first time I held a gun. I wasn't raised around hunters and the only other cop in my family history was my great-great-grandfather. He was a cop in New York City and I imagine he carried nothing but a nightstick.

I had completed all other requirements for licensure as a police officer and the time had come for the firearms portion of the training and competency. Having bought all my equipment and prepared for the drills, I readied myself for the next step. I was surprised at my reaction.

I stood on the firing line waiting for the command: "Draw!" And out it came, my Beretta 92FS 9mm. I lifted my gun and quickly found my sights twenty yards down range. I was taken aback and in awe at the power I held in my hand. It was at this moment that I came to terms with my commitment to the profession that had been my calling. I slowly brought my arm down by my side and took a deep breath, giving reverence to the machine that could determine life and death. "I can never take a bullet back," I thought to myself. And it has been a thought that has stayed with me throughout my career. The gun is a powerful tool of the trade and should never be taken for granted.

Hundreds of rounds later, I am a practiced shooter, and I enjoy the drills at our monthly qualifications. As a woman in this field, I have a compelling drive to be more than adequate. Women are still a minority and I am proud to be a part of this legacy. I now carry a Glock .40 and am prepared with the Remington shotgun, but the type of gun I carry has no bearing on the respect I maintain for all weaponry. It is life that is to be revered, and I have sworn to protect it.

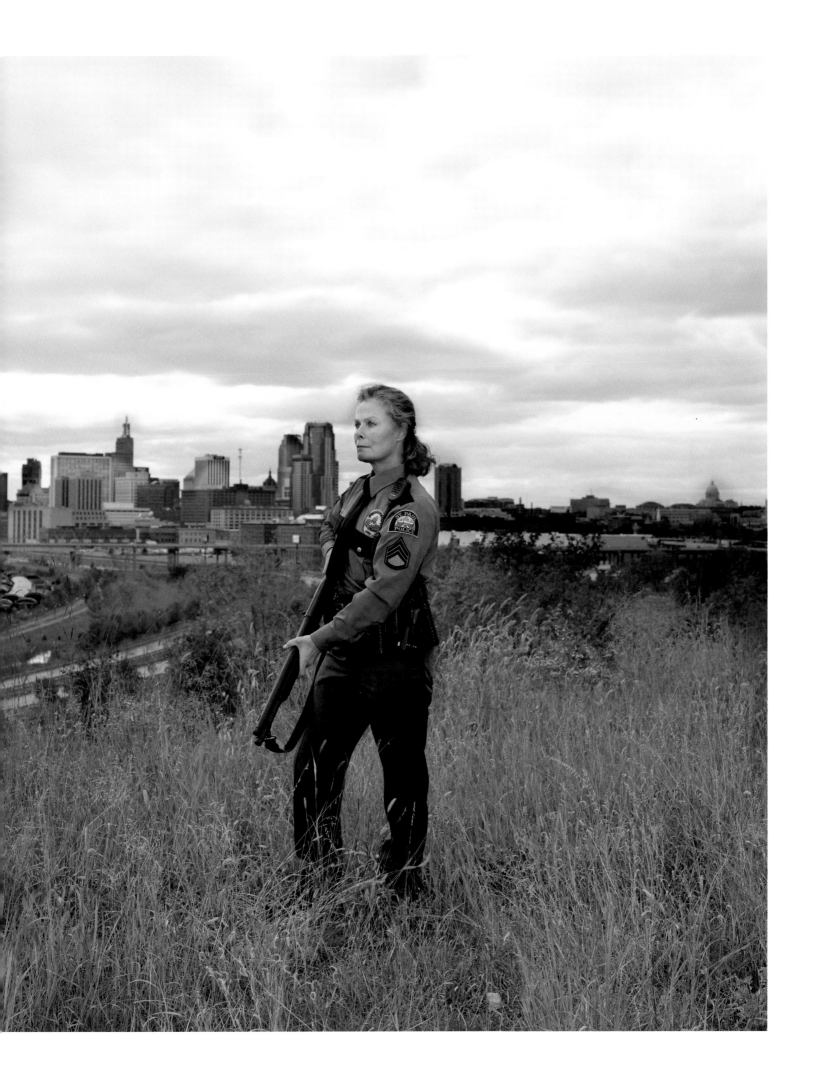

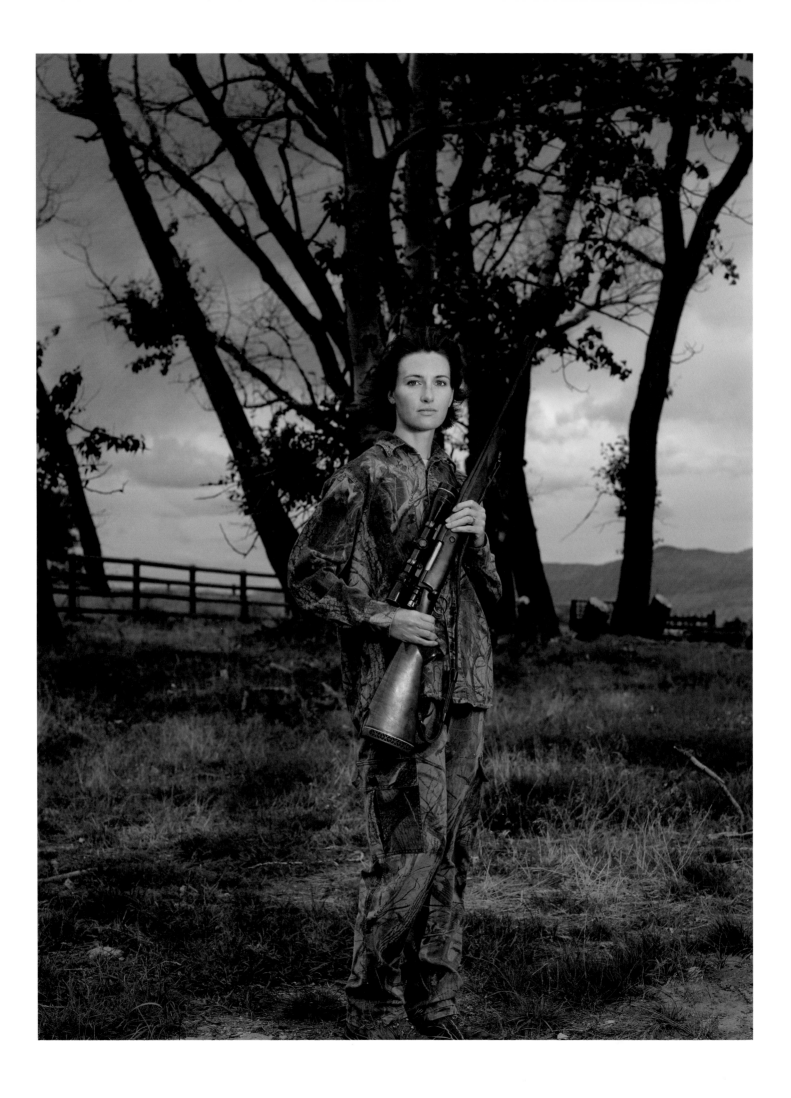

JEN
Emigrant, MT
Browning .270 with a Leupold scope & handmade sling

My favorite gun to date is the one I shoot most often now—a .270 Weatherby mag with an ultralight barrel. I don't know if it's the one that I shoot the best, but my husband bought it for me. It was so nice of him to do such a nice thing for me. He got it because I drew a mountain goat tag and he wanted me to have a light gun to pack around in the cliffs. I did shoot a goat with it too. That was one of the most fun hunts ever. I got to see tons of country and lots of goats. I worked hard and enjoyed every second of it. The best part was being surrounded by ice and cliffs. And, just as the sun was thinking about going down, on a ledge about 800 yards away looking at me was a nanny with one of her babies. The sun was coming behind them so it illuminated their hair and they looked like little balls of glowing fuzz. I will never forget that.

Hunting is very important to me for many reasons. Hunting doesn't mean killing—it's about the amazing experiences that you almost always have when you are out in nature. Hunting is what you make it; and for me being out seeing what Mother Nature has to offer and sharing these experiences with my kids is so special and important. I wouldn't want them to learn it from anyone else.

We also have hounds. We chase mountain lions with them. We chase and tree but are very selective about what we kill. Watching the dogs work and letting people come with you to see a lion is really cool. Most people don't get to see a mountain lion in nature. They are very cautious and are really good at making sure we don't know they are there. I'm blessed that my kids have gotten to run lions with me too.

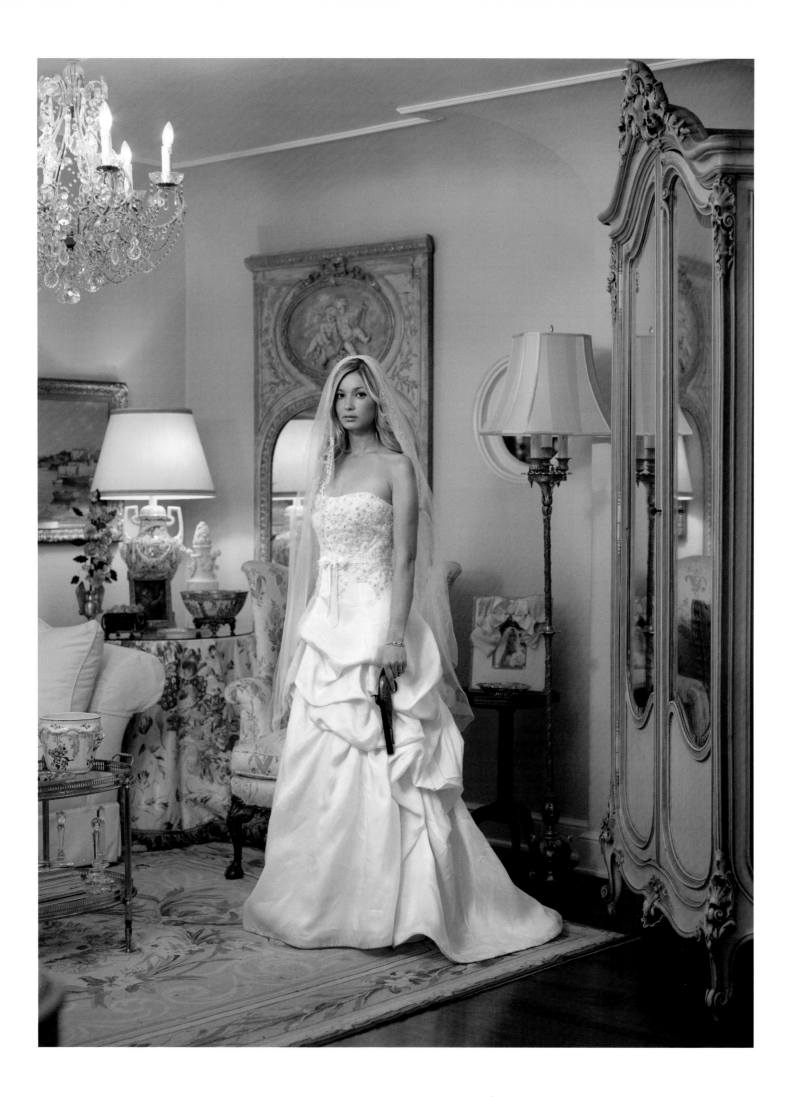

JENEVIEVE
San Antonio, TX
Antique single-shot percussion dueling pistol

My husband and I actually met on a blind date that was set up because we needed escorts to make our debut in Fiesta. Fiesta is a spectacular, citywide celebration of Texas history that has been going on in San Antonio for a hundred years. Anyway, the date was on a ranch on the outskirts of town, and the main activity was skeet shooting. Now I did not know the girls would be asked to participate in the shooting, but we were, and they made a game out of it. All the girls lined up, and when a clay was thrown the first girl in the line shot. If she missed, the next girl would take a shot at it, and so on. If you hit another girl's clay after she had missed, then she was out of the race. I of course wanted to do well to impress my date, Frank, who I was already a bit smitten with. In the first heat I knocked out three girls. He later told me that's when he knew it was over for him. The many afternoons of quality time spent shooting with my dad certainly paid off. Shooting had not really been my thing and I had learned mostly to appease my father and make him happy. All it took was a guy to steal my heart for shooting to steal mine.

Since that day, hunting and Frank have been in my life. My dad is thrilled that I have taken a liking to his favorite hobby, even if it took a boy to get me interested.

In this photograph I am holding an antique pistol that has been passed down in my family for years. It was a wedding present from my father and originally belonged to his father. That gun is very, very old. It's important for me to have this photograph with my wedding dress and the gun because of their significance to my relationship both with my father and with my husband. But I wouldn't want anyone to think it was a shotgun wedding!

JAMIE
Loomis, CA
.44 Magnum Ruger Super Redhawk
double-action revolver

I got a BB gun when I was six years old and practiced shooting at old cans and such. I got my first .22-caliber rifle, which I still have, when I was ten, and I still have that very first paper target from the shooting range. Now I have several favorite guns, my Blaser .300 WSM, Kimber .45 ACP Ultra CDP II, and Ruger Super Redhawk .44, which is the one in the picture. I love the imposing figure that the Ruger creates. The Ruger means business: there's no question about it. It's menacing looking, like the *Dirty Harry* gun.

I was a police officer for five years. When I started with the police department I had a Smith & Wesson .357 Magnum, which was a revolver. They call it a wheel gun. I wore the Marksman pin in my police department. It was something you were proud to wear. When I was in the academy, the shooting instructor knew immediately that I had been shooting before. I was just a young woman then, and they assume you don't have the same skills. I think they were really impressed that I could shoot. I thought, "You know? I'll show these guys I can do this."

When I first met my husband, I told him I liked to shoot and he was like, "Oh, okay, really?" So we went to the range. He had a pistol. We started shooting and he wanted to show me how because he didn't know yet if I could shoot or not. So he shot the target, and the way he tells the story, it's pretty funny. He says he was lucky if he hit the paper. When he was done, he handed the gun over to me. He was watching me and said, "Oh look, you missed, you missed!" All of a sudden, you could see daylight coming right through the center of the target. He thought I had missed the first time, but I kept putting the bullet very close to the same hole, and the center of the target had been blown open. Then he said, "And I thought I was going to impress you!" It was funny because the range master had come over and given him some tips. When I started shooting, the range master came over and stood behind me and watched, waiting to give me tips. Then he just looked at my husband and said, "Well we don't need to worry about her."

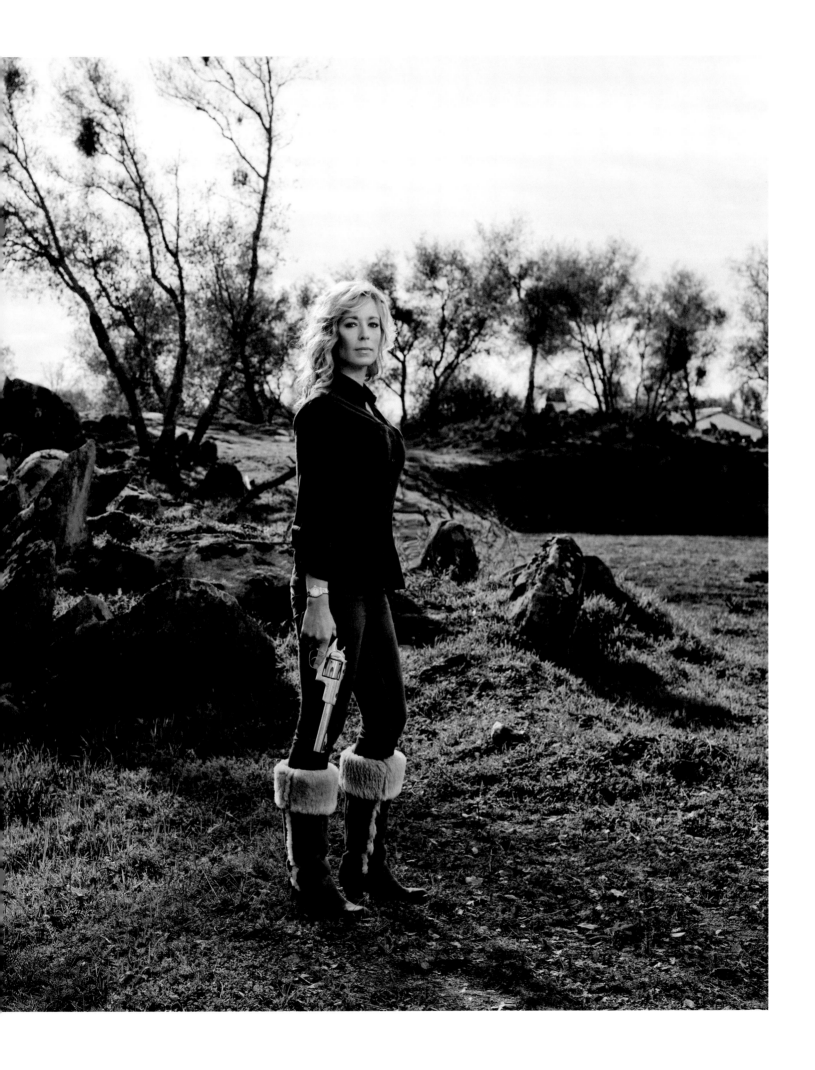

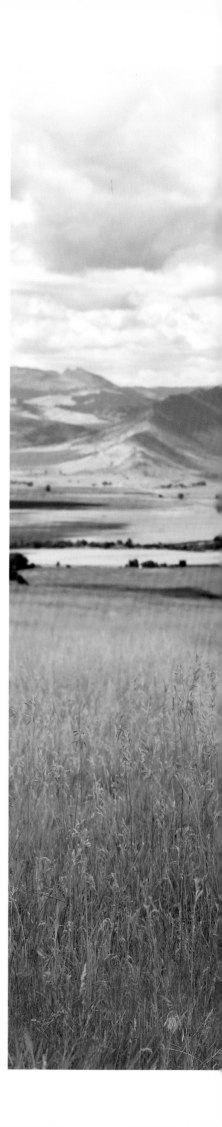

SAMANTHA
Livingston, MT
PWA AR-15

I first started shooting when I was about eight years old. My brother taught me to shoot with a pellet gun. We would shoot tin cans, milk jugs, and the occasional dinner plate. I showed horses competitively, and shooting was just another form of competition—against myself and, of course, my older brothers.

I purchased my first gun when I was twenty-one years old. I had shot many different kinds of guns but had not owned my own until then. I was going to college in Arizona, not living in the most desirable neighborhood, and I wanted a gun for home protection. I knew that once you had a gun in your home for protection reasons, you take on a different responsibility. After reading the Arizona gun owner's manual cover to cover at least a dozen times, I felt I knew my rights and responsibilities as a gun owner. I bought a Smith & Wesson .45 automatic handgun. I shot targets regularly to get as comfortable with it as I could. I am very diligent about how, when, and where I use my guns.

When I met my husband, a retired law-enforcement officer, he taught me a whole new side of shooting. My past shooting experiences had been "successful" if I had managed to hit the intended target. My husband taught me that there was so much more to shooting than just hitting the target. He taught me how to shoot more proficiently than I ever thought I could. By using different "drills" I learned how to shoot from different positions, angles, and distances. The biggest thing Bill has taught me is to know my range. In the past, if I wasn't hitting the target, I would move to a position where I could hit it. Now I have the ability to take a shot from where I want to, not where I have to.

The rifle in the photograph is an AR-15 semi-automatic .223-caliber; it has an adjustable Magpul stock, a target-grade barrel, a custom trigger, and a 2×7 Redfield scope. I use this gun for target shooting. The AR-15 is very popular because it is accurate and has minimal recoil. It is a semi-automatic version of the military-issued M16. The M16 was developed by Eugene Stoner of the U.S. company Fairchild ArmaLite in 1957. In 1959 the rights were sold to the Colt manufacturing company. The M16 was first introduced into the U.S. Army in South Vietnam in 1963. By 1969, it was the standard-issue rifle, replacing the M14, and versions of it are still in service today.

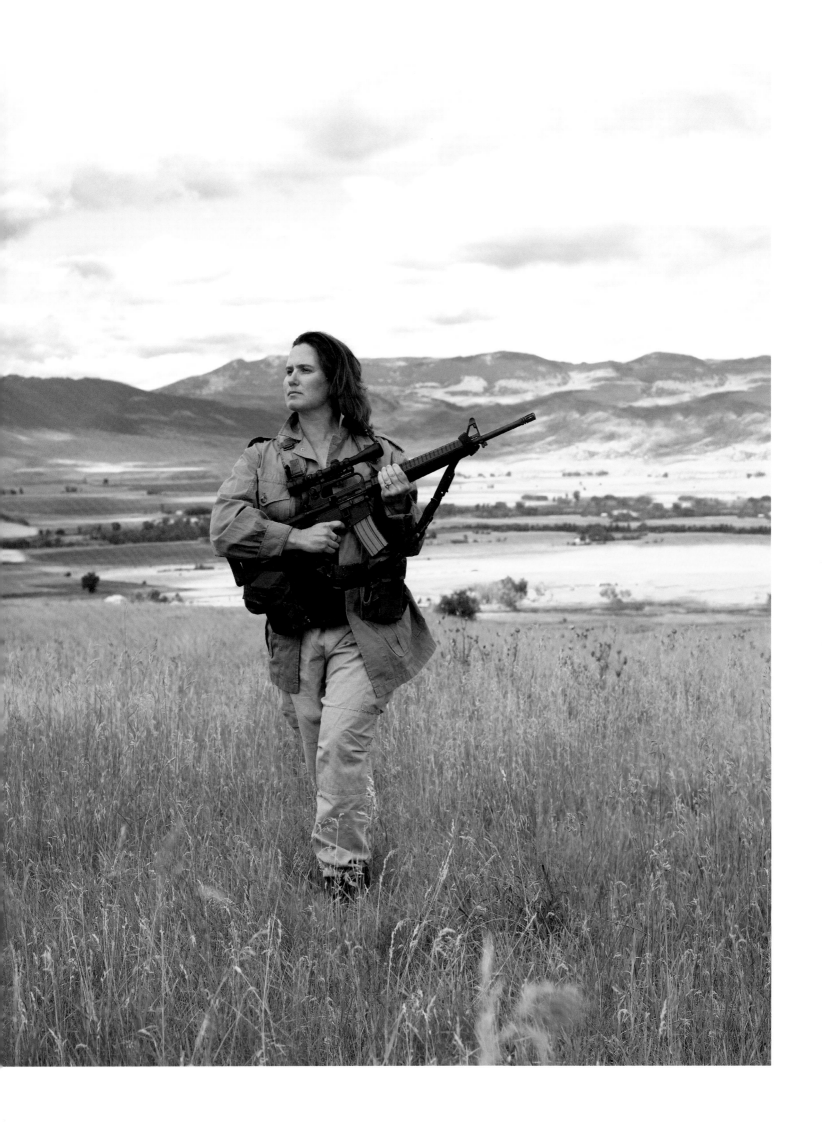

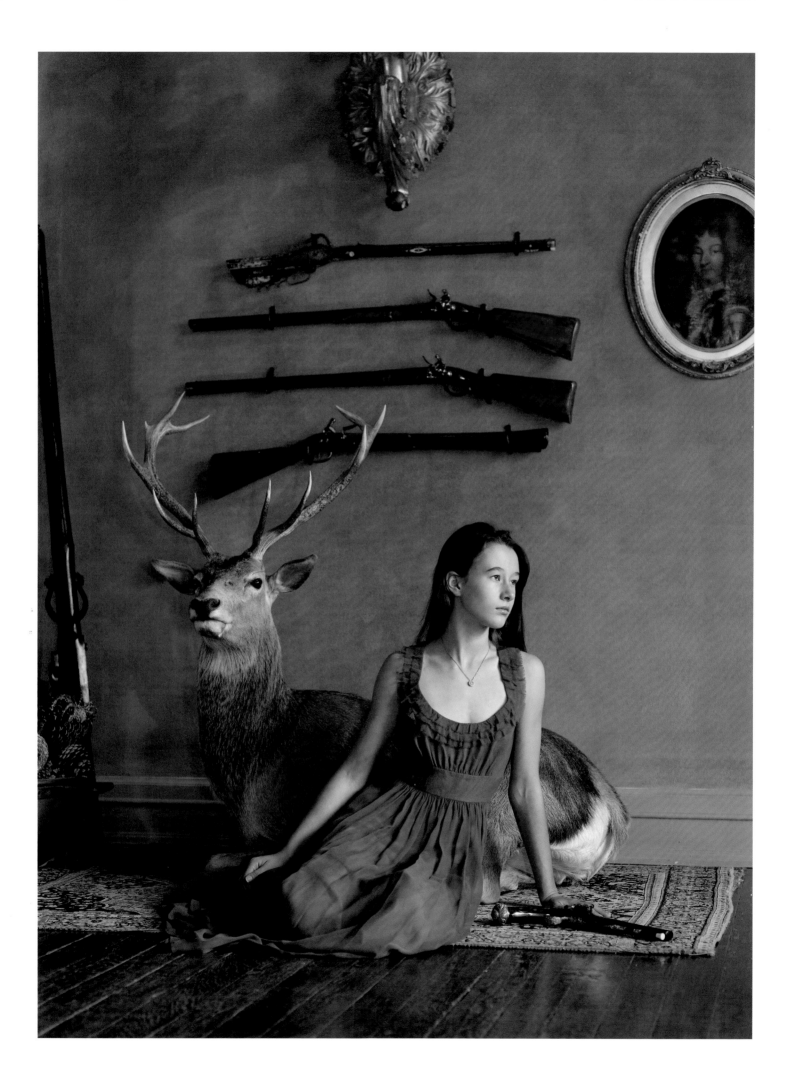

GRETA
Napa Valley, CA
English Forsyth system scent bottle pistol, ca. 1820

I was only seven or eight months old when I received my first gun, a gift from a longtime friend of my parents. A miniature stocked Colt 1861 Navy revolver, it has a personalized inscription with an engraved stock. I still have it, of course. A picture of me with this gun was published in *Man at Arms* magazine and can also be found in *Steel Canvas: The Art of American Arms* by R. L. Wilson.

For my seventh birthday, my father gave me my first BB gun. The two of us would line up tin cans and make it a competition to see who could knock over the most targets. In addition, I was challenged to hit a small brass bell hanging from our outdoor stone barbeque. It was thrilling each time I made it swing and produce a soft "ding."

Many weekends were spent on hunting trips and I loved waking up early to begin the adventure. As I wanted to be a true part of the shooting parties, I studied hard with my dad's help and completed the Hunter's Safety Course at the California Department of Fish and Game so I could receive a Lifetime Hunting License. I was so proud when the certificate arrived in the mail three weeks before my tenth birthday! As I got older and became more familiar with guns, I graduated to a beautiful .22 Winchester automatic rifle, which I am still using for target shooting.

In 2006, I played the young Annie Oakley in a PBS *American Experience* production. Originally I was only supposed to be in a short outdoor clip, but after the producer saw the footage of me shooting flyers with a 20-gauge double-barrel shotgun, she also wanted me to portray Annie Oakley on stage. If you watch the footage, you will see me shooting a Frank Wesson single-shot .22 target rifle as well as a Stevens .22 single-shot target pistol, which are the same types of guns Annie Oakley used in her performances. From the makeup to pretending to hit playing cards, candles, and cigars out of the mouth of another actor, this was one of the most exciting experiences of my childhood.

Guns and antiquities have always been part of my life, and I couldn't imagine it any other way.

SARITA
Armstrong, TX
Parker 20-gauge side-by-side

I grew up on a cattle ranch in South Texas, where shooting was a part of daily life and hunting traditions abounded. My late father taught his five children to shoot shot-guns, rifles, and pistols before we were ten. We were also instructed in gun safety and how to field-dress and clean all game we shot. Shooting is still an integral part of our ranch life and work. Most of our entertaining at the ranch revolves around shooting and hunting. We shoot dove, quail, duck, turkey, deer, and Nilgai antelope. In addition to recreational hunting we use shooting as a game-management tool and to control varmint, feral hog, and Nilgai over-population.

My favorite gun is a lovely Parker gun my father gave me when I was a teenager. I have been shooting quail with it ever since. It is a double-trigger, 20-gauge, side-by-side shotgun made in 1912. It has definitely lived up to the Parker nickname, "Old Reliable." Several years ago I was shooting quail with an older fellow who was working pointer dogs on a neighboring ranch. At the end of the day he asked if he could take a closer look at my Parker. After inspecting it, he inquired how I came to own it. I explained it was a gift from my father, who had pur-chased it from a local gun dealer. He asked if by chance the dealer's name was Ray Gabba and I replied that it was. He laughed and told me that this was the very same gun he had learned how to shoot with as a young boy growing up in Tennessee. The gun had been sold by his father to Ray, and he had always wondered where it had ended up. I was pleased when he added he was glad to see it was in good hands. I hope to leave the gun to a granddaughter someday.

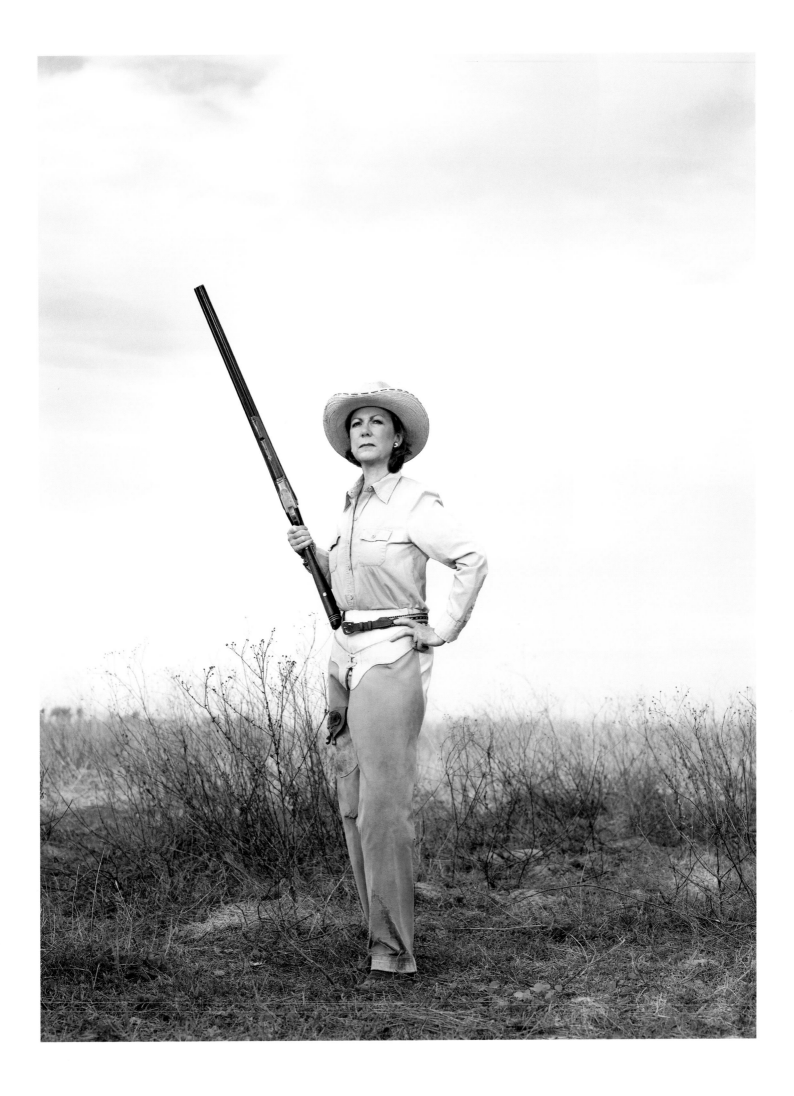

LIZ
San Jose, CA
Beretta 96G Vertec .40-caliber pistol

I went to the police academy, was hired on by my agency, and started out in patrol. I worked a regular beat in patrol for about two and a half years. Then I moved into the detective bureau, where I was a Crimes Against Persons detective in charge of adult sexual assault, domestic violence, and certain homicides. After three years I moved into my current position as the community relations manager. I'm in charge of all the media relations for the department. I run the Crime Prevention Unit and the Volunteer Program, and I also work on special projects or assignments for the chief. I am no longer a sworn officer, but I still have a gun at home for home protection. Being in law enforcement and having been a detective, I am acutely aware of things that can go wrong. Since I've been in law enforcement, I've always had a gun in my night-stand that I keep loaded, no safety on, ready to go, one in the chamber, because that's the only way I feel it's effec-tive. If I had kids it would be a different story. I would never, under any circumstances, have a loaded gun in the house if there were children there. That is extremely unsafe. I can't think of a worse thing to do.

When really bad things happen, they oftentimes hap-pen at night when you're sleeping. My husband doesn't have any experience with shooting, defensive tactics, or law enforcement, so we have an understanding. Since I do have the training and experience—and the gun—my job and my role, if something bad were to happen, is to pro-tect us and our home. His role is to stay safe and to get on the phone with 911. We've talked about it extensively and even if he had to flee the house and leave me there, it's critical that we reach 911 and that somebody is on the way, but it's also critical that somebody is protecting us. So my role would be to grab the gun and engage the suspect or suspects and defend us, and his role would be to get help for us and to stay safe. We're both comfortable with our plan. He doesn't have any problem with it.

My Beretta is a 96G Vertec; it's a .40-caliber hand-gun. I got it when I was in the police academy because the .40-caliber Glock that was issued to me was really not designed for smaller hands or for women's hands in general. It caused an injury while I was in the academy, so I had to start looking for alternatives. The Beretta 96G Vertec can carry a higher capacity magazine for law enforcement, but it has a single-stack magazine instead of a double-stack. That means the butt is much smaller in circumference and easier for me to handle. We had a running joke at the police academy that it was the My Little Pony gun or the Barbie gun and joked about paint-ing it pink. Although we joked about it, it's really just been a fabulous gun.

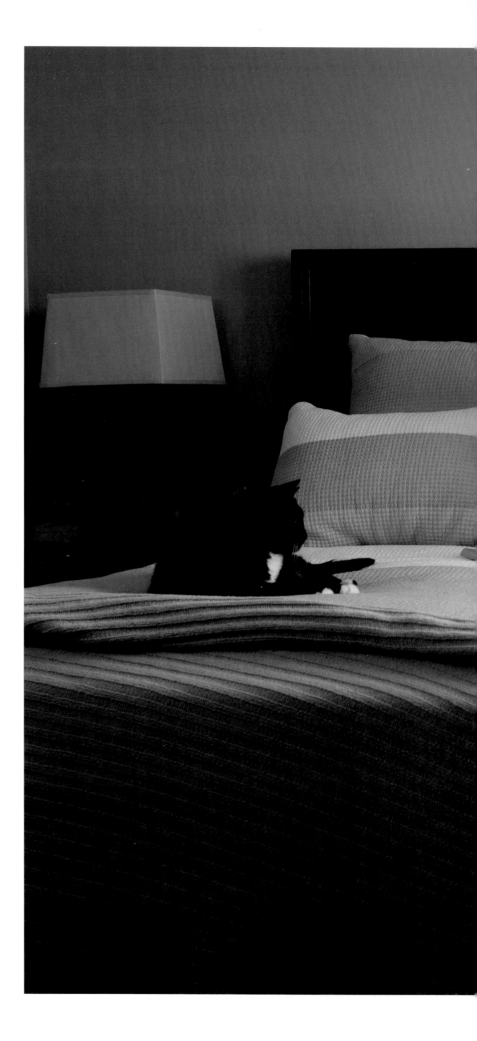

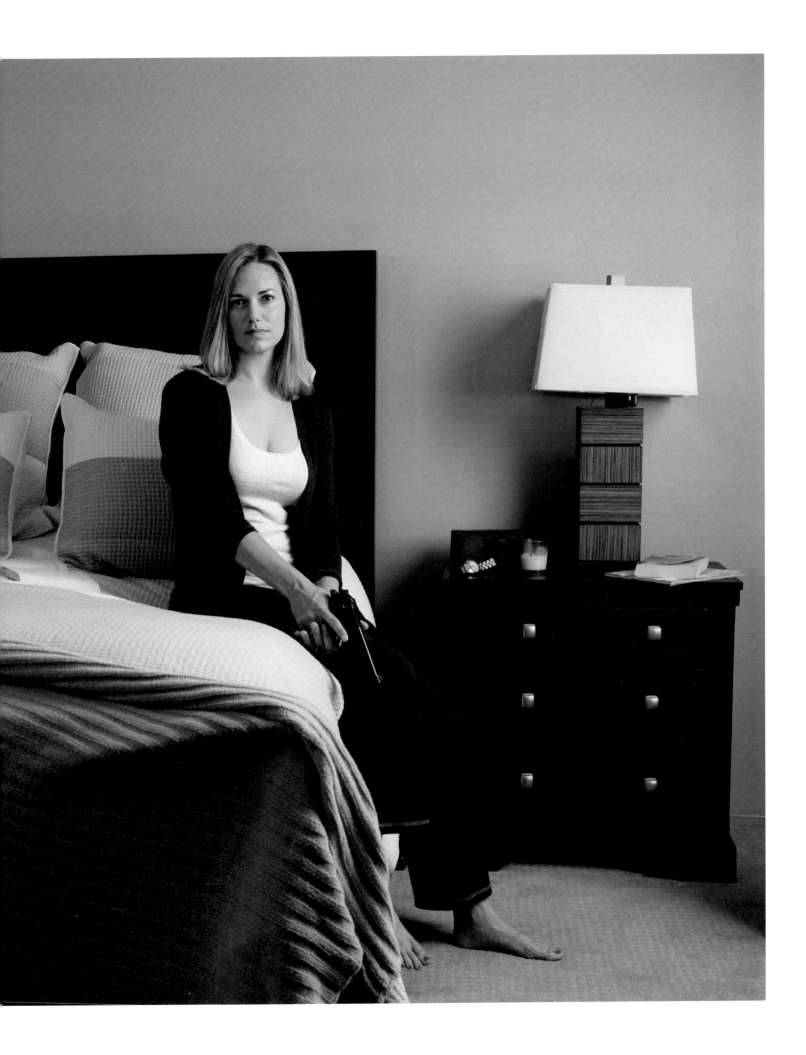

MERRILYN

Hollister, CA

Matched pair of Ruger .44-40 Vaqueros

With only smoking cap guns as prior credit, I outshot my
husband at the age of twenty-one to win my first pistol,
a small .22 revolver. This ignited a forty-five-year pro-
gressive fascination with guns. From target shooting
to reloading, collecting, studying the rich history of
guns, and dressing period Western, I've been enjoy-
ing gun aficionados' camaraderie for many years, now
also as an active grandmother! With the audacity of a
Granny Clampett, I shoot a mean mortar too. Raised in
rural Oregon and now living in northern California, I
come from mixed pioneer stock and Hupa-Yurok Native
American heritage. I respect and enjoy the hobby that's
given me a lifetime of fulfillment.

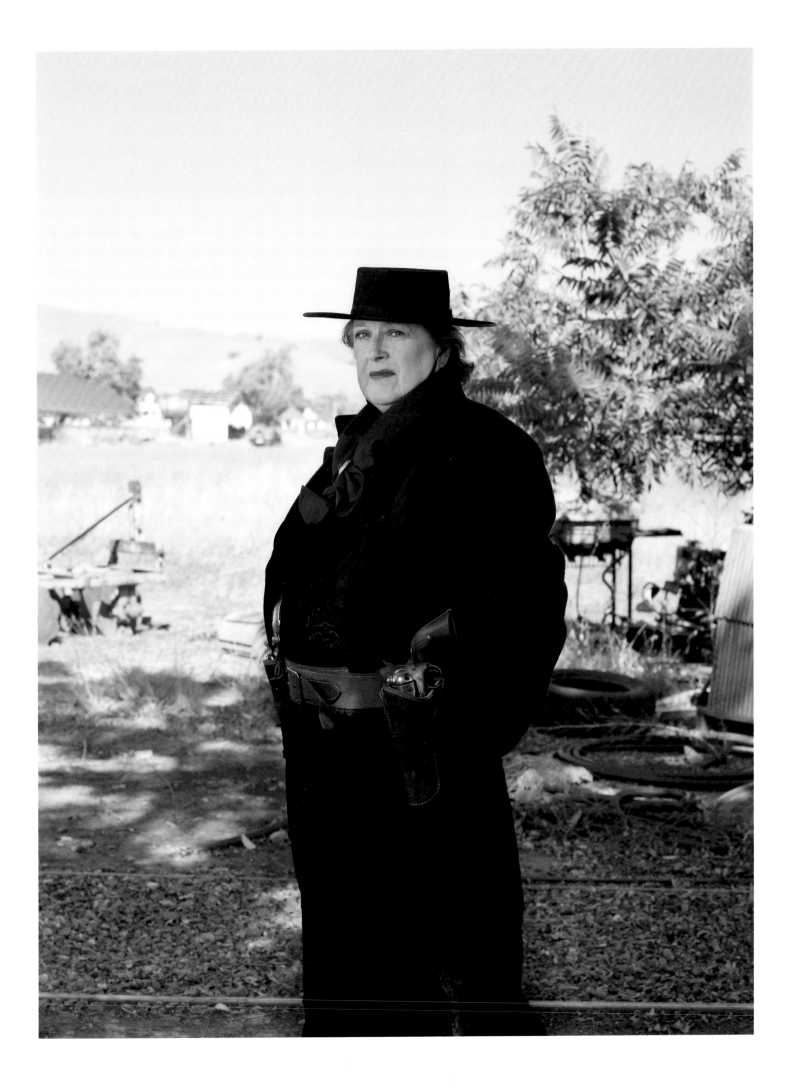

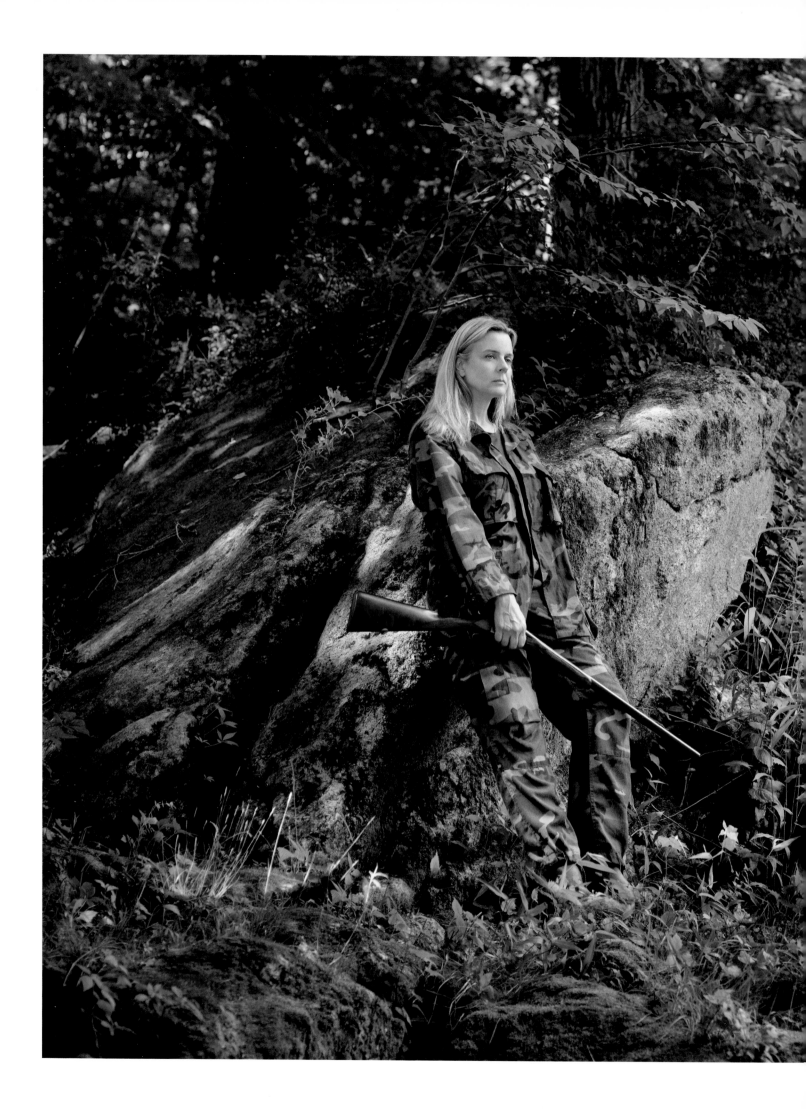

CYNTHIA
Stamford, CT
Parker 28-gauge side-by-side

I got interested in shooting because my boyfriend at the time, who later became my husband, is an amazing shooter. I mean, phenomenal. We would go shooting and I would spectate. Then I decided it wasn't a spectator sport, so I learned how to shoot. I found I really loved it and even after I got divorced, I kept shooting.

For most of the women I've met, it's a sport they do with their husbands or boyfriends. I think a lot of wives shoot because it's what the husband wants them to do. Shooting has traditionally been a man's sport. Because the gun is much more of a masculine thing, because it's a weapon, I think it's not necessarily in a woman's nature to take it on. But I loved it. That's why I like to teach and encourage women from the beginning. I try to get them enthusiastic about the sport, not because of their boyfriends or their husbands but because of *them* and the opportunities that they have.

Bird shooting is exceptionally challenging for me. When you're trying to shoot a driven grouse that's coming at you at about 50 miles an hour with a back wind of however many miles per hour, and this thing's like a little bullet coming toward you, the skill level and the concentration level are really acute and it's really, really tough and it's really, really challenging—and I like that. It's the whole process of bird shooting that I really love; and I love being outside. It could be pouring rain, it could be snowing, it could be a gorgeous day—it's just the whole thing together.

My favorite gun is a Beretta 20-gauge over-and-under. I have a matched pair.

ELENA
Roseburg, OR
Glock .40-caliber

Four-and-a-half years ago I got a job as a 911 dispatcher. Dealing with the calls that we field on a daily basis made me really aware of what people are capable of doing. Before then I never thought about guns or needing protection, but my job was a big eye-opener for me. I'm a single mom and I've got two kids, so I feel like if I'm ever put in a situation where I need to protect them, I'd prefer to have a gun.

My brother was the one who stepped up and said I needed a gun because I was by myself with my two kids. He gave me a Makarov 918 and taught me how to use it. He collects guns and is into hunting, so he's very familiar with them. Since I didn't really know what I was doing, he taught me how to shoot and how to handle a firearm. People have guns, but are they going to know how to react and how to use them? Being comfortable with the gun and actually knowing how to use it is a big thing. It's not that I enjoy going out and shooting, I just have a gun for protection.

When I got my gun, I had to sit my kids down and talk to them. Kids are kids and they can get into things like that. They are seven and eight, so I wanted to take them shooting so they could see how powerful guns are. It scared them at first—the loud bang and seeing the watermelon explode like it did—but they realized how important it was that you never, ever play with guns.

So many people own guns, and one of our policies at 911 is that whenever someone calls in and they are scared and have a gun, we have to stay on the phone with them until the officers get there to make sure their guns are put away and there are no accidents. I've had people call in when someone's breaking into their home and they're scared to death, and they have no weapons on them, and I'm thinking, that's NOT gonna be me. That happens quite a bit, and I've dealt with every kind of call you can imagine where guns have been involved in both negative and positive ways.

Let's put it this way: I've taken a lot of calls and enough of them involving domestic situations where if people would have had a gun, I believe things could have possibly turned out differently or they might have been able to protect themselves.

I'll be honest, I didn't think I needed a gun in my house, and I really didn't want one. I didn't want an accident to happen with my kids. It made me very uncomfortable to have a gun in my home, but now I'm thankful I have one.

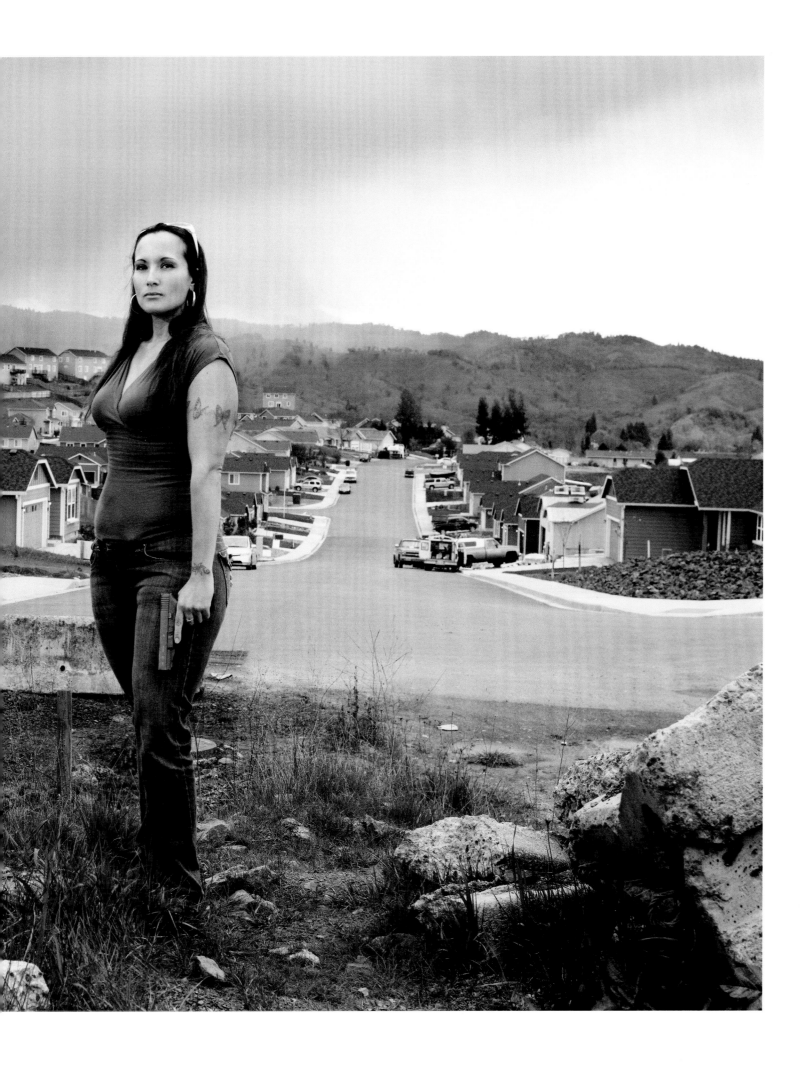

CARSON
Premont, TX
Browning 20-gauge side-by-side

I was not born into the South Texas life but was introduced to it by my future husband and it captured me. What I love about South Texas is impossible to fully describe. Its big skies, breathtaking sunsets, and flat, cactus-laden country are infinitely appealing to me. There is a calmness as well as an energy here. There is a camaraderie that is unique to this place.

As a family, we are happiest in South Texas. Our two daughters love it as much as we do, and we spend a great deal of time here. Our youngest shoots cactus and her big sister has graduated from cactus to small game and is a dead-eye shot! They shoot the .22 rifle their father used when he first started shooting at age seven, but our eldest just got her first gun, a .410, this year. The country provides loads of outdoor fun for them—go-carts, nature walks, games, jeep rides, watching the bats fly at sunset, and just being in the wide-open country. I love that they are growing up in, and wrapping their arms around, this country's culture.

Having a house full of friends adds to the fun. There is a stone in our rock garden that says, "Fun is important," and that principle seems to govern the weekends. Whether standing in the fields waiting for the dove to fly, or walking through the brush with the dogs on a quail hunt, or sitting in the field at dusk sipping field drinks, it is good, easy fun. There is always a margarita waiting at the end of the day, some good Texas music, and a big meal. Then to gather on the back porch or around the fireside outdoors, listening to the night sounds, tall tales, and laughter ... there is simply, for us, no better place to be.

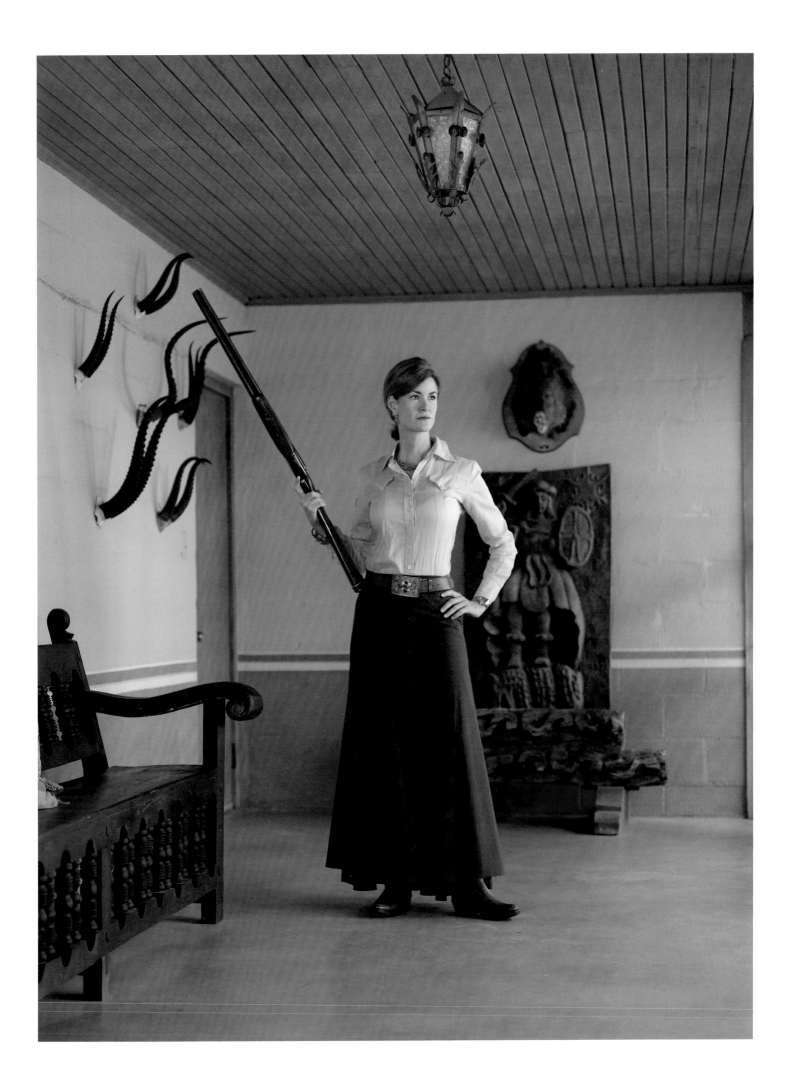

CHERIE

Livingston, MT
Rock River Arms M4 & Sig Sauer P229 pistol
in .357 Sig caliber

I always had an interest in firearms and hunting, but it wasn't until I started my law enforcement career that I truly was able to do either. At 5'3", I am one of the smallest troopers on the Montana Highway Patrol and work in a mostly rural area, where my backup can be miles or even hours away. It is crucial that I have good communication skills and be proficient with all of my weapons should things go bad.

I initially struggled with the shotgun in the academy, but once they had the stock customized to fit me properly, I excelled. I went on to qualify as a Distinguished Expert, and the shotgun is now one of my favorite weapons. I was very flattered one day when I was told that one of the firearms instructors I work with uses me as an example when he teaches at the academy. When guys twice my size complain about the recoil, he tells them about me and how he would put me up against anyone with my shotgun: if I can do it, so can they. It's always fun to see the reactions of people I have never shot with before when I use my shotgun at the range.

For me, firearms are a tool that I am rarely without. On duty, I carry a Sig Sauer P229 in .357 Sig caliber and a Kahr PM9 chambered in 9MM as a backup/off-duty weapon. I also have a Remington 870 shotgun and Rock River Arms M4 rifle in my patrol car. In addition to off-duty holsters, I have a small collection of purses with concealment holsters in them. I get teased a lot by my coworkers about how "there are no purses in law enforcement," but they come in handy. I have actually drawn my gun from my purse when backing up another officer while off-duty.

I am also a hunter. A lot of women who hunt learned either from their fathers or their husbands. Circumstances prevented me from having the opportunity to pursue the sport when I was growing up, so finally, a few years ago, I asked a few friends and coworkers to teach me. I was hooked the first day, despite coming home empty handed. I shot my first deer at 350 yards with my Ruger M77 Hawkeye .270 rifle and I am not sure who was more excited, my hunting partners or me. Of course, it also impressed the guys at work. Hunting is not only a stress reliever but a different challenge from the combat shooting tactics we use on the job. Now I take advantage of every opportunity to hunt, from ducks to bison, although I think that elk are my favorite due to the challenge they present. If I could do a different job, and it didn't matter how much money I made, I think it would be to have my own TV show where my friends and I could demonstrate the outdoor lifestyle of our area, featuring people with a variety of experience and skill levels.

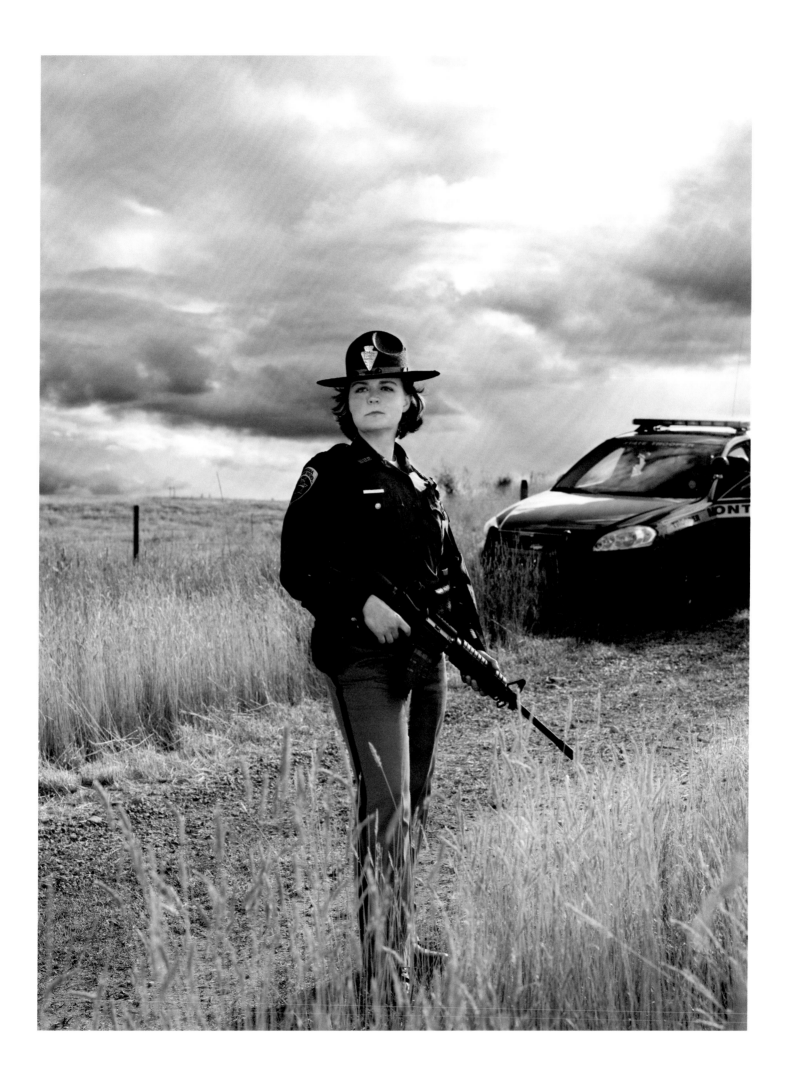

KATE
St. Paul, MN
Remington Model 870 Express in 20-gauge Magnum

Sixteen years ago, when my husband and I were first dating, he invited me to join him trap shooting. As I was trying to present my best side, I agreed to join him. There was a degree of nervousness that I repressed since I was completely unfamiliar with shooting a firearm. To add to my anxiety, I was the only woman in a group of guys, and I wanted to make a good impression on his friends. My now husband took such care and time to explain to me how the gun worked. He focused on safety and having respect for firearms. When I took my first shot, I was surprised by the impact on my shoulder, and the noise. However, after missing the shot, I was determined to figure it out. I was hooked. Over the years my husband has been an extremely patient teacher and can still watch my shot and figure out what adjustments I need to make. I have also learned that listening to his advice works much better than an eye roll, a lesson that has proved to have a much broader application.

The hunters and outdoorsmen and -women I know are also environmentalists and feel a great responsibility to the land that provides their recreation and enjoyment. I am passionate about preserving and restoring the environment, and being exposed to hunting has only fueled that fire. My husband and I are now fortunate enough to have a small piece of land in the country and are always trying to find ways to welcome wildlife and preserve the wild state of our property.

I'd have to say that my favorite gun is my Remington 20-gauge shotgun, which is pretty fabulous. There are more luxurious shotguns out there, but the manual pump action has always made me feel like Linda Hamilton in *Terminator 2*. I also have a soft spot in my heart for my .38 Special revolver. It was a gift from my father-in-law, who felt that it was an appropriate handgun for me, which I thought was such a thoughtful gesture from someone who spends so much time thinking about and collecting firearms.

I think all women should know how to drive a manual transmission and handle a gun.

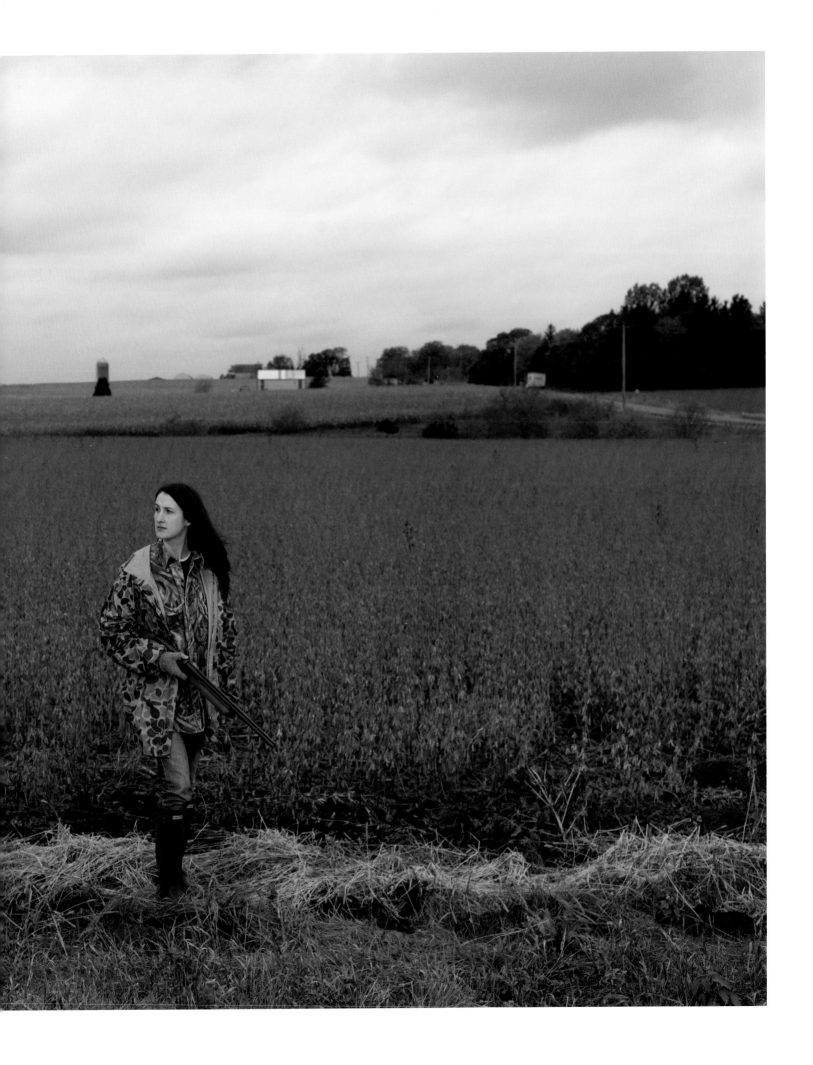

JENEVIEVE

San Antonio, TX
Peter Chapman 20-gauge side-by-side

Growing up I was all girl: ballet, sparkles, and plenty
of pink. I loved dancing and princesses and hated getting
dirty. I took after my mother, or so I thought. My dad,
on the other hand, was the complete opposite—guns,
dirt, and ranching. My father is an avid hunter and hunts
every day he possibly can during hunting season. He
even took my mother on a hunting trip for their honey-
moon. (Actually, I think she might've gotten conned into
going …) My dad tried and tried to spark my interest in
hunting but it simply was not my cup of tea. Eventually
our father-daughter time turned to shooting, and I started
practicing by aiming and shooting at targets. Being the
competitive person I am, I was soon interested. Our
Sunday practice sessions quickly turned into afternoons
and weekends spent hunting. I learned to shoot with
his .22 rifle and shot my first deer with him when I was
around thirteen.

 Fiesta is a week-long celebration in San Antonio,
Texas, sort of like Mardi Gras. It's the social event of the
year and it's very important to our family. The Fiesta
tradition dates back over a hundred years and honors the
heroes of the battles of the Alamo and San Jacinto. The
whole city comes together and celebrates, so being a part
of it is a big honor. The Order of the Alamo, one of the
oldest Fiesta organizations, chooses a queen and her court
every year. The twelve girls who are chosen get to wear
these fabulous handmade beaded gowns that typically
take about nine months to make. My dress in the pho-
tograph weighs forty pounds and the train that attaches
weighs about eighty pounds. Our family has been partici-
pating since the beginning. We have a long family history
of Fiesta duchesses, princesses, and queens.

 Fiesta was the only time that my father would
trade in his camouflage and guns for tuxedos and elegant
balls. He loved Fiesta and Fiesta loved him. And just as
he expected, I adored Fiesta too, so much that I became
queen the following year. When I was chosen, I don't
think I've ever seen my dad happier, except maybe on my
wedding day. Once again, something he had talked me
into became something I truly loved. Clearly, father knows
best. His two favorite things had become two of my most
cherished activities and events.

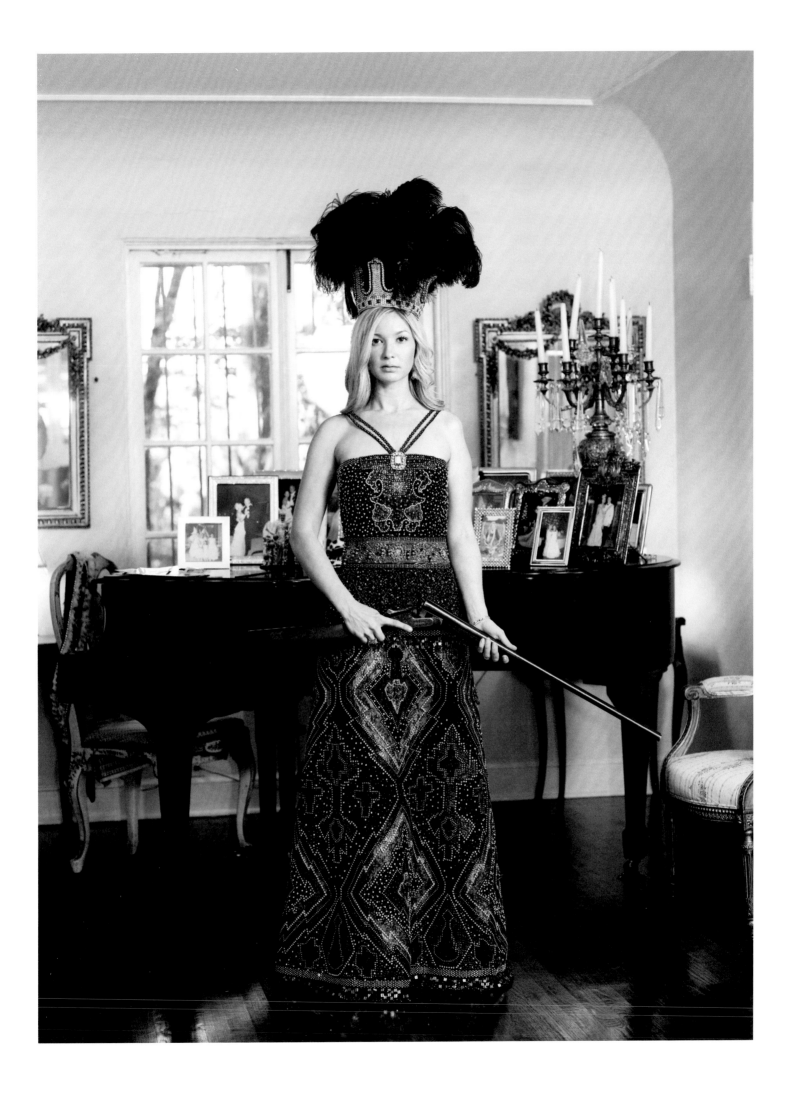

MEDINA
Three Forks, MT
Bounty Hunter 12-gauge side-by-side coach gun

Before I met my husband, Dave, I was not interested in
guns. Actually, I was kind of scared of them. But my hus-
band got me out of that shyness with guns. We went out
to the woods up toward Big Sky and he taught me how to
shoot. I felt nervous, but after a few rounds it started to
become fun. Actually, it was exciting. For a long time we
went out once or twice a week to practice target shooting.

I've been shooting now for about six and a half years.
It's given me a great sense of confidence and accomplish-
ment because I've achieved something I wasn't sure I'd be
able to.

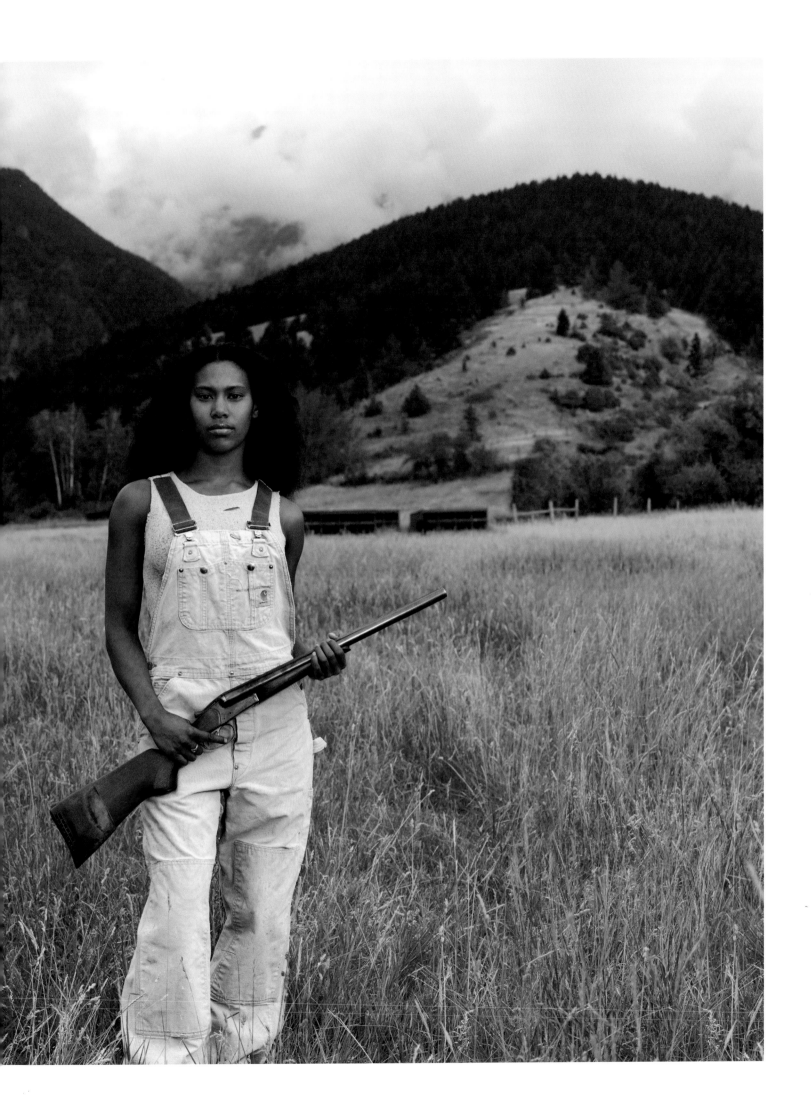

ASHTON
Atwater, CA
Colt .45 double-action New Service revolver &
Ruger .44 Magnum single-action revolver

I don't remember when I shot my first gun—I was proba-
bly about five or six—but ever since I was little I remember
I was learning how to shoot and how to aim, and trying
to hit the target. When I got older I got to go on different
hunts with my parents, mostly bear and caribou hunts.

I was twelve when we went to Alaska to hunt
caribou. My mom and I were running through the tundra
because there was a herd of caribou about 700 yards out.
We were running to them, trying to get there, tripping
over the tundra and falling into holes. The weeds were so
high they reached over our heads and you couldn't even
see us. Anyway, my mom lay back and I put my gun on
her knees to try to aim it and hold it steady at the caribou.
I was nervous and excited, so like a lot of people I put the
gun underneath my arm, when it should have been on
my shoulder—I was not paying attention. I just kinda shot
and I didn't know what happened, but the scope went
right into my forehead and it started bleeding. My mom
had the binoculars and was trying to see if I had hit the
caribou, while I was trying to figure out what was going
on and why my head was hurting. Despite the fact that I
missed the shot and scoped my head, it was still a lot of
fun. To this day I have the scar and some wonderful
memories from that hunt.

The moose you see in the photograph was in the
museum my grandfather built in Merced, California.
Since the museum closed down, the moose has traveled
with our family to three of our homes. I love it and it's
a reminder of the many memories that I've had hunting
with my family.

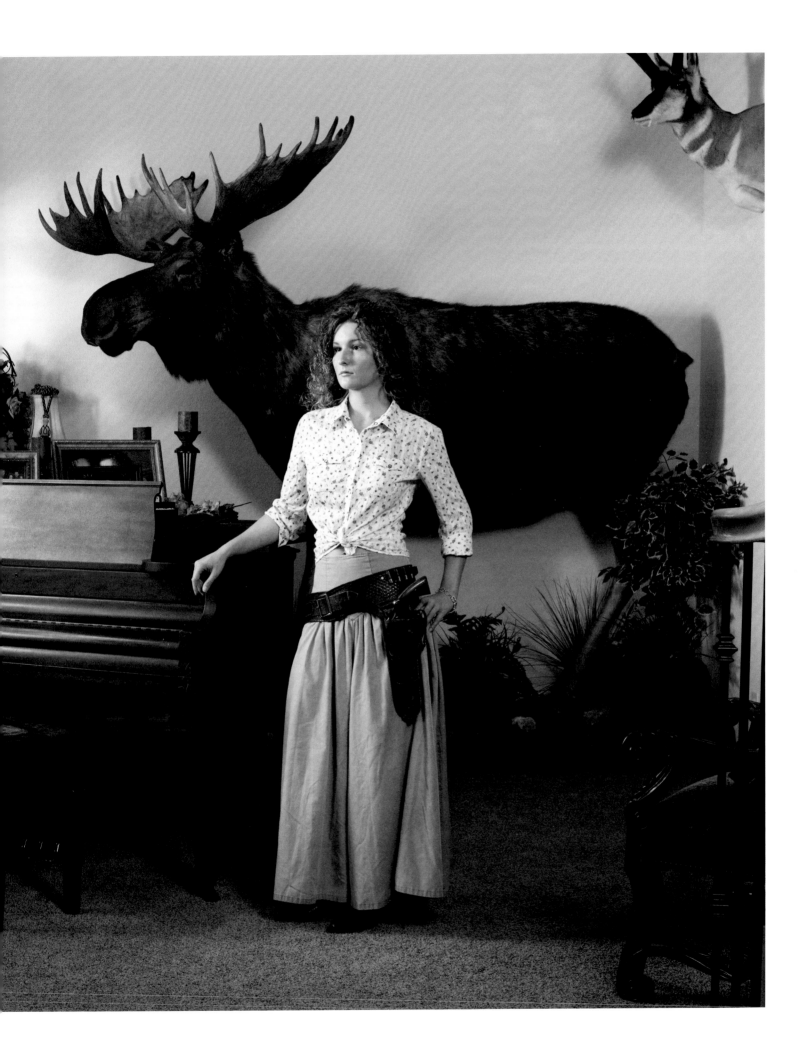

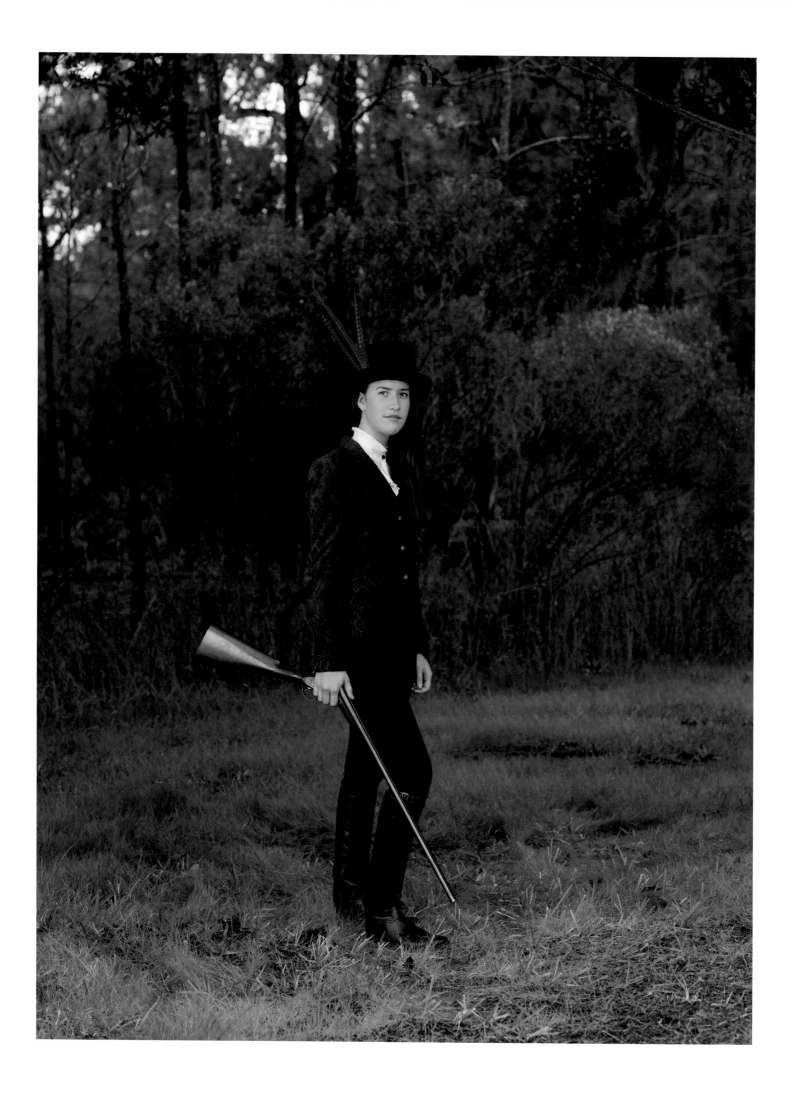

MARLEE
Richmond, VA
Boss 20-gauge side-by-side

My grandfather handed me responsibility at age seven in the form of a shotgun. I was never allowed to play with toy guns. My grandfather taught me the rules of safety long before I was ever given a cartridge to shoot. The barrel always stays pointed in the air or to the ground, and when not in use the chamber is empty. Treat all guns as if they are loaded.

I grew up in the South, where hunting is a large part of the culture. I began learning to shoot deer and game birds at a young age. Walking through the fields with my grandfather taught me a lot about game management, habitat protection, and gun safety. I also learned respect for both the sport and the people who participate in it. It is a sport deeply rooted in conservation, tradition, and family. We eat what we kill, and as a family we take pride in trying to eat game exclusively year-round. Hunting also introduced me to a world full of interesting people and places.

In South Carolina's Low Country, friends and family come together at Thanksgiving and Christmas for white-tailed deer driven by horses through tall pines and grassy marshes. At home in Virginia, we rise at dawn to watch ducks glide gracefully into local ponds.

My grandfather shared his world with me, a world that can be difficult to understand and even seem politically incorrect. His world taught me of our responsibility to protect and conserve the habitat of wild animals and the land that has given us so much.

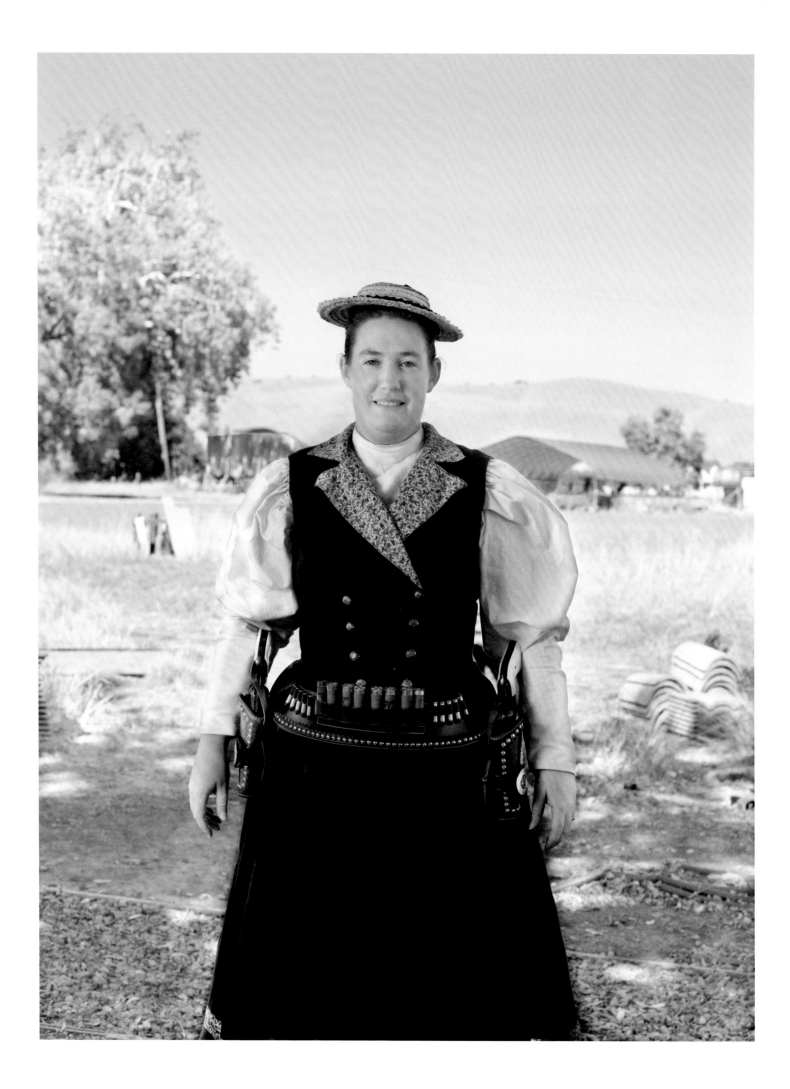

ELIZABETH
San Jose, CA
Matched pair of Special Edition .357 Magnum
Ruger Vaqueros

I learned to shoot when I was six years old. My father started me out shooting tin cans with a .22 rifle at our family cabin in the woods. My family has been shooting and hunting since before I was born. My father hunts, shoots competition (high power, IPSC, and Cowboy Action), and does some gunsmithing. My mom shoots and hunts some as well, though she prefers to stick with Cowboy Action. For my tenth birthday, my parents gave me a 20-gauge shotgun so that I could join my father on his duck and pheasant hunts. For my twenty-first birthday, they gave me a Springfield 1911 .45 so that I could learn to shoot a pistol. By the way, twenty-one is the youngest age one can own a handgun in California, and this has now become a tradition in my family for my younger sister, as well as my cousins.

Over the years I have shot competitively with air rifles and .22 rimfires, learned to hunt with high-powered rifles and shotguns, and shot skeet and trap. Most recently, I started Cowboy Action Shooting together with my husband and my parents. I really enjoy Cowboy Action Shooting since it allows me to participate in two of my favorite hobbies at the same time, historical costuming and shooting!

LISA

Flagstaff, AZ

Sears semi-automatic in .22 long rifle caliber

I grew up knowing nothing about guns, my parents both being peace activists. My desire to learn about guns began when I was eight, in 1968. I watched *Dialing for Dollars* and hated it when the girls in the movies would hold their ears and scream when the hero would drop his gun. I'd yell at the TV for the girl to pick up the gun. Then I would wonder what you do once you pick it up.

I also knew a lot for a child about the Vietnam War, the defenseless women and children in the villages that were massacred—they had no way to defend themselves. I wondered what would happen to me if we were invaded; sure, I could pick up a gun, but then what? I'd be damned if I was going to be a helpless girl waiting for a man to save me.

So at the age of nineteen I joined the army, a perfect rebellion against my upbringing. I chose military police; that would give me the most exposure to a variety of weapons for a female in the service. My first time out with an M16, I qualified as a marksman. I'm a lefty shooting righty. I requalified shortly thereafter as an expert. I also qualified as a sharpshooter with .38- and .45-caliber pistols and a grenade launcher. Now I am certain that I will be no one's damsel in distress.

Twenty-four years ago I received a 12-gauge as a wedding present. It's probably my favorite weapon. It has a nice balance and always hits its mark.

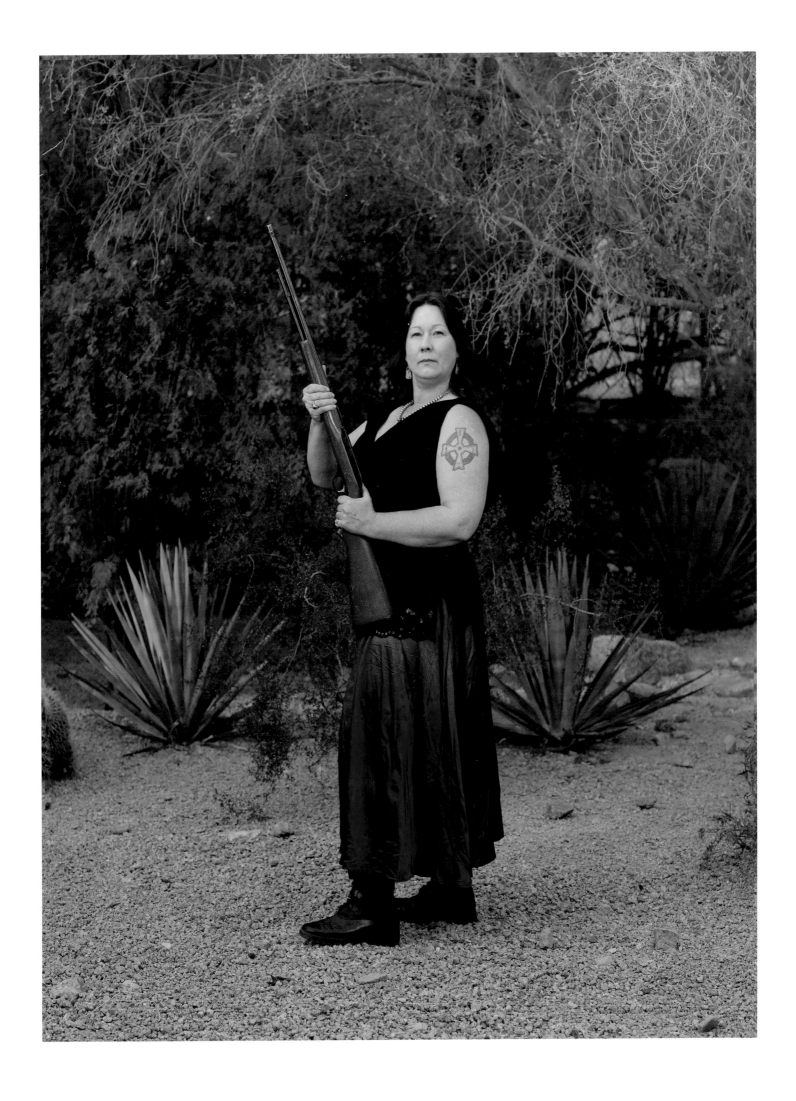

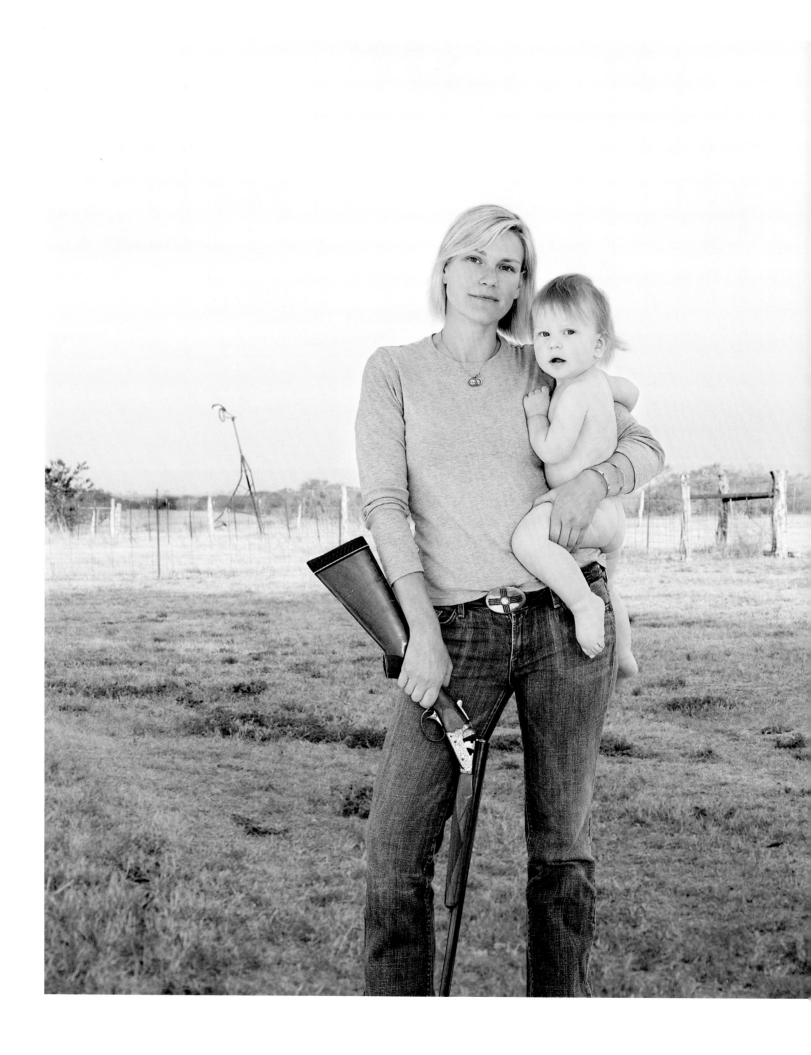

ALEXANDRA & TRUETT
Houston, TX
Ithaca 20-gauge side-by-side

Guns, like everything in my childhood home, were considered treasures and works of art. My brother and I respected the barrels of Ithacas, Arietas, and Belgian Brownings that collected in my dad's gun closet. The picturesque worlds created in my young mind by stories of my parents' hunting excursions to South Texas dove tanks, West Texas blue quail-chasing marathons, or bone-chilling North Dakota upland bird hunts in my mother's native homeland caught my attention and curiosity. My parents taught me to appreciate the art of the hunt, the serenity of the outdoors, and the magnificence of it all.

I now have two sons, Thomson, five, and Truett, three years old. The bundled energy and palpable excitement in their eyes as they watch us pack the car with hunting gear is intoxicating! This book actually made me realize that the guns my father gave me when I was married will one day pass to my sons.

I feel fortunate they will know and understand the significance of an heirloom firearm and possess the trait of respect for the outdoors. For me, the real art lies in the unspoken, in what is created watching my boy shoot his first bird over a tank against a fire-burning South Texas sky. That's art, and worth passing on to another generation.

I hunted with my family and friends growing up, but was absent from hunting in college and for the eight years I lived in NYC. When I got married and moved back to Texas, I started to go on bird hunts again. I love hunting trips with couples, friends, and families. Sports in which everyone can take part are rare, but hunting is a sport that can bring everyone together. It is not discriminatory of age, education, gender, or bloodline. It takes you to the most sacred and beautiful areas of the world, and my guns are the beautiful accessories I take with me.

I guess there is a reason why I make timeless luxury accessories out of alligator with names engraved on custom platinum nameplates inside. It is the craftsmanship and the art of making the animal skin look its best without manipulating it. I love the idea of the nameplate inside so generations of women can pass it down in their family. I honestly got this idea from my gun, which was handed down to me.

Hunting this past weekend in South Texas, I thought of the beautiful picture I have. It brings tears to my eyes because I see generations of respect and love. I have my grandfather's gun, which my father taught me to master, in my hand while holding my youngest son, naked, pristine, and innocent, in my arm. I'm so eager to teach my boys everything I know. They went out into the field with us this weekend and I loved every minute of it, all of us together with the beautiful sun setting in the sky. Knowing that one day they will be teaching their boys or girls the same thing with the same gun makes me smile.

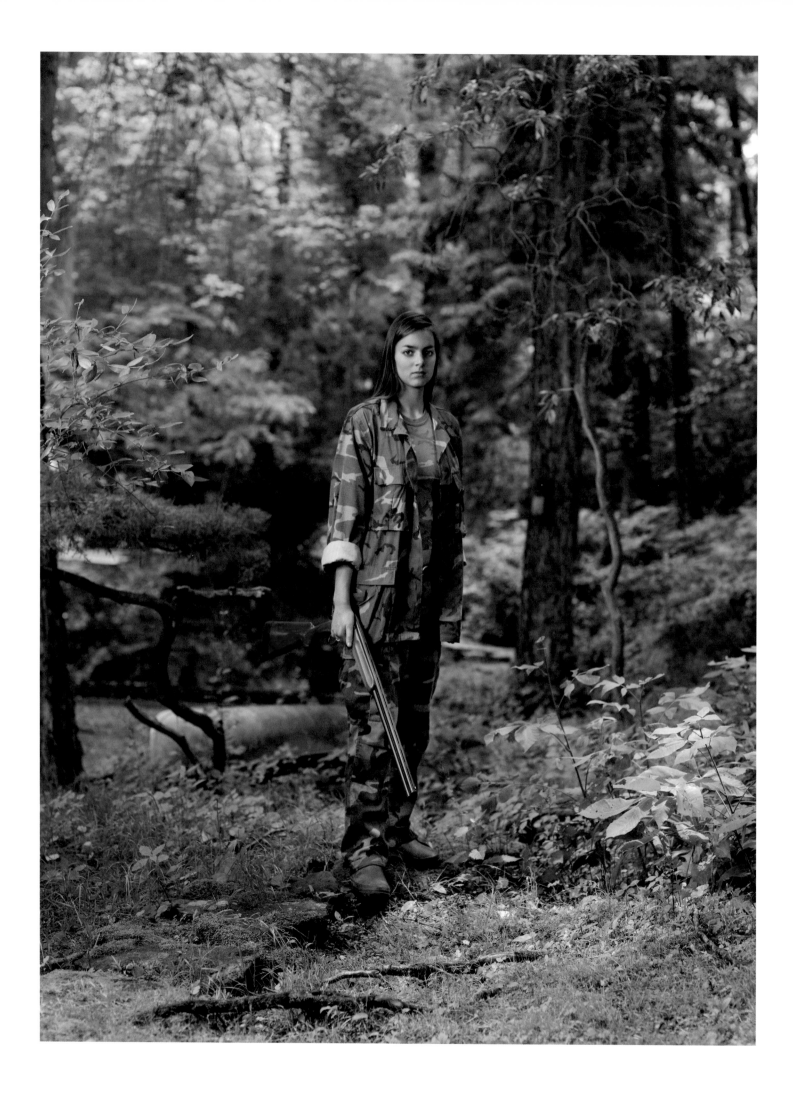

VICTORIA
Stamford, CT
Beretta 20-gauge over-and-under

I have been around guns and shooting my whole life.
My father and mother are both very good shots and love
to hunt all around the world. My dad and numerous
instructors taught me how to shoot, and my mom and my
dad were both thrilled to have me become a shooter.
I only shoot every so often, when the opportunity comes
along. My father has a sporting clays course, which I
practice on quite a bit. I love shooting a 28-gauge because
even though it's a smaller gauge, it doesn't have as much
of a kick and it challenges me to have better aim. I think
it's great that women have begun to hunt and shoot
because it's a fun sport and something that men and
women can do together. You can be a girly girl and still
shoot just as good as a guy.

ELIZA
Houston, TX
Beretta 20-gauge over-and-under

For me the fun of hunting is being in the middle of
nowhere, far away from the city with your family and
friends. I started hunting in South Texas during college
when my dad figured out that although my brother didn't
like to hunt, his summer camp-going girls loved the
outdoors and the whole hunting thing. The first year my
little sister and I shot cactus and turtles, and by the third
year we were keeping up with the men—maybe using
a few more boxes of bullets, but we were holding our
own. I started out with a Smith & Wesson automatic, just
a very basic gun. I enjoyed that extra third shot during
those first years.

 During my college years, and after, we would often
each invite a friend or two on our hunting weekends
away. We'd go into Mexico at night, to the Cadillac Bar in
Nuevo Laredo or Madernos in Piedras Negras. Anyone
who hunted South Texas back then has probably been to
both. You have to picture the old crushed-velvet uphol-
stery on the booths and the painting of Elvis hanging
proudly on the wall. Some of my best memories for sure.

 For a wedding present, my husband and I gave each
other Berettas, and I still use my over-and-under today.
I love it. It is very light and fits me perfectly. Having a gun
you can carry a long time when you're hunting in the
field is key.

 The best part of hunting for me is getting to know
people and really bonding on a weekend away together.
Those hours on the quail truck chatting, chasing birds, and
sharing cocktails at sunset on a tank or high hill can't be
beat. The stars, sounds, and fresh air are all things I will
never get tired of.

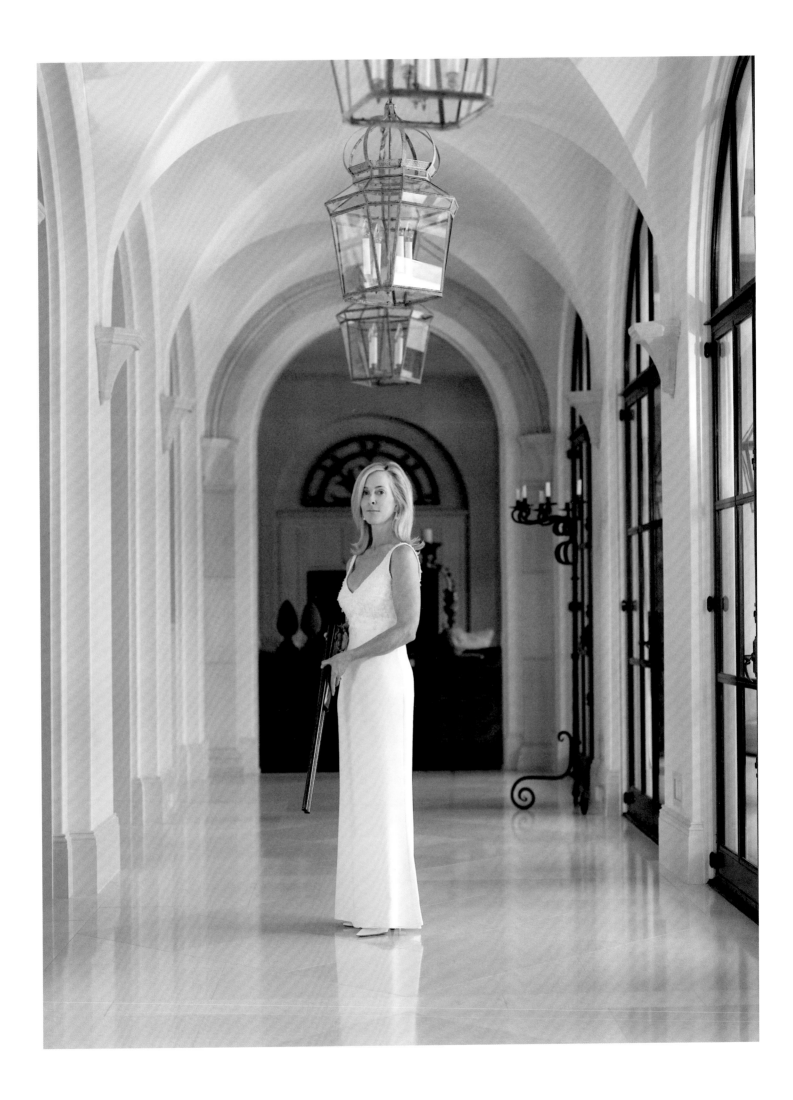

MARGOT
Pinehurst, NC
Remington Model 700 with a Redfield Illuminator scope

The youngest of four, with three older brothers, I was forced to sit and watch with envy as my brother Clark and his friends would take out their BB guns in search of squirrels and other targets around the farm. I remember feeling unable to constrain myself as I heard each plink of the BBs, wishing to be out there with them. It wasn't until Christmas when I was about ten that I was finally able to convince my parents to give me my own Daisy BB gun. The seed had been planted for the love of guns and shooting.

My love of shooting grew when my parents brought me to Pinehurst, NC, the home of Annie Oakley and her husband, Frank Butler. My mother saw Annie shoot in the early twenties at what later became the Annie Oakley Gun Club, and I still remember my mother's stories about Annie and how amazing a shot she was. Before it finally closed, I would take my son to the Gun Club to shoot and admire the historical memorabilia of Annie Oakley and her days there. It's the love of Pinehurst, Annie Oakley, and quail shooting that has brought me back to this very special place.

My passion for shooting has led me to Scotland, Wales, Colombia, Mexico, and Africa, where I have shot large game. I cannot describe the exhilaration and self-discovery that has come as a result of being up close and personal to large game with a rifle in my hands. However, my favorite times are watching the dogs work and honor one another while quail hunting in North Carolina, where the pine trees and fields are so beautiful in the mornings.

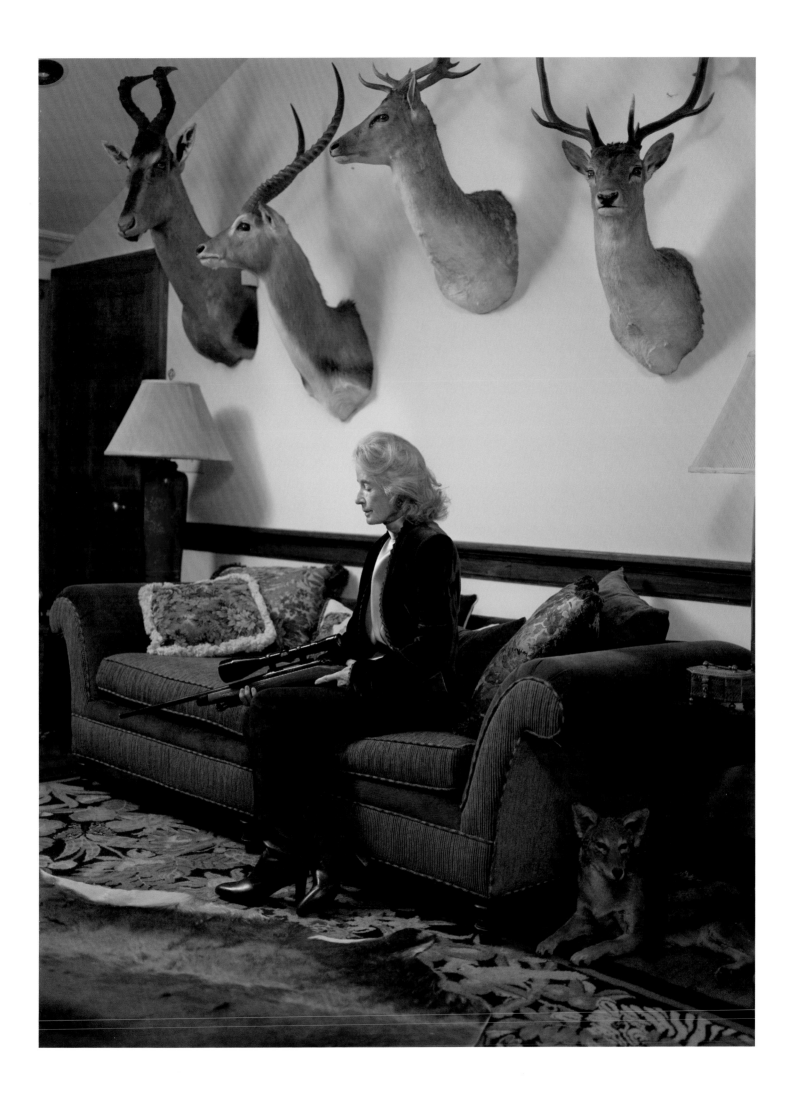

MARGARET: Growing up in a hunting family meant adventures so great that the images of these trips loomed large in my childhood imagination. Watching the preparation, gathering the gear, cleaning the guns, listening to the talk of hope and success in the field.

There were storied family lodges, duck-hunting camps located on Knotts Island or up north on Cape Ann. The men in our family hunted together as far back as any can remember. The skills and guns passed down from generation to generation. The game books, dating back to the early 1800s, boasted of the days when the flyways would darken the skies with birds. When punt guns were used by market hunters, canvasbacks were everywhere and swan were fair game.

Yet these men skipped a generation ... of women. Their "no girls allowed" view of women at the lodges during hunting season meant that my mother, sister, and I were never invited to go along.

One white Christmas, my father was asked by his great-uncles to invite our family friend Bing Crosby (Uncle Bing) to a News Year's shoot at a family camp on Currituck Sound. Bing, known for his love of hunting, accepted with pleasure and a small caveat: could he bring his wife? My father was charged with telling him that the rules of the camp did not include women. My uncles suggested that my dad offer Aunt Kathryn shelter at an inn down the road. Bing declined the invitation. The uncles mused, "What sort of man hunts with his wife?"

My stepfather's first gift to my mother was a shotgun—and this man hunts with his wife. The gift was like a shot off the bow. Now, all the women in our family shoot. They shoot well, often, and best of all, around the globe. We travel to shoot driven pheasant in Cornwall, pigeon, perdiz, duck, and dove in Argentina and then home again for quail and deer at our plantation in the Low Country.

My stepfather's christening gift to his first granddaughter was a Chipmunk .22 rifle. The cycle is complete. We are now a hunting family. We talk of conservation, we share a love of land, and nature's cycles call us all together again each season. We plan family shooting trips to new, familiar, and unfamiliar places. It looks like our family will not skip any more women. My father, my stepfather, my mother, and their grandchildren—we all have our own hunting stories to share and pass down.

I'd love to hear Uncle Bing croon about that.

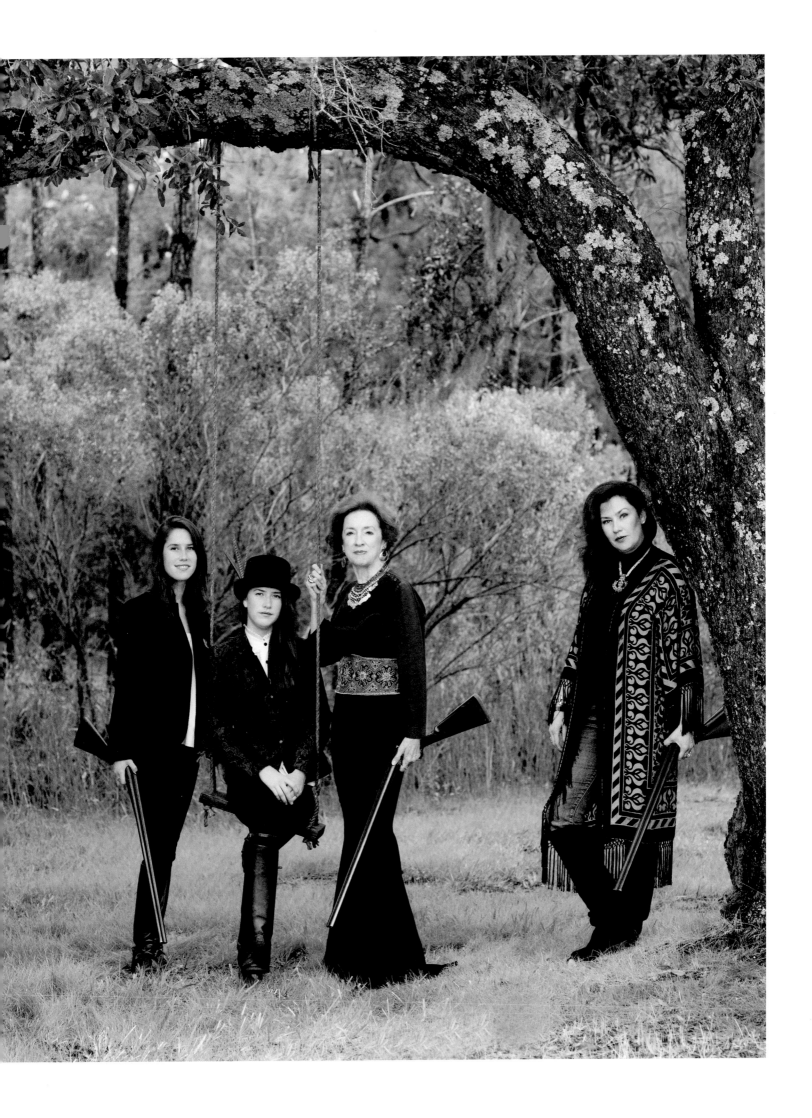

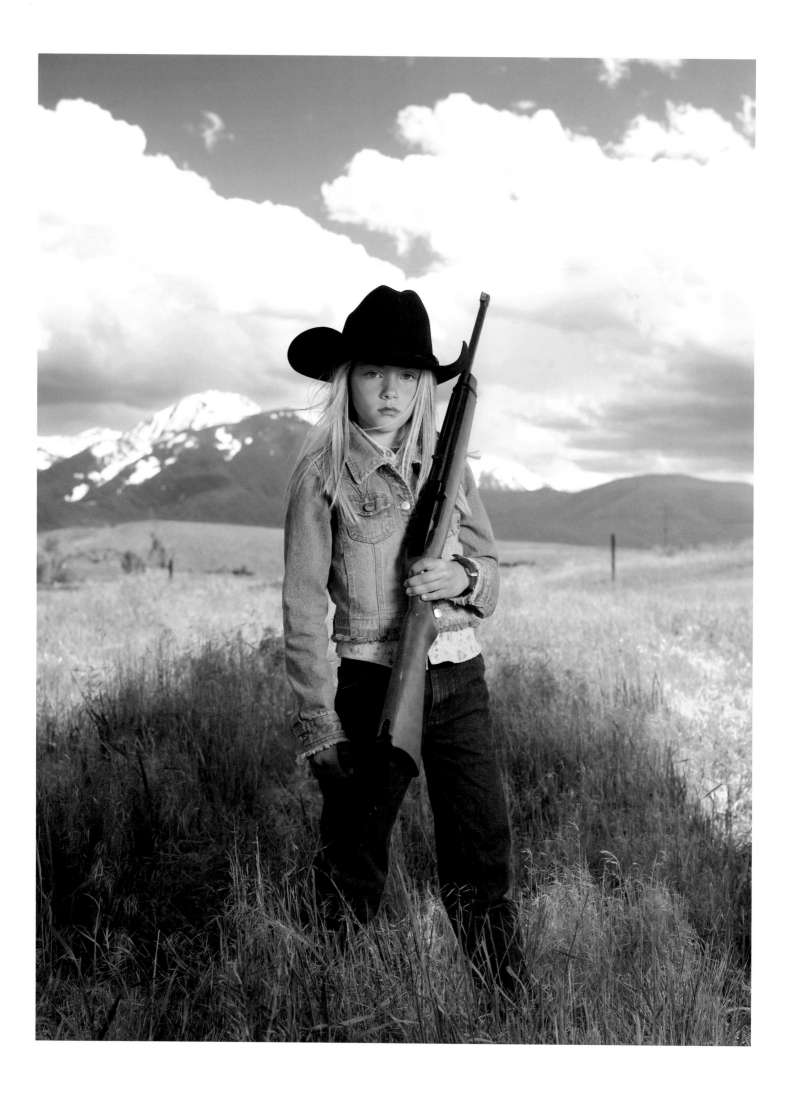

LILLY
Livingston, MT
Ruger 10/22 carbine

When this picture was taken, I was eight. I was included because my big sisters were being photographed too. I thought it was cool. Guns are a normal part of our life. There's usually a .22 in the pickup.

I'm turning twelve this summer, so I will take hunter safety classes to get my hunting license in time for hunting season this fall. I'm really excited. It's a family tradition that I get my first deer and elk with the .250-3,000 Savage Super Sporter. My great-grandfather gave this rifle to my grandpa in 1936 when he turned twelve. Since then my dad, my brothers, and my sisters have shot their first elk or deer with it.

The first time I shot a .22 was with my dad, sisters, and little brother. My sisters and I were in our back section shooting gophers—I was just tagging along—when my dad drove over on the four-wheeler. There was an empty oil jug that he put up for target practice for us. He showed me how to load, hold, and aim, so I did it. I hit it every time. It was fun.

Every spring we shoot gophers. There's always target practice before hunting season opens—usually the day before. We hunt right here on our ranch. When the elk come through there are usually lots so everyone gets one. I go out every morning with my dad and sisters during hunting season. This year I'll be hunting, too.

We also learn how to care for our guns. Through the years my brothers and sisters have gotten their own guns but we still use our old favorites. The gun I'm holding in the picture is my sister Eliza's. It's a Ruger 10/22 that my older sister Laura gave to Eliza for her twelfth birthday. I'm looking forward to hunting season!

EUGENIE
Greenwich, CT
Parker 28-gauge side-by-side

I come from a family where shooting was a way of life. My father had a passion bordering on obsession for driven game, and my mother took up the sport when she married him. I would not have chosen this pastime for myself were it not for them. I was a girly girl; I liked painting, pretty dresses, and playing with Barbies.

My first gun appeared under the Christmas tree when I was just ten. I hadn't asked for a gun; in fact, I had probably asked for more shoes, clothes, and a new Barbie, but there it was, a beautiful Spanish AYA .410. I guess you could say I came to the sport because that's what Santa brought me.

My father was very forward thinking when he introduced me to this sport. When I was growing up in England, girls did NOT shoot. If anything, they were discouraged from shooting and were encouraged instead to work the retrieving dogs on the field or to ride horses. Shooting is a serious sport and requires a substantial investment in equipment. When I was in college, I would invite large co-ed groups to come and stay, and inevitably we would go clay pigeon shooting for fun. It was great entertainment and the girls, after shedding their hesitation and horror of firing a gun, would shriek with delight as their targets broke into pieces. But afterward, my guy friends would complain and say: "You can't introduce this sport to my girlfriend because if she likes it, I can't afford it."

I love the sport simply because it's what I've always done. What I enjoy most about it is that it's extremely challenging and every bird is different in its environment. I'm exclusively a bird shot and have been very fortunate to shoot primarily wild birds most of my life: driven grouse, bobwhite quail, Spanish red-legged partridge, English grey partridge and pheasant.

Driven grouse is the most challenging and difficult shooting I have ever done or will ever do. They're wild and untamable. They come at you, sight unseen, like bullets. It's exhilarating and humbling at the same time. On a different level of enjoyment and challenge are wood pigeons and duck flighting. These require a great deal of patience and dedication.

I have never lost my girly-girl side, and to this day I still prefer to shoot wearing a skirt when possible.

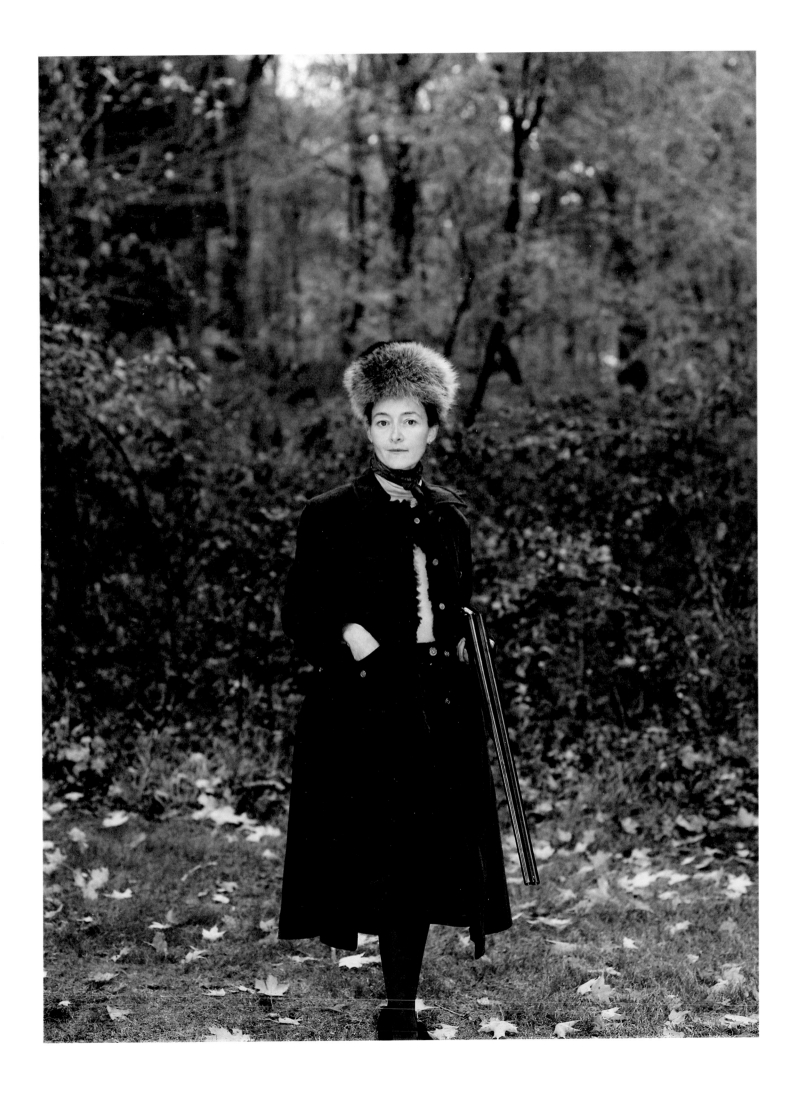

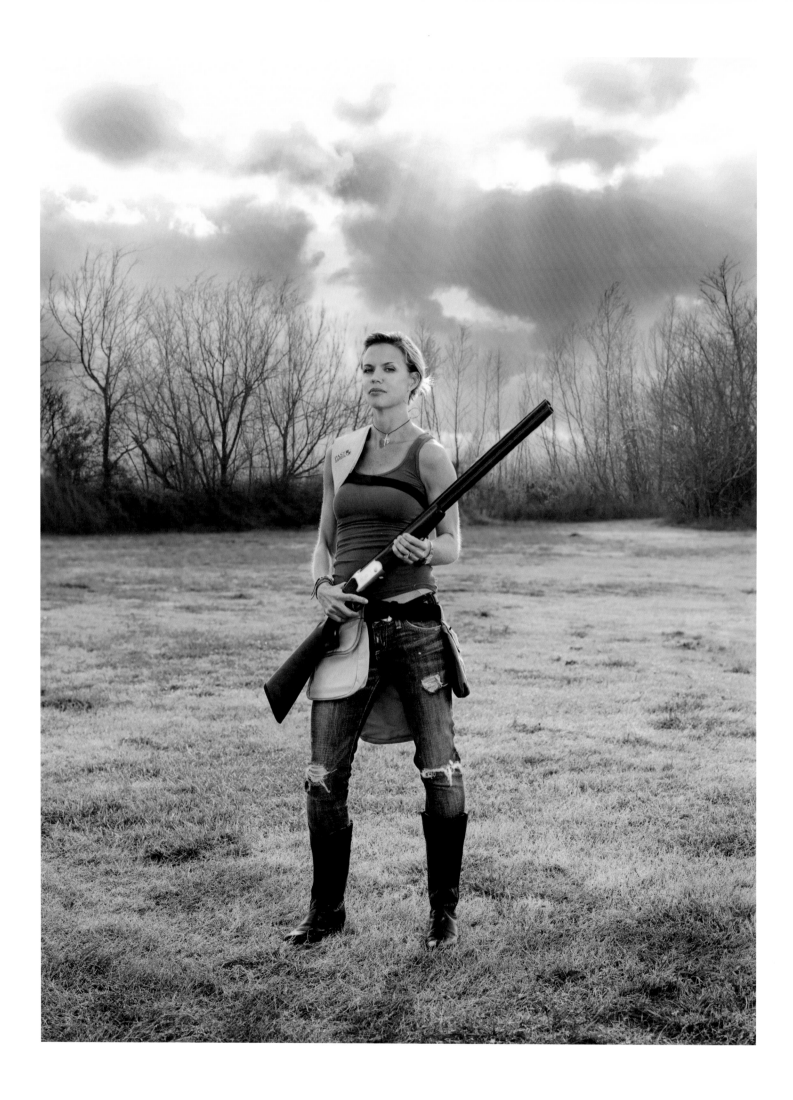

COURTNEY
Houston, TX
Yildiz 20-gauge

I remember my brother, Harper, and I setting up cans. See, my brother was shooting a single-shot 12-gauge shotgun. You should not miss any aluminum cans with that gun. I was still young and had my youth shotgun, the 20-gauge, but I had three shots on that. My brother went first, as always. He blew that beer can right off the fence. It was almost scary to see the sheer power of his gun. I went next. I missed. He went next. He missed, and I made sure he knew what a loser he was. He was not happy. I had all three shots in my gun. I clicked my safety, stood up, squinted, closed my left eye, and shot one—hit it off the fence. Shot two, hit that one clear off the fence. Shot three, hit the last one off the fence. "Game over, Harper," I said very smugly, knowing it would anger him. That is one of my favorite memories of all time. After that I was convinced I was ready to go deer hunting with the boys. Many might describe this event as kids playing with guns. But we were not. We were target practicing with adults nearby. We had been trained about gun safety since we were little. I knew how to carry a gun. I knew to make sure your gun is unloaded at all times until you are prepared to shoot. I knew to never bring a loaded gun inside. I knew to keep your safety on until right before you plan to fire. I knew to keep my barrel up or broken. I had a healthy fear of guns, knowing that a small mistake could end in death. With the right to use a gun, to go hunting, came great responsibility. If guns were mishandled or rules not followed, then your gun or hunting experience was over. You lost the privilege to use guns. We, my brother and I—my sisters never cared for hunting or guns—never handled guns without adult supervision. I pass on these rules and philosophies to my own children. Even when my four-year-old son is playing with a play gun, it gives me the opportunity to teach him about gun safety.

My favorite gun is a 20-gauge over-and-under. The 12-gauge I can use, but it has too much kick for the kind of hunting/shooting that I like to do. I recently bought a ladies' Turkish 20-gauge side-by-side that I love. It is lightweight, and it looks pretty. And I like the look of side-by-sides and over-and-unders. I like to break my gun and carry it that way. I also really like to dress to hunt even though dove are colorblind. It is just fun. There is a feeling of satisfaction when you see your bird drop whether it is a dove or a quail. I prefer the taste of quail but seem to do more dove hunting for some reason. I do soak the dove in soy sauce, then add a slice of jalapeño and a slice of Monterey Jack cheese, wrap it all up in cooked bacon, put a toothpick through it, and throw it on the grill. That is South Texas!

ALICIA & CRYSTAL
Myrtle Creek, OR
Crickett .22 rimfire rifle

My husband and I own a Beretta 92FS pistol. We bought it for protection at the house. My husband's a forester and sometimes he has to go out on fires. The last time he was out on a fire I was left alone for two weeks. Living out in the woods, and now being five months pregnant, it's good to know I have something to rely on for protection when my husband's gone. Of course, if something happened I would call 911 first, but I doubt I could stand up to a burglar all by myself. At least with a gun I might be able to scare them away.

My nine-year-old daughter, Crystal, got her first gun, a little Crickett .22, last year. The first thing we taught her was gun safety. She knows that all our guns stay locked up and she is never to touch them without adult supervision.

What we like about her gun is that it's a single-shot rifle, which means it can only shoot one bullet at a time. You have to stop and load it again. It teaches her patience and she likes it.

Some think that it's not a women's sport or a woman's place to have a gun. But I think it's good to know how to use one and how to keep them responsibly and safely.

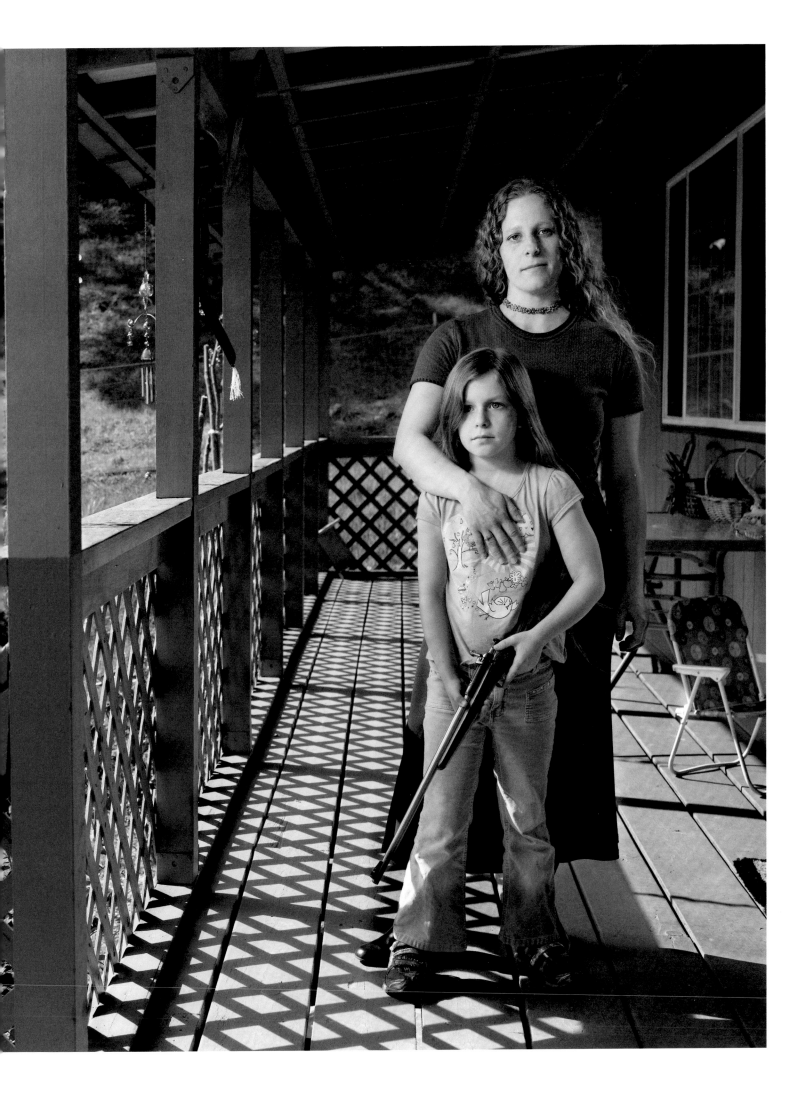

JOYCE
Lakeview, NC
Blaser F3 12-gauge over-and-under

The two greatest influences on my ability and progress in shooting have been my father and my personal instructor Dave Lemon. My father was a Los Angeles police officer. He started my training by impressing upon me that a weapon was a tool and deserved the greatest respect and care. Lesson One was that you do not play with weapons. In my formative years weapons were only looked at when an adult was present. Lesson Two was that all weapons are considered loaded until you prove otherwise.

I have had several instructors as I progressed in sporting clays, but Dave Lemon of Backwoods Quail Club in South Carolina has been the one with whom I have learned the most and advanced the furthest. He and I click. He has a way of demystifying a target and can have me breaking the most difficult shots within five minutes. When I shoot tournaments well it is because of Dave's ability to make me see what needs to take place during a shot.

Sporting clays emigrated from merry old England sometime in the 1970s. By the 1980s the sport started to grow into what we play today. Its original purpose was to prepare bird hunters for the upcoming hunting season, but it has developed into a competitive sport played all around the world.

It is unique in that it is an individual sport played in a group. It can also be played by an individual for practice or with a referee in competition. As part of the group you are not necessarily competing with your squad mates (unless they are of the same class) but against the trap setter. It is usually played over a course of fourteen stations. Each station has two traps and you are required to break three or four pairs of targets on each station. The total number of targets is one hundred. Sporting clays is fundamentally a game of physics and geometry. Five percent of the sport is physical (safety, gun, shells, stance, hold point, break point). The other 95 percent is mental. The mental game is what separates the sportsman from the champion.

Sporting clays is both an individual and a family sport. Its competitors are both male and female, ranging in age from seven to seventy-five. It's a sport you can participate in throughout your life. The handicapped also enjoy this sport. Three things can help you succeed: desire, dedication, and discipline. All three have contributed to my being the North Carolina State Lady's Champion for the last four consecutive years.

The weapons I use are utilitarian, rather than works of art. In competition I use a Blaser F3 12-gauge, 32-inch barrels, and Muller chokes. For hunting my weapon of choice is a .257 Weatherby Magnum. For bird hunting I carry a 12-gauge Beretta 391.

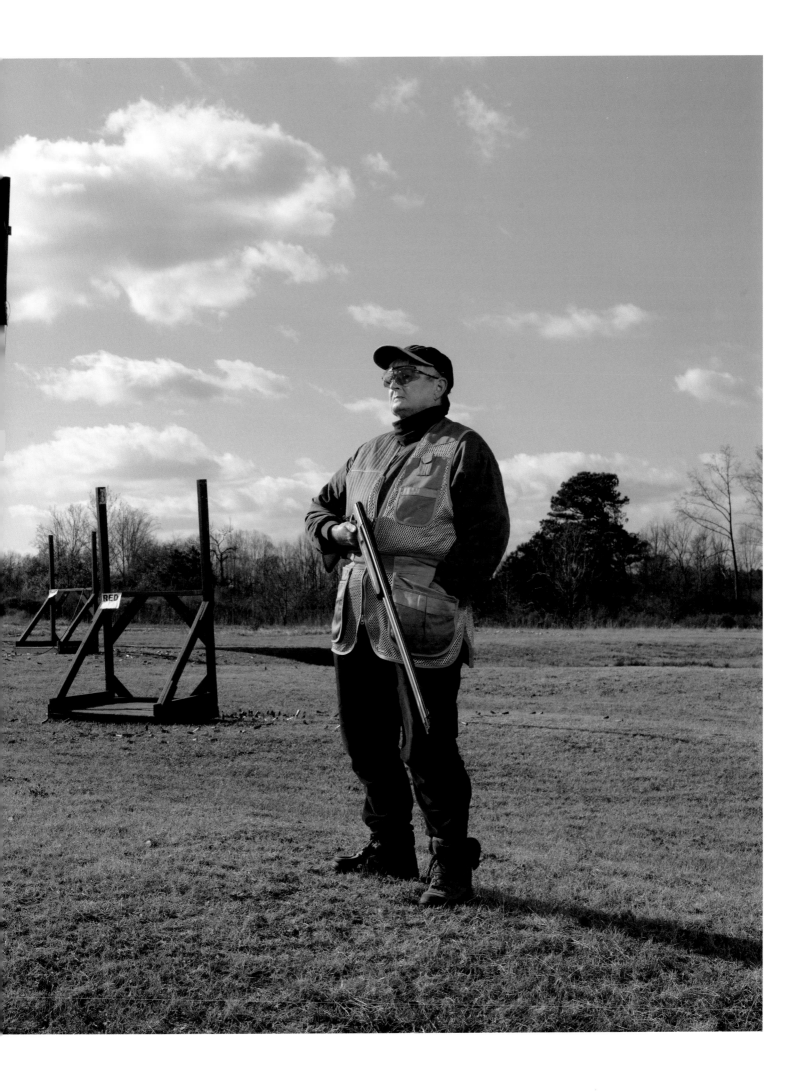

HEATHER

San Antonio, TX
Beretta 20-gauge over-and-under

I'm an only child and the only granddaughter on both sides of my family with six boy cousins in total. My father, who is truly responsible for my love of hunting game and wing shooting, introduced me to guns and gun safety very early on. I shot and gutted my first deer with my dad, and learned to respect all firearms and therefore enjoy them. I remember a Christmas we spent at the ranch when I was about six years old. I can't remember what I wanted that year—I'm sure it was something to do with horses. I always hated dolls and Barbies, but I loved stuffed animals, so that's probably what I expected to find in the big box under the tree. When I opened it up on Christmas morning, there was a very small, cut just to my size, .22-caliber rifle with a little scope on it.

I do remember being a little confused—not disappointed at all, just confused—because I was not supposed to touch the guns in the house. My dad helped me lift it out of the box and then started telling me about all the fun we were going to have with it once I knew how to safely use it. That's how it all began! I remember shooting that gun at a target plate nailed to a wooden block in my grandfather's back yard. He loved that I loved guns. What I am most grateful for is not the little .22 but the special way that it helped this only daughter and granddaughter find a unique relationship with those two men who I loved so much. My mother has always been a shooter as well—and my very best friend—so that camaraderie was easily found. But with my father and Pa, it was almost like the gun showed them that this little girl was not breakable, and it opened up a world of adventures for us. I miss those days shooting at targets and trail riding with Pa, and I'm lucky that Dad and I still go on a big bird shoot each year in Pennsylvania, as well as shoots at our ranch in the Texas Hill Country. I just had a baby boy, and I'm looking forward to sharing all of this with him. Needless to say, his grandparents have big plans for the next generation— they are already preparing for his first African safari!

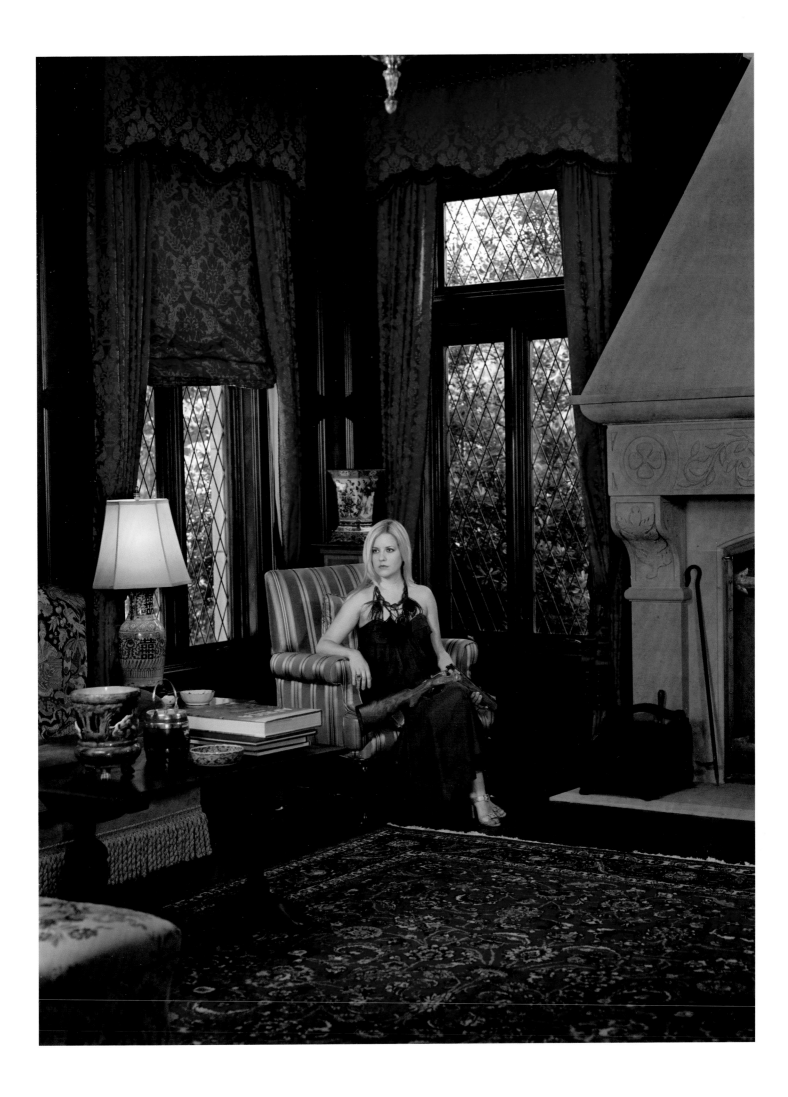

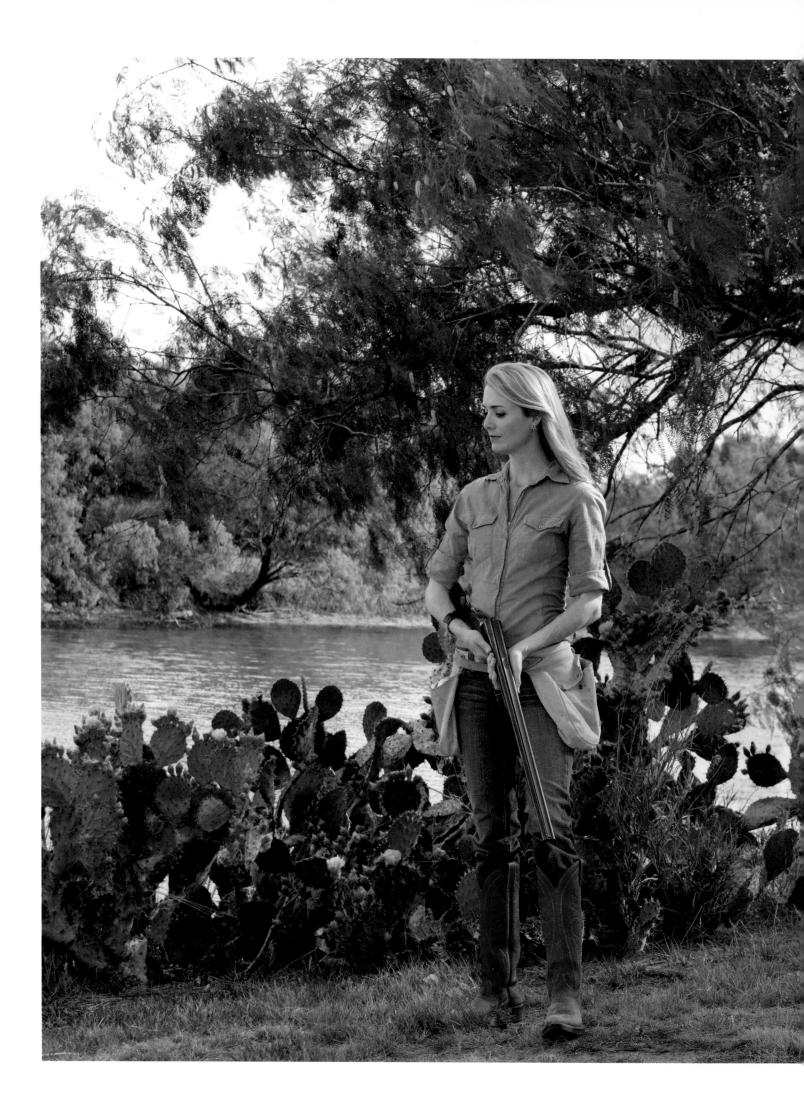

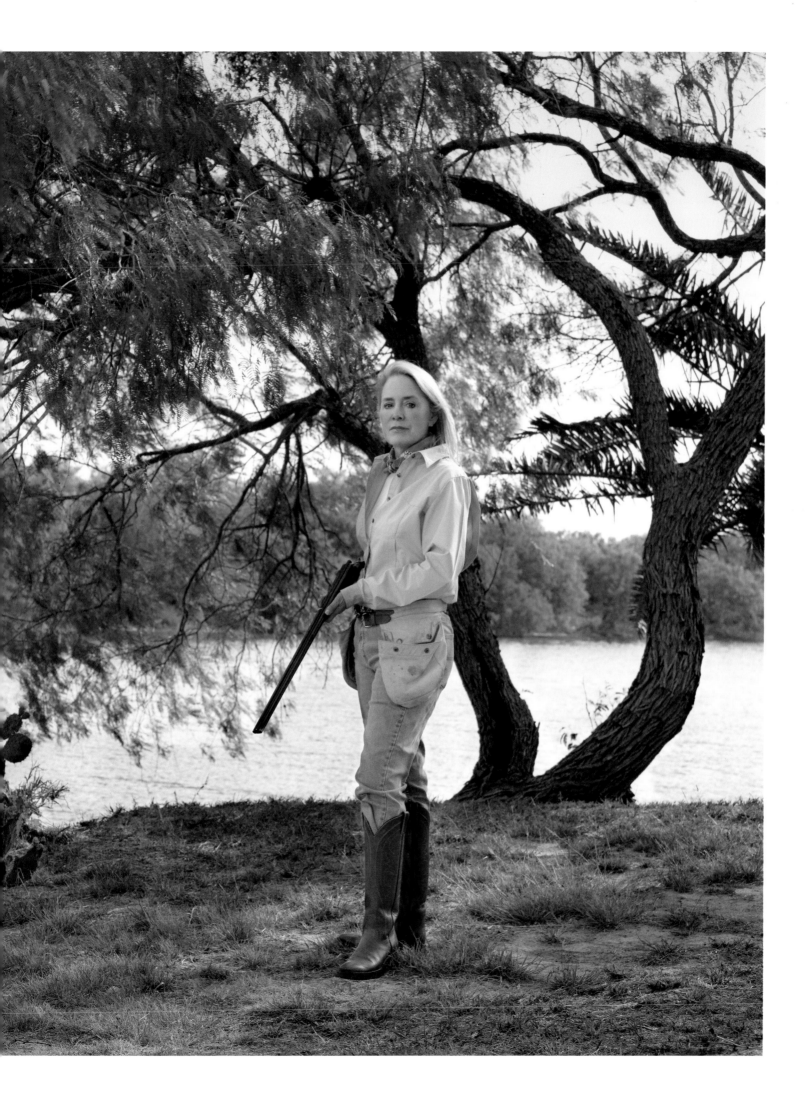

<<

ADRIAN
Kingsville, TX
Parker 28-gauge side-by-side

I started shooting when I was eleven years old with a single shot .410. At that point, I found driving the hunting car all day much more entertaining than shooting. When I was about fifteen or sixteen years old, I started getting really interested in quail hunting. Every Thanksgiving and Christmas break we would go quail hunting as a family, and my dad would give me pointers on how to actually shoot a bird, not just shoot bullets. My parents were very focused on gun safety and game conservation, and I was always told, "When you shoot a bird, watch it and pick it up."

My dad was given a Parker 28-gauge, double-barrel, side-by-side shotgun by the managers at the ranch when he retired. When my dad decided that it was time for me to move from a 20-gauge, he let me borrow, under his watchful eye, his coveted 28-gauge. Ever since the first day he let me shoot his gun, I have not shot another. I asked him if I could have it, but he said, "Absolutely not, maybe when I die."

I enjoy taking my children quail hunting, and they love being outside, watching the dogs and, most of all, driving the hunting truck.

JANELL
Kingsville, TX
Westley Richards .410-gauge side-by-side

I began shooting with my father when I was a child of seven or eight. We shot doves in the fall and quail in the winter on the ranches my grandfather had established when he came to Texas in 1886 by wagon train from Virginia. The quail in the Colorado River region in Central Texas were abundant in those days. We simply walked them up and used the family dog to retrieve them. My grandmother prepared a feast of fried quail in her big farmhouse kitchen.

We worked cattle most of the year. With 40,000 mother cows in a grazing rotation of over 800,000 acres, it was a year-round, 24-7 job for 43 cowboys on horseback and about 3,000 head of working horses. Our children, like most of the children on the cattle ranches, helped at weaning and branding time. Quail hunting was the most accurate method of surveying the habitat in those days, walking behind a bird dog is an effective way to examine plant life and grass cover to maintain a balance in native species and grazing management according to soil moisture.

A broken collarbone unexpectedly became a stroke of luck because it meant I had to find a lighter shotgun. A Westley Richards .460 rifle that had been a gamekeeper's rifle, bored out to become a .410 shotgun, fit me perfectly. It had long heavy barrels, the stock was "cast on," and it was full and extra full bore. It was easy to carry behind a dog all day and delivered a "clean shot or a clean miss," eliminating wounded birds.

AMANDA
Old Westbury, NY
Purdey 20-gauge side-by-side

Having a mother who grew up shooting game birds on southern plantations, a father who spent our childhood as a part-time professional hunter throughout Africa, and grandparents who traveled to the farthest reaches of the globe in search of the most challenging game, I would be an anomaly if I did not embrace the tradition of the sports gun.

My early memories are of sitting in the skeet house with my father, playing backgammon in front of the fire and waiting our turn, so I could go out and help him load his gun. As I got older, I would follow him out into the English countryside to pick up his birds and then help clean his guns at the end of the day. But it was as a teenager, when my grandparents started to take me to places like Argentina and Denmark, that I was able to completely join in and enjoy the shooting parties.

I would have to say it is my grandmother who has had the greatest influence on my shooting. She is all of 5'1" with fire red hair, and at ninety-two can still outshoot most of the men in any given line. It is with her that I have not only been welcomed on some of the greatest shoots worldwide, but also enjoyed wonderful fall afternoons sitting on our own in a cornfield shooting dove for a simple game dinner.

My shotguns are to me as horses are to an equestrian. They need to be respected and well taken care of. My favorite, is a small 28-gauge Parker. It was made for my great-grandmother, passed down to my mother, and then to me. As I said, the family tradition runs deep, and I hope to pass this gun along to my children one day, along with the love and respect for the game and the sport.

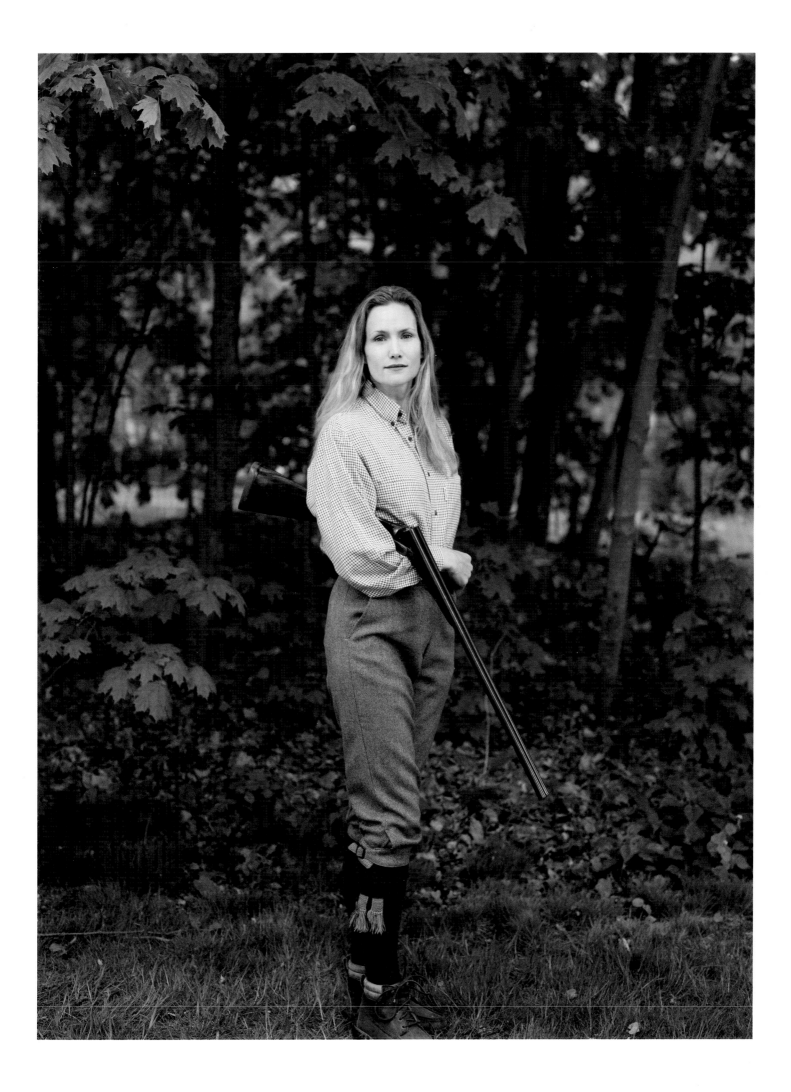

LAURA

Livingston, MT

Winchester Model 94 carbine in .30-30 caliber

I grew up on a ranch where hunting and shooting are a given—that's just what we do. Having such a large family, we needed to put food on the table. I got interested in hunting because my dad is my hero and he is a hunter and a guide. Naturally I wanted to do everything he and my brothers did. My dad taught me how to care for guns and have respect for them. I learned how to shoot at a young age by going out into the pastures and shooting gophers. When it came time for a hunting rifle, my dad and I did target practice with my grandfather's .250 Savage until I could hit the target dead on. In my family it is a tradition that for your first year hunting you use Grandpa's rifle until the next kid in line is old enough to hunt or you buy your own gun. I started hunting as soon as I was old enough to get a license and have hunted every year since. All I know is that I shoot because I enjoy getting out into the great outdoors, whether it's for target practice or hunting.

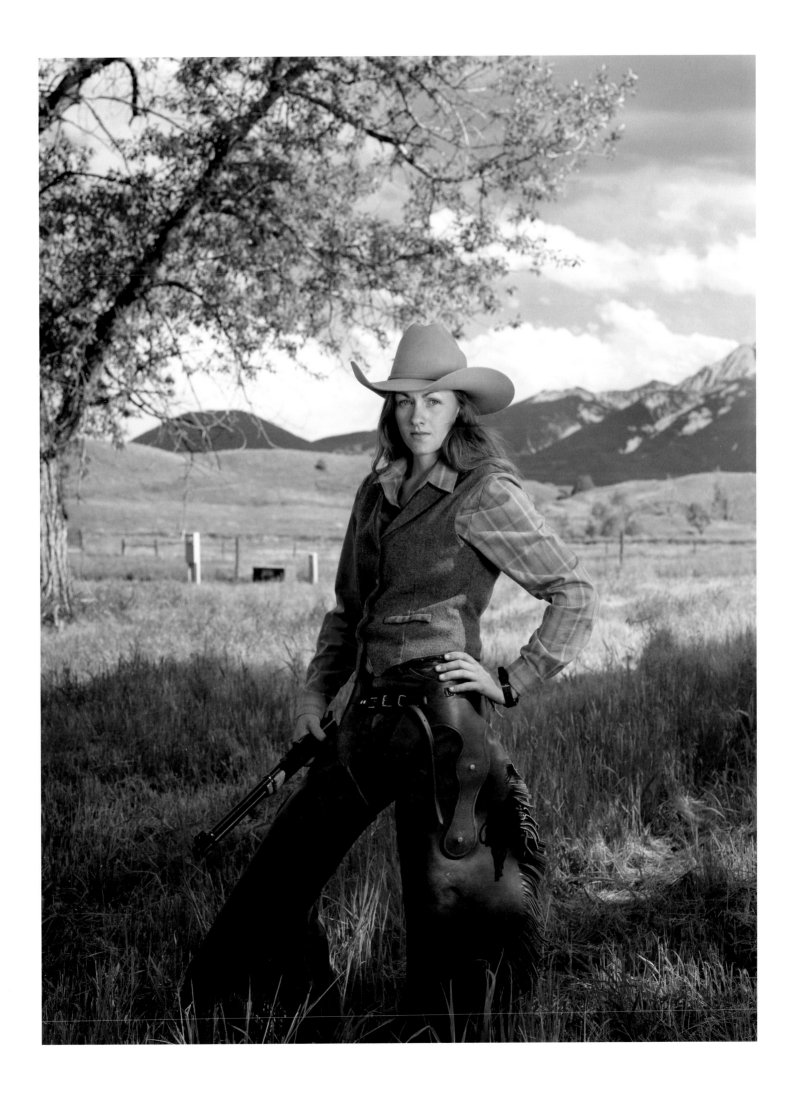

LAKE & RUBY
Healdsburg, CA
Stainless-steel Smith & Wesson in .357 Magnum
with 6" barrel

I didn't used to sleep with a gun next to my bed, but now that I'm a single mom with an eight-year-old daughter, I take more comfort in having a gun. It makes me feel safe.

With that knowledge comes the importance of teaching my daughter gun safety and the responsibility required to possess a firearm. Owning a gun is no small thing. With safety and knowledge comes confidence.

I think it takes strength to really look at yourself and confront your fears. It can stop you from seeing what you can be. The small steps I've taken to find that strength have been part of my journey. I hope my daughter grows up to be fearless and follows her dreams.

In the picture Ruby's holding one of her vintage cap guns. I got her the guns at antique stores all across the United States. She loves them, but I think now she's more interested in horses.

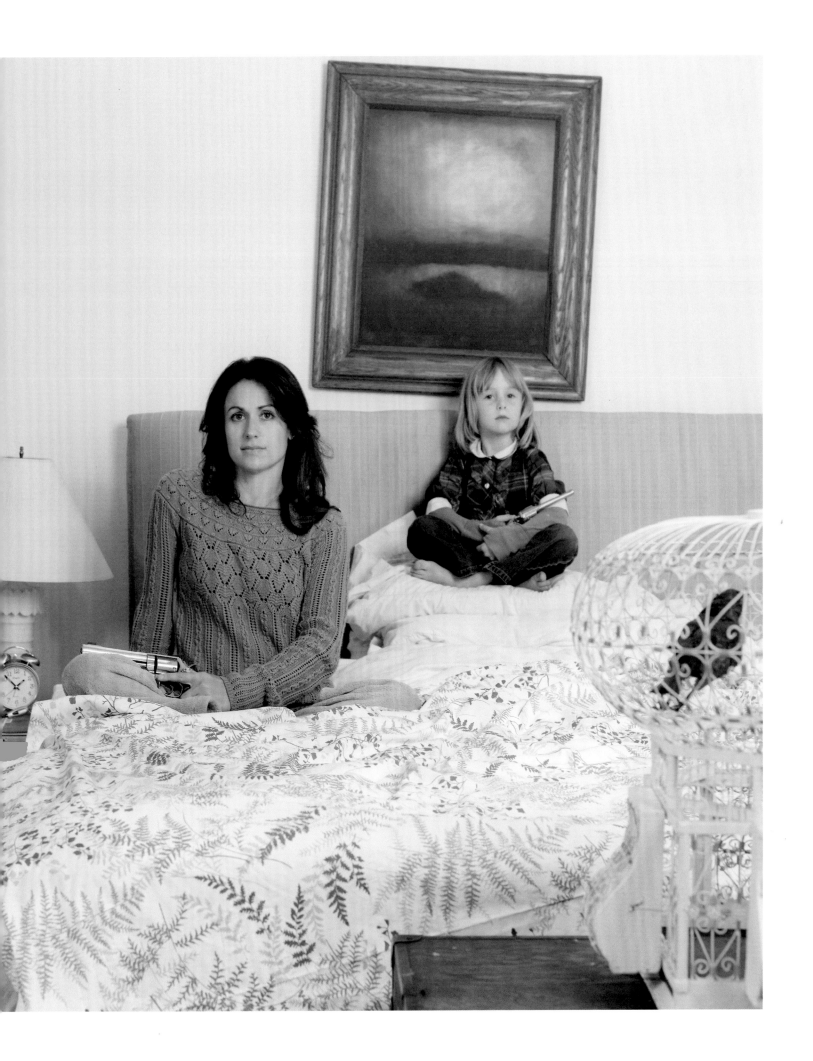

MORGAN

Pray, MT

.17 H.M.R. Savage Model 93R17 bolt-action rifle with
AccuTrigger, fitted with a Bushnell 3×–9× Leupold scope

I grew up around guns, so hunting and guns were just
a part of my childhood. I started shooting gophers with a
.22 rifle when I was maybe five, if not earlier, and I started
competing in 4-H when I was ten.

My dad always tells a story about me. When I was
around three years old, he was unloading our version of a
Happy Meal, which was a steer we fed out to eat, and there
was an elk and two deer hanging up in the shop where our
freezer is. I said, "Daddy, Daddy! We're rich, we're rich!"
and he was like, "What are you talking about, Morgan?"
And I said "Look, Daddy, we have a freezer full of beef, and
an elk, and deer hanging yet!"

When I turned twelve, the age you have to be to get
a license, I started to hunt. My first large animal was an
antelope; I shot him at a dead run, led him, and happened
to hit him in the head. I couldn't believe it! From then
on it was hard to aim at anything else since that was my
best shot and I was good at it.

I am slow stalking, very consistent with the shots I
take, and I don't really get nervous. My favorite gun would
have to be my Savage Model 11 .243-caliber. It is a bolt-
action and it has an AccuTrigger that I like with a 3×–9×
Leupold scope on it. I am dead on with it whenever I shoot
it. Having confidence in your gun is everything, so the
more I shoot it the better.

I love to hunt and camp in the mountains with my
horse and my mom. We often go for a week. I don't like
getting cold much, yet it always seems like it's below zero
when we go. I pretty much always get what I am hunt-
ing for. After the hunt, my mom and I make all kinds of
sausages and salami from the elk and deer, and we also
can some of it. I like to hang the mounts on the wall if
they are nice. My mom and I are going to Alaska to hunt
moose next September, just the two of us, and that should
be really fun!

When this picture was taken I was holding a .17-
caliber rifle we had instead of the .243 rifle that I shoot
big game with, and I was embarrassed. Usually I have
a higher-powered rifle than a .17 in my hand. After all,
that's a gopher gun!!!

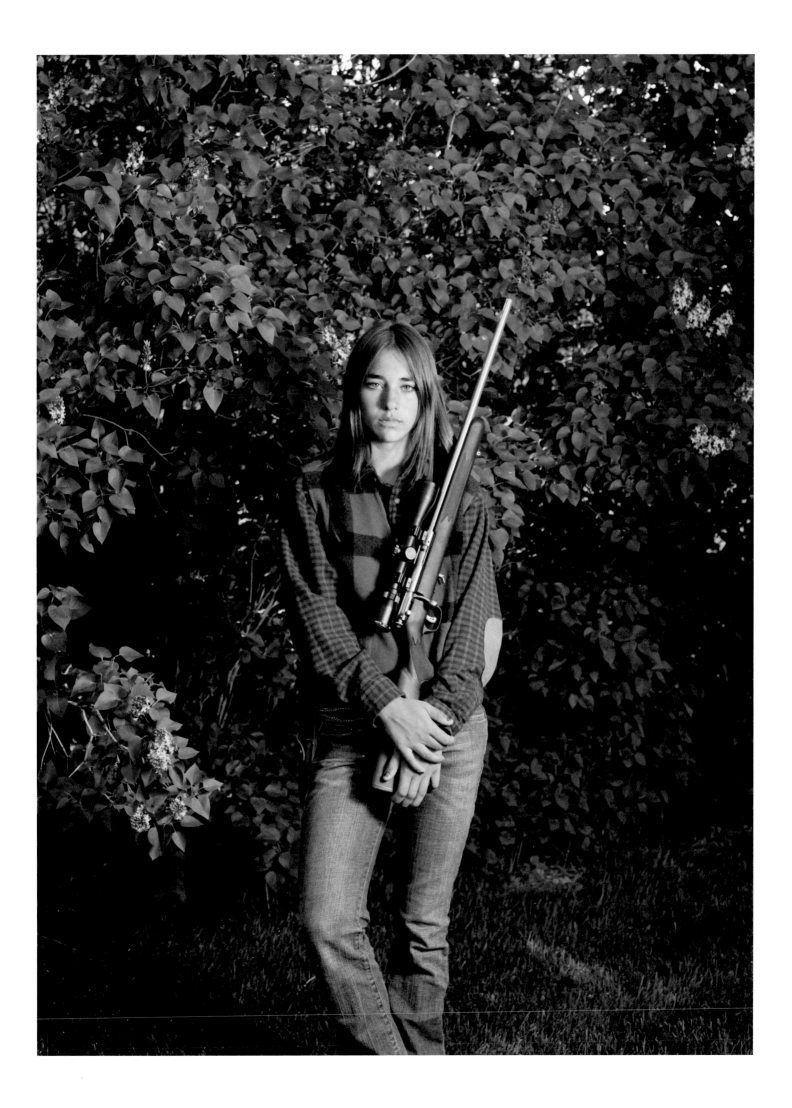

HEIDI
Roseburg, OR
Smith & Wesson .38 Special double-action revolver

My father has collected guns his whole life, so I've been around them since I was born. My mom shot occasionally, but not like my dad. He's got four and a half acres in the country, so we could just go out and shoot. My dad's always made his own bullets. He still does. He's got a pretty impressive collection, including a WWII Garand with a bayonet on it. It's in mint condition. That's one of his pride and joys.

My folks always kept their guns up. When I was a kid my dad had them mounted on racks above doorways and such, and the other guns were locked up in a case.

When I was little, my folks read in a gun magazine about a way to teach children gun safety. So they made a dummy, dressed him in clothes, used a milk jug for the head, and put a hat on him. They put water and red food dye in the jug and at that point explained to me that it was just a dummy, not a real person. Then my dad shot a hole in the head so you could see the red food dye coming out, and he said, "These are guns. This is what a gun can do. If you saw a gun lying on a table, Heidi, what would you do?" And I said, "I would not touch it." I was four years old.

I work as a forester now and do timber sale layout for a government agency. Some of my duties are to determine timber sale boundaries, potential harvest methods, access to the sale, and haul routes. I also write contracts, make maps, and work with other specialists to determine sensitive areas within the sale unit. Since I work for a government agency, I'm not allowed to have any firearms on me while I'm working. I just use guns on my own. I'm planning to get a concealed-weapons permit. I don't have one yet, but I want to because when you're out in the woods, sometimes there are scary people. In this area, if somebody's causing problems and you just have a gun on your hip, you can make them think twice. For example, one of my co-workers was telling me about this guy who was harassing him and his wife and daughter while they were camping. The guy just wouldn't leave them alone. Abe had his gun, walked up, put his hands on his hips, and looked at the guy. The guy left and didn't come back after that. He saw he had a gun. It was that simple.

The gun in the picture is my .38 Smith & Wesson revolver. I use it mostly for target shooting and protection. I have a bow, too, that I target shoot with. I think I'm a damn good shot.

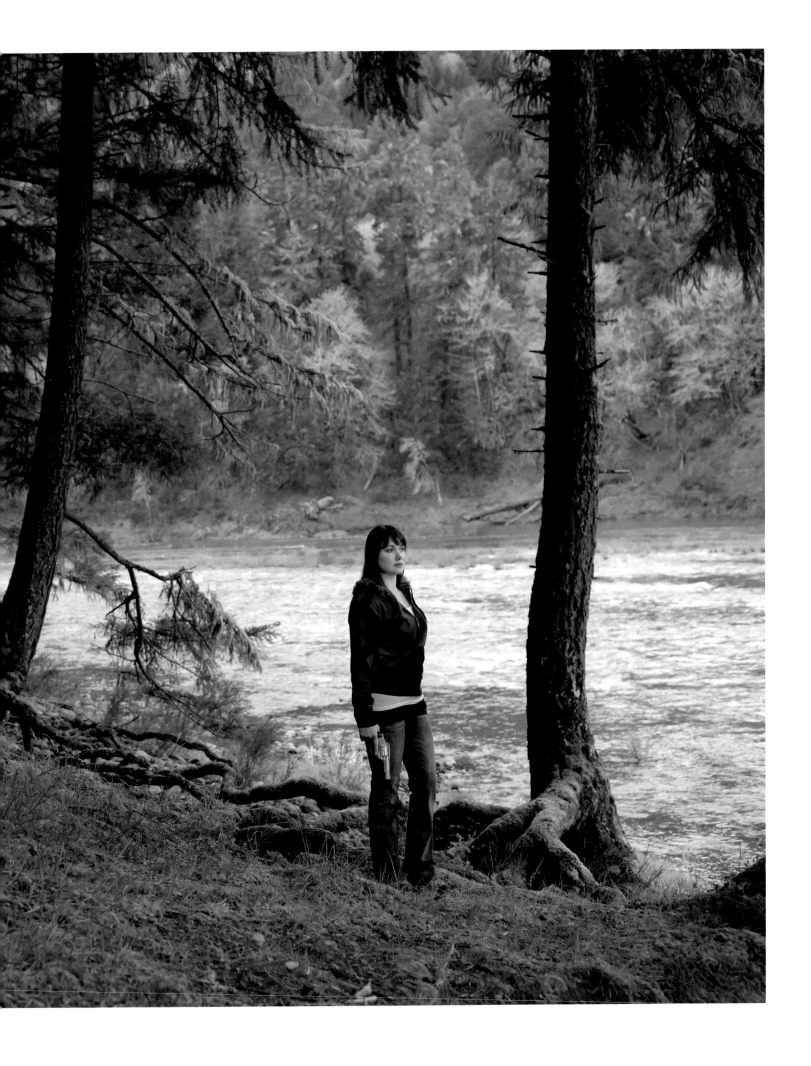

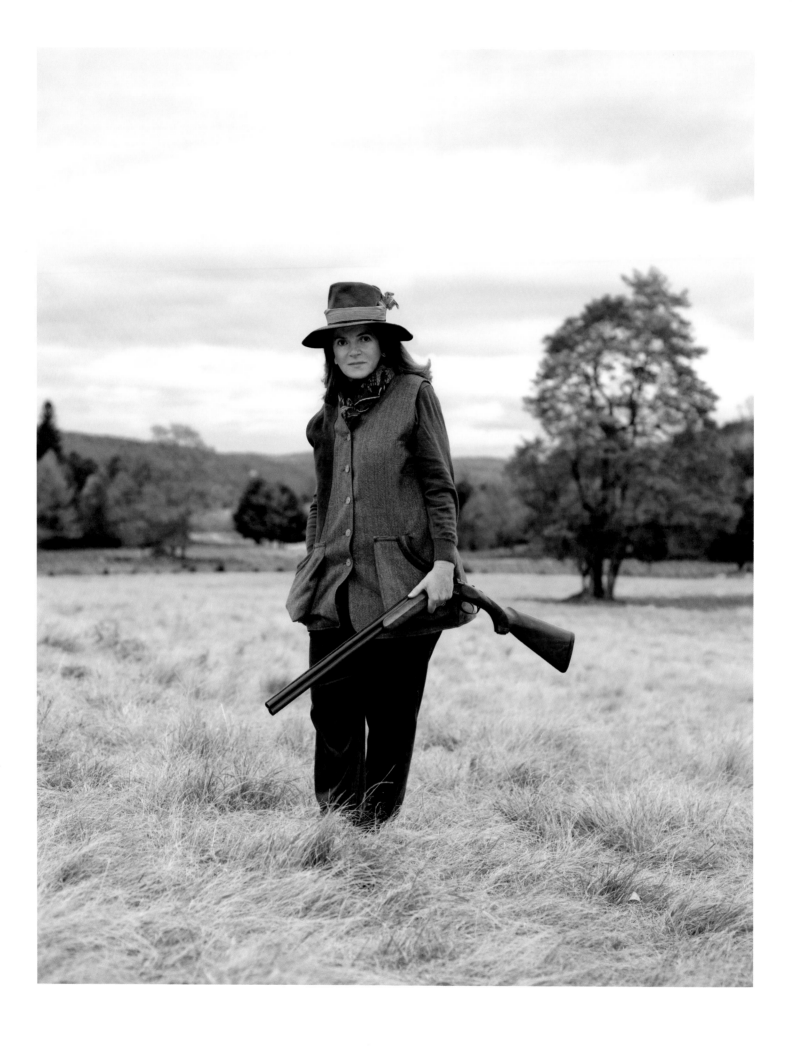

SUSIE
Millbrook, NY
Browning 20-gauge over-and-under

My shooting has taken several paths, from bird hunting at home and in faraway places to competitive clay pigeon shooting. I was lucky enough to be born into a bird-shooting family and have wonderful memories of walking through fields after pheasants with my father, freezing in a tiny boat waiting for broadbill to come in on the Great South Bay, clumping about in snake leggings after quail—and the smell of the reward being cooked by my mother in herbs and butter over a wood fire. Seeing a camel caravan at dusk going around a large water hole in Pakistan and watching large game animals looking at smaller prey at a water hole in Kenya on my honeymoon are memories that are still vivid and belie the song from *Annie Get Your Gun*, "You Can't Catch a Man with a Gun." What fun I have had with this sport and also how very lucky I've been.

The late Tom Ruger thought more women should be buying his guns and sponsored a ladies' team to compete in sporting clay competitions. He gave the five of us—all of whom became closest of friends—a coach, Ruger 12-gauge shotguns, and the most fun for a few memorable years you can possibly imagine. I was again lucky enough to be on the first U.S. team to compete in the World F.I.T.A.S.C. (Fédération Internationale de Tir aux Armes Sportives de Chasse) competition in France in 1991. The ladies' team came home with the bronze medal and I now know what it is like to stand and hear our national anthem played while the medals were placed around our necks—unforgettable. Years later, the sport still has its hold over me. The targets are much harder, the competition much younger, but the fun is still there. However, nothing beats watching my husband and son have a go at high-flying birds and seeing their pleasure at bringing home dinner.

STACIE
Phoenix, AZ
Perazzi MX1

I was raised on the family farm back in Iowa. Both my parents shot, and I grew up watching members of my family compete in trap shooting. I was involved in the sport at a young age and worked at the Iowa State Trap shoots keeping score and taking care of trophy lists.

When I moved to Arizona in 1997 I began shooting seriously. I had just started my master's in physical therapy and was looking for something to do that was familiar and would also allow me a bit of social life. I started shooting my very own TM1 single-barrel Perazzi, which my dad was proud to buy me. I started with clay targets, American trap shooting, as I had grown up around the sport. You end up seeing the same individuals competing and traveling to the shoots, so after a while it seems like a mobile city and everyone's almost family. Many of these people had an influence on my shooting.

As I became more experienced behind the gun and my skills sharpened, my shooting interests expanded to a variety of shotgun sports—sporting clays, helice, bunker, and flyers. That's when I traded my TM1 and Mirage Perazzi for the MX9 Model. It was a more versatile gun, and with that gun I won my first World Cup title and World Helice Championship in the same year. After that season, I changed guns. This is not a normal practice, but it was unexpectedly the best thing I could have done. Well, actually it was because Perazzi built me a new gun. New gun, new season, and I completed a full sweep in the international flyer world. Shooting the MX1 Perazzi, I won all the big cups in 2009: the European Championships (Elche, Spain), World Championships and Africa Cup (Marrakech, Morocco), King's Cup (Madrid, Spain), Mexican Cup (Toluca, Mexico), and finished the season with the World Cup. I even stood on the stand at some shoots with the men. It was an incredible season, and I racked up many frequent flyer miles and memories.

Shooting has given me amazing opportunities both personally and professionally. Not only do I enjoy shooting, but I even enjoy watching novice shooters experience the sport. Through my competitive travels, I have grown my extended shooting family and friends, and even expanded my linguistic abilities and fondness for many different kinds of cuisine. Since I make my living as a physical therapist, it is challenging to work, travel, and shoot competitively. It has been a balancing act and at times it seems I live two separate lives, but it has been extraordinary. I've learned both how to lose and how to cherish a win. A combination of practice and discipline in mind and body has helped me achieve my goals. What helped me most was learning not how to focus on the competition but how to channel my energy and anticipation into focusing on the shooting itself. The simple fact is, I shoot for myself; it has nothing to do with anyone else. When you shoot for yourself and just enjoy it, then everything comes together.

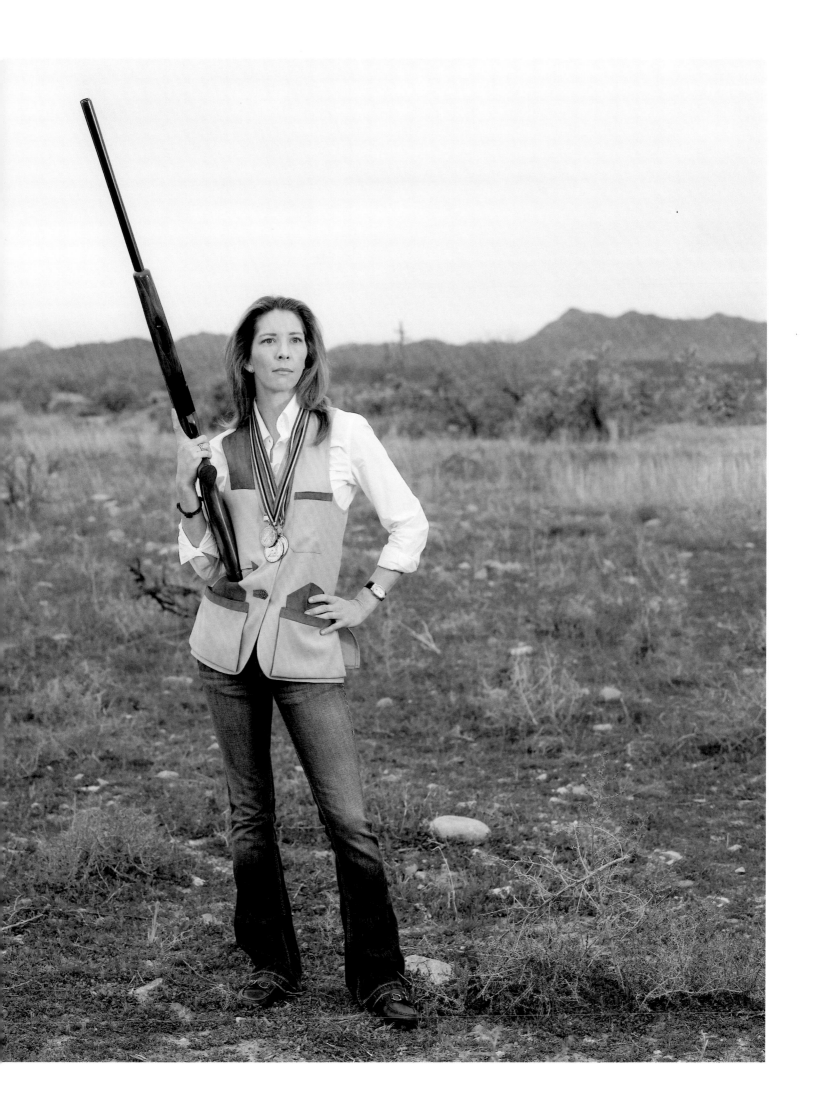

MARIE

Greenwich, CT
Browning 20-gauge over-and-under

My husband first introduced me to hunting sixty years
ago. He used to shoot roebucks in Germany at his father's
place in Wiesbaden, so naturally I had to learn. Both
his mother and father shot and he wanted me in the field
with him. I started shooting a 20-gauge Winchester 21,
then graduated to a Browning in 1951. Of course, it
was early on for the females to shoot in the field, but I
thought it was grand.

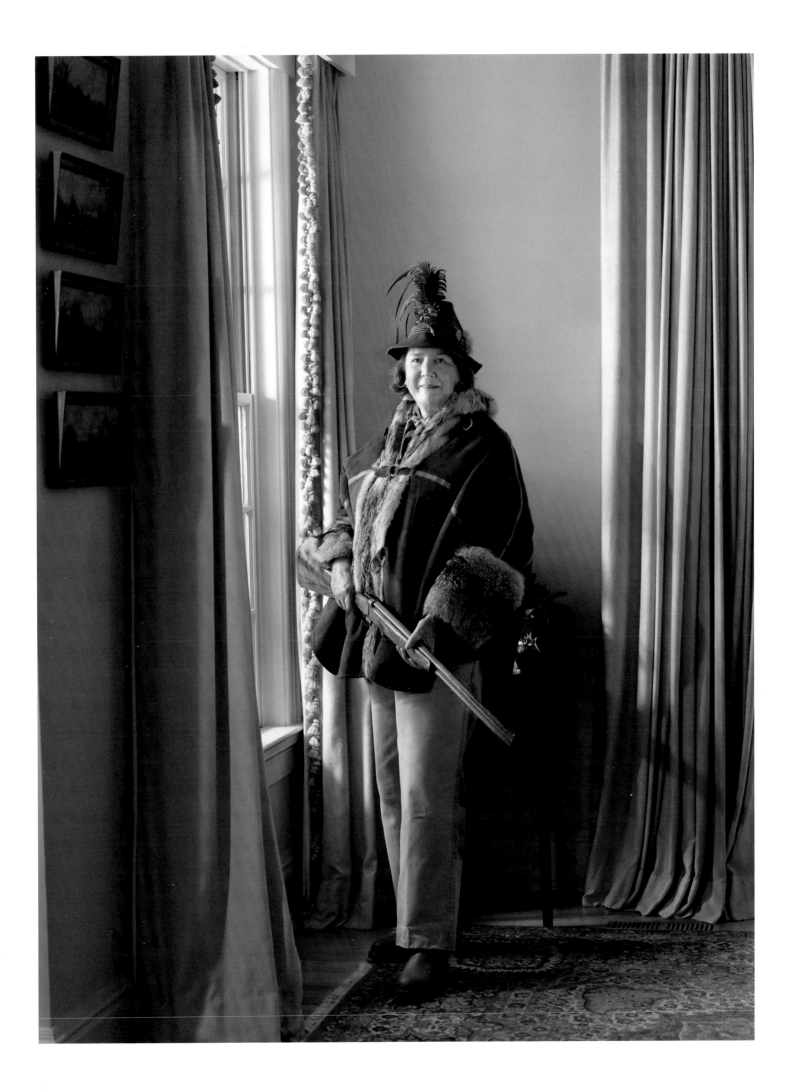

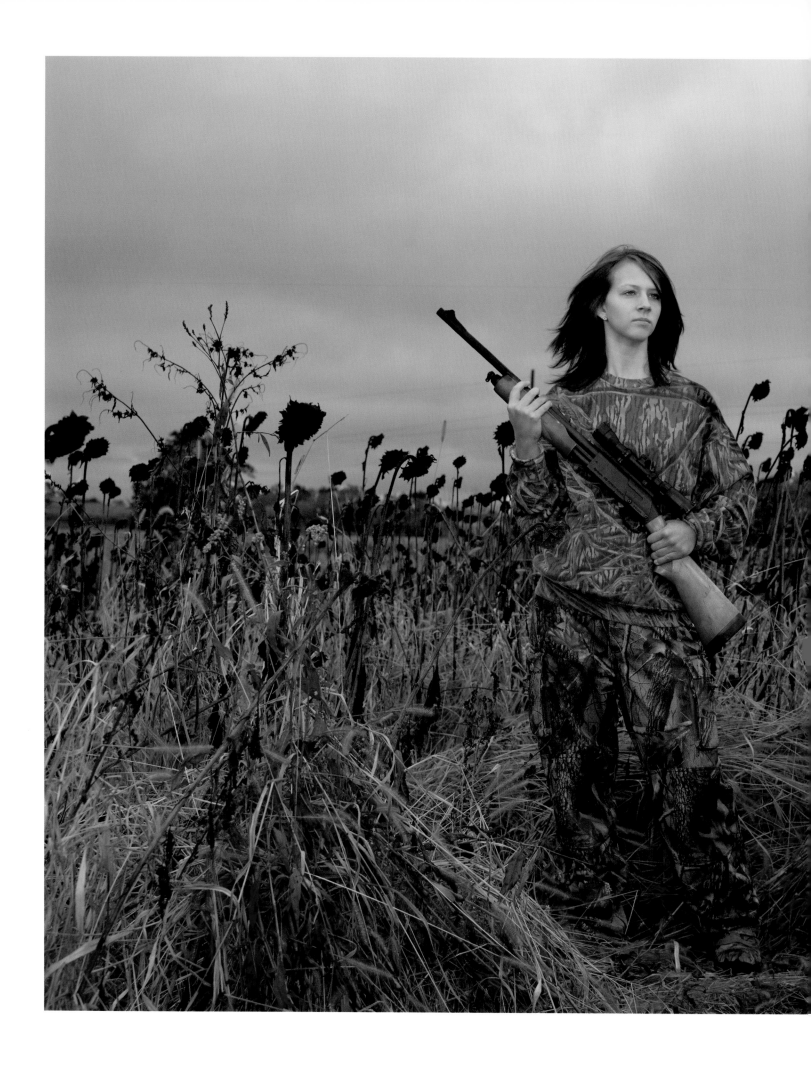

HALEY
Norwood Young America, MN
Remington Express 20-gauge

I first became interested in hunting after watching my dad shoot and hearing about his hunting trips. He was the one who taught me how to shoot. He also taught me a lot about gun safety. I've been hunting for six years, since I was twelve years old.

I have an ongoing friendly competition with my uncle to see who can shoot the largest deer each year. Unfortunately, he won for the first time in the fall of 2009. I shot at a deer but hit a small tree branch that deflected my shot. My dad cut off the branch without my knowing it and my uncle made a trophy out of it and gave it to me for Christmas. We have it on display in our family room.

My favorite gun is my 20-gauge Remington 870 Express Magnum with a 1–4.5× variable Bushnell scope. It's the gun I used to shoot three whitetail bucks and one Minnesota black bear.

I think women make good hunters because we have patience, and we also look good in camouflage :)

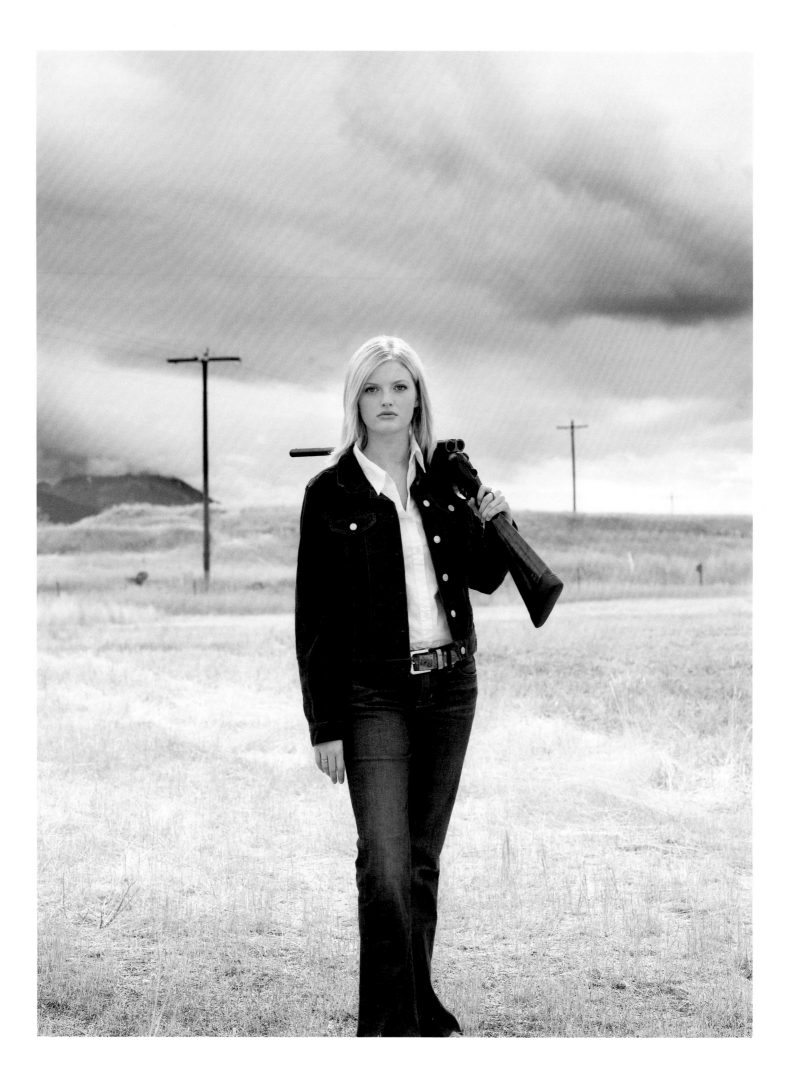

JESSICA
Bozeman, MT
Abercrombie & Fitch 20-gauge side-by-side

For anyone growing up on the plains and coulees of north-central Montana, there has always been ample opportunity to hunt the state's varied wildlife. Those plains and coulees fostered my interest in activities and sports involving firearms, as did my father, whose hobby was being a firearms instructor.

For as long as I can remember, my dad has been involved in both hunting and competitive shooting to such an extent that it was hard not to get involved myself. I'll never forget the first time my father put a .22 in my hands. It was during a typical dry, windy summer, the kind where fifty-mile-an-hour gusts leave grit in your teeth. We drove to a neighboring famer's property and asked if we could hunt for prairie dogs. They said yes, of course, and soon we were out driving on the old dirt roads, having a little father-daughter bonding time.

At first it was a little bit intimidating and frightening holding and using something so powerful. But my father taught me that as long as I was confident and strong, there was no reason for me to be afraid. He explained the importance of knowing how to handle a firearm correctly, making sure I understood that they weren't toys but that I could still have fun. By accompanying him to shoots, taking shots at gophers, and helping him reload and clean his guns, I developed the confidence and strength I needed to hunt and to compete.

Shooting became a shared interest for my father and me, and it remains a lifelong passion for us both. Learning to shoot gave me traits that I will always carry with me, and I believe that it has made me a more powerful and self-respecting individual. My hope is that as my own son grows older, I'll be able to teach him the lessons that my father taught me.

RENEE
Elk Grove, CA
Remington Model 700, in 7mm Weatherby Magnum,
with custom walnut stock by Harry Lawson,
fitted with Swarovski TDS 6×16 telescope sight

I was fortunate to grow up in Salmon, Idaho, a rural
community surrounded by the Bitterroot Range of the
Sawtooth Mountains and the Salmon River, also known as
the River of No Return, flowing through the town. It was
a sportsman's paradise, and my father was an avid sports-
man. My parents both enjoyed the outdoors and therefore,
as children, we were always outdoors with them. We were
always hunting, fishing, sleighing, picnicking, or simply
enjoying a jeep ride into the mountains. And although my
father invited me along on his deer and elk hunts when I
was a child, he made it perfectly clear that I was never to
touch his rifles. I was simply thrilled to be tagging along
and can say in all honesty that I never had any desire to
shoot any game. I feel blessed to have a father who was
an excellent shooter and a very skilled outdoorsman. His
enthusiasm for the outdoors became imbedded in me at
an early age.

For several years I joined my husband, Paul, on his
annual elk hunt to the Continental Divide. In 1982 he
asked me to "sight in" his Weatherby .300 mag before
we arrived at our hunting destination. Of course, I had
never fired a rifle before and was a little reluctant with
his request. He calmly said, "Just hold the gun tightly
and aim for the bull's-eye. I want to see if you can hit the
100-yard target." I gently squeezed the trigger and hit
the bull's-eye! Paul, somewhat surprised, calmly handed
me another cartridge and said, "I want to see if you can
do that twice." I can honestly say that when I hit the
bull's-eye the second time, we were both surprised. After
that display of marksmanship, Paul encouraged me to
carry a rifle when we went on hunts. I kept telling him
I was just happy to tag along and had no desire to shoot
any game. He kept insisting that I carry a rifle as a "back-
up" shooter if necessary, explaining that it was a safety
issue. Shortly after that I realized I could make a clean
shot at considerable distances and on difficult terrain and
began to hunt for myself.

Following in my father's footsteps and building on
my outdoor skills while hunting with Paul for many years,
I have been both privileged and fortunate to hunt all the
huntable continents of the world. Along the way I accom-
plished several prestigious hunting award milestones: the
African Big Five (elephant, cape buffalo, lion, leopard, and
rhino), the Golden Malek Award, Capra World Slam Super
30 Award, Ovis World Slam Super 30 Award, and the
North American Super Slam Award. To my knowledge, I
am the only woman to have reached these milestones. As
a young girl, tramping along behind my father, it never
entered my mind that I would hunt throughout the world
or even attempt these goals, much less achieve them.
Thanks, Dad and Paul!

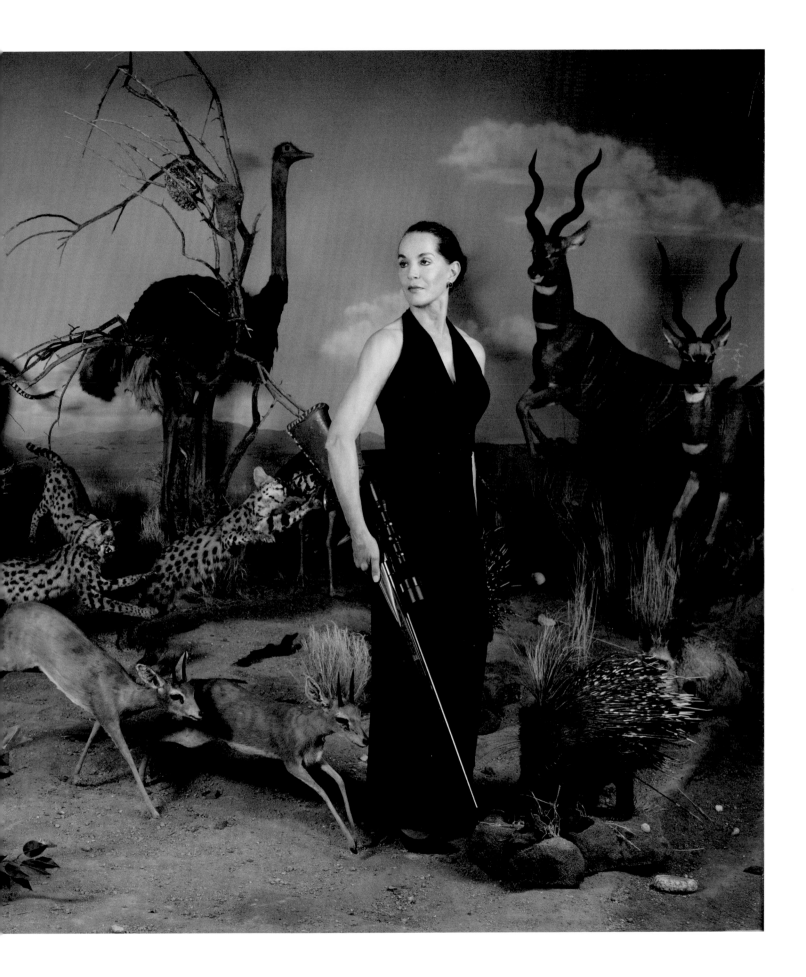

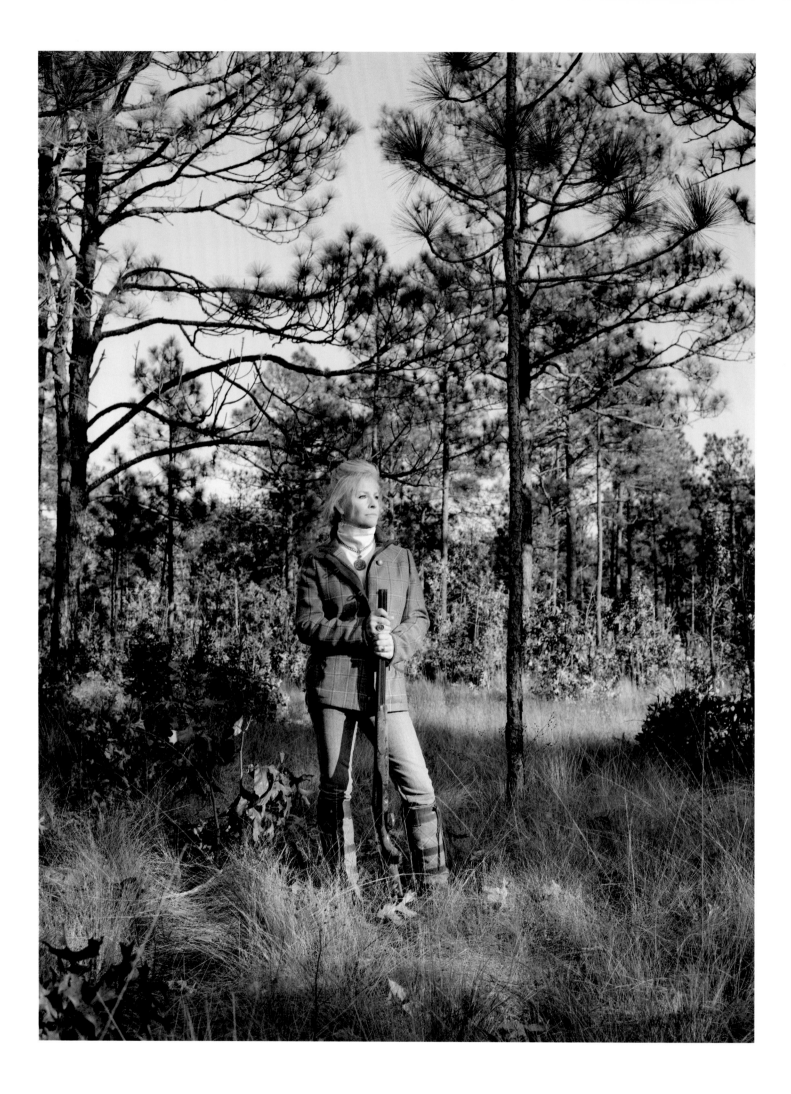

ELIZABETH
Sandy Hook, VA
Winchester Model 21 12-gauge

"PULL!" What can I say? It is my favorite four-letter word! It is the word that releases a clay target, but what it really turns loose is more fun than should be legal!

As an avid shotgunner and NSCA Level II Shotgun instructor, I am often asked how I got so involved in the shooting sports. Several years ago I gave my husband shooting lessons as a present. He was already a hunter and wing shooter but had not had much experience with clay targets. The day he took his lesson I went along as well. The instructor insisted that I give it a try. I did—and I LOVED it!

Somehow, between carpooling three children around, after-school activities, and keeping up with home and family obligations, I managed to squeeze in and steal his remaining lessons.

I quickly realized I was one of few women having fun with a gun. It was the sheer enjoyment of shooting and the need for social interaction while doing so that led me to form a women's shooting group called the GRITS.

Yes, the GRITS—Girls Really In To Shooting. The group was formed as a way to get more women together who might enjoy shooting but might not be comfortable or confident enough to give it a try or go to a shooting alone, and for those who might otherwise feel some intimidation entering into a sport traditionally enjoyed by more men than women. And the GRITS are going strong, shooting once a month and taking shooting trips together several times a year!

Forming that group made me realize the importance of good first experiences with a gun. With that in mind, I went and got my Level I instructor's certification. I needed to be sure that as I guided new people into this sport I was doing it correctly. After two years and hundreds of hours of instruction, I went on to get my Level II certification. I now teach on an almost full-time basis.

Though I teach men, women, and children, what gives me the greatest joy is seeing the women evolve as they rise to the challenge, take pride in their improvement, and experience the sometimes therapeutic benefits of shooting. It is certainly a great release from the daily grind.

As I watch these women at the end of the day talking about the hits, the misses, and the sometimes "handsome" distractions on the course, I cannot help but smile and be thankful for the somewhat serendipitous journey that has led me to love saying "PULL!" and far beyond.

JEN
Emigrant, MT
Browning .270 with a Leupold scope

Well, I guess at the beginning I used to play with toy guns
and use my imagination to be like Annie Oakley. My mom
has a picture of me when I was four on my spring horse
with my cowboy getup and my toy rifle. Then I used to go
hunting with my dad. I went for as long as I can remember.
My dad always worked as a ranch hand, so we didn't make
very much money and we always lived a long ways away
from town. The only way we could afford to feed everyone
was to hunt. We also had to control rodents. Shooting
gophers with my dad's .22 was how I developed my confi-
dence. I spent quite a bit of time seeing from how far away
I could shoot them.

The way I see it, there are two kinds of hunters. Meat
hunters: the ones who eat what they shoot and shoot
what's best for them. And trophy hunters: the ones who
really want an outstanding animal. That is different for
everyone. Some may call an animal a trophy because of the
size of the horns or because of the hunt itself. There are
so many different kinds of hunting that how you took the
animal might be a way to decide whether to consider it a
trophy or not.

Killing and poaching should not be lumped together
with hunting. These are not characteristics of sport or
feeding your family. I'm not sure how you become one of
these two things, a killer or a poacher, but it is not any-
thing that I could be.

I have tried to pass things down to my kids. They
shoot paper targets, pop cans, pumpkins left over from
Halloween and whatever else we can think of that would
be fun. My son Clay has been with me on several really
wonderful hunts. He actually has a bear rug hanging in
his room from a hunt when he was two. He was with
me when we spotted the bear. I took it in one shot and I
waddled down the mountain with my gun on my shoulder
and him on my hip. He was a little scared at first, but it
didn't take him long to decide that he was a hunter too.

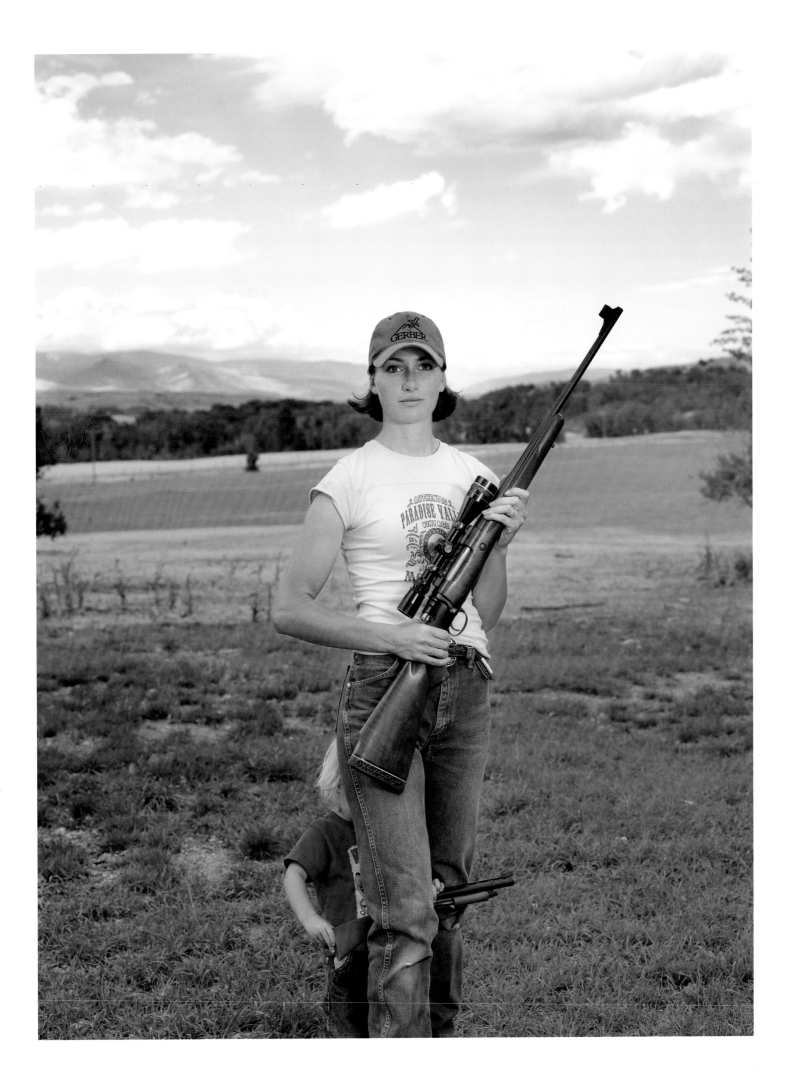

PARKER
Amenia, NY
Browning 20-gauge side-by-side

Growing up in western North Carolina, I was exposed to guns at a very early age. My father gave me my first Daisy BB gun when I was seven years old. Naturally, he and I began trading up from there. We enjoyed shooting skeet and trap together at our local gun club, and often shot dove and quail locally. After leaving the South I moved to New York City and was able to make a career out of my passion for guns in the outdoor magazine publishing field. I remember driving into Springfield, Massachusetts, on my first sales call to the Smith & Wesson firearms company. I saw "Welcome Parker" on the marquis. I was so thrilled. After listening to my sales pitch, the marketing director opened the entire weapons arsenal up to me. Even though my light blue suit quickly became gunpowder blue, I loved shooting all the semi- and automatic weapons. I knew then that I was in the right business.

I loved dealing with all the gun manufacturers and enjoyed hunting in Europe, Africa, and South America regularly. I was fortunately chosen to be a member of the Sturm, Ruger Ladies Sporting Clays team, and had incredible coaching and instruction, which I still rely on to this day. I had always been able to mimic better players in most sports and thought I could bring this skill to competitive shooting. Unfortunately, during my first F.I.T.A.S.C. (Fédération Internationale de Tir aux Armes Sportives de Chasse) competition I thought I had been blessed to have France's finest shot on my squad. I went to the first parcour and set up for every target exactly as this gentleman had. It wasn't until I had missed twenty-five targets that a fellow teammate pointed out that, in fact, he was a left-handed shooter. Once I recovered from my embarrassment, I decided to learn to shoot my own game.

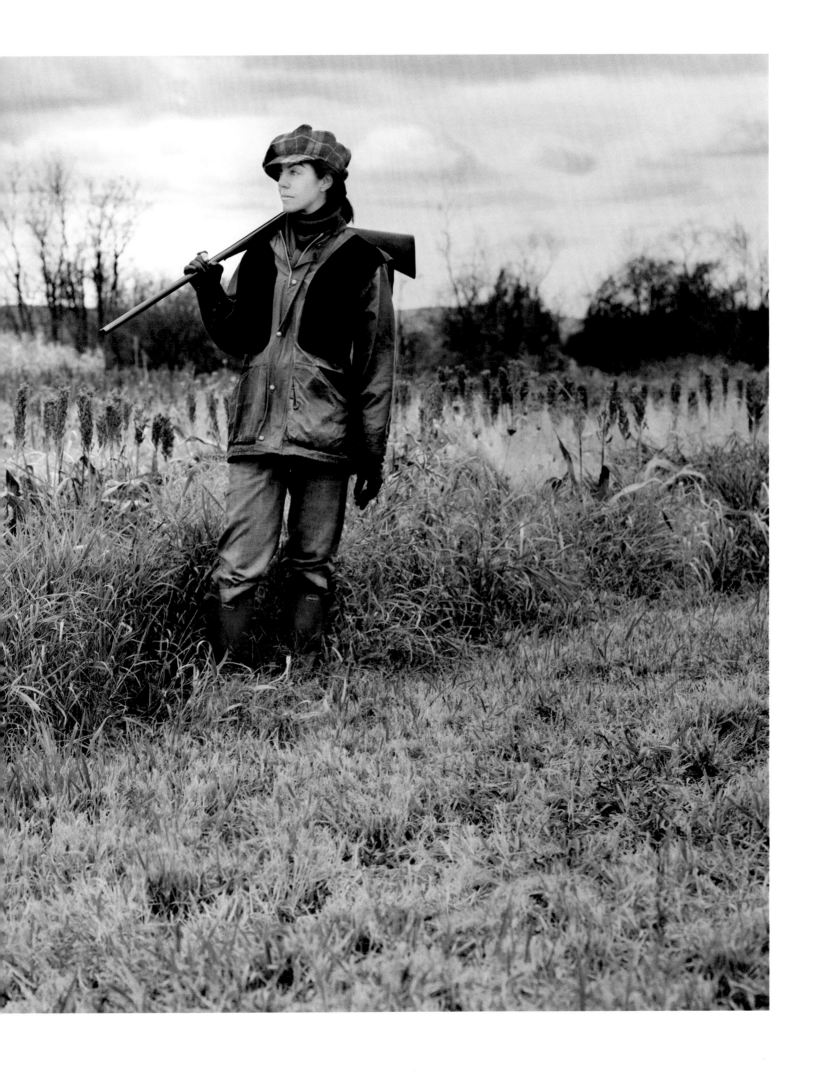

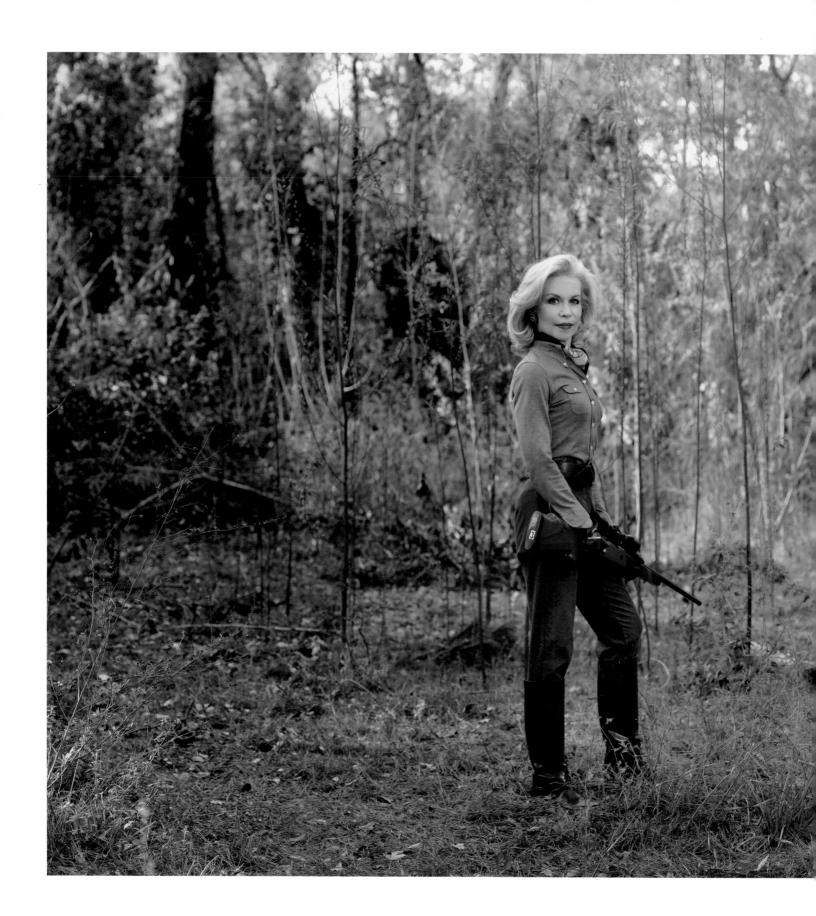

LYNN
Houston, TX
Sako .308 bolt-action rifle with scope

I'm a Texas girl who loves adventure. We Texas girls
have that frontier, can-do spirit that envelops our entire
nature. At the age of nine, I went away to camp, from
Texas all the way to Maine. The girls at camp were from
all over the United States, but they had never met anyone
from my great state. When I told them I was from Texas,
their eyes got as big as saucers. "Oh you're from Texas!"
sounded like I said I was from Mars. That's when I knew
the Texas girl was special. It's an inner independence that
I personally embrace.

I first learned how to shoot a gun at camp and
excelled in riflery and archery. My parents had a ranch
and every once in a while we'd go deer or bird hunting.
It wasn't until after I was married that I started hunting,
with my husband. He taught me how to hold a heavy
rifle with a scope and how important it is to hold the gun
very tightly against your shoulder to protect yourself
from the recoil when you squeeze the trigger. So it was
my husband who really taught me how to hunt and stalk
an animal.

I think my philosophy of hunting has always been
about the adventure itself. During the years we've been
married, my husband, Oscar, and I have been on some
amazing hunts. At the North Pole we stayed in an ice house
built by our guides, ice brick by ice brick, before our very
eyes. Pulled by dog sleds during the day, at night we slept
in sleeping bags on top of several layers of blankets and
sealskins on the ice. At 30 degrees below zero I sure hated
to crawl out of the sack, literally. We've hunted from our
log cabins in Colorado and Utah, and we've also hunted in
Georgia and of course Texas. Once in 1982 on an African
safari I tracked a lion for ten and a half hours. It was
exhilarating!

I love the juxtaposition of stalking game one day
and then dressing for a glamorous evening the next. It's
appreciating and enjoying the most out of each experi-
ence. I also love observing nature at our ranch, watching
a beautiful sunset in the wide Texas sky and listening to
all the sounds in the countryside, including the silence of
being alone. I need the balance of being with nature and
being with my loving family and friends. That's life at its
fullest, and experiencing both facets—at close range, if
you will—is what appeals to me. It's a combination of grit
and grace.

Since I was the only child and I know Father wanted a boy,
he taught me how to shoot when I was just a little girl.
And so I grew up shooting with him. I can remember how
he taught me safety first, which was wonderful to know.
He said that was the best thing of all—to know where
the people you are hunting and shooting with are, and to
always be careful. My father was such a good shot, and
we had so much fun together.

When I got married, I married one of the best shots in
the whole state of Georgia and everything just fit right in
place. My husband stepped right into my father's footsteps
because he loved to shoot. So when we got married, that
was it; we were just shooting together all the time.

We all hunt together with our friends, which has
been marvelous, and we love it. We've been doing it all
our lives and it's just fun and a wonderful sport. I'm
eighty-five years old and I started when I was about five.
That's a long time; and when hunting season is in, we are
still doing it every day of our lives, at our age! So that's
the way that goes!

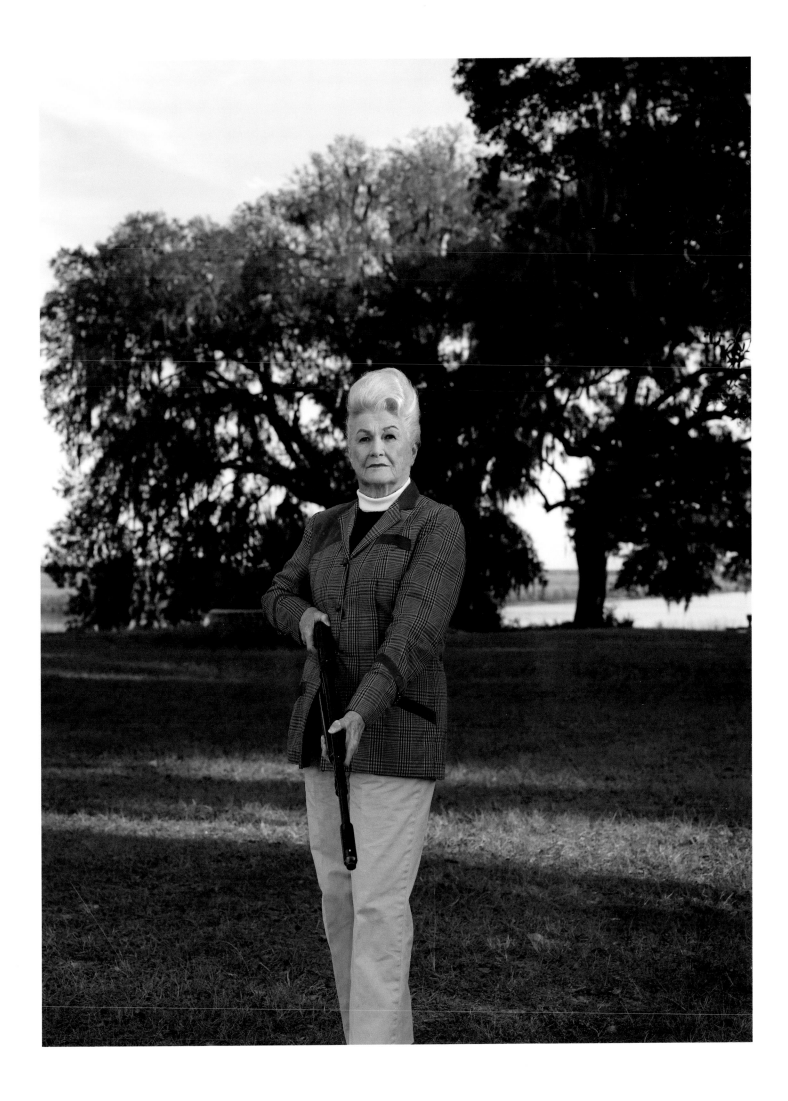

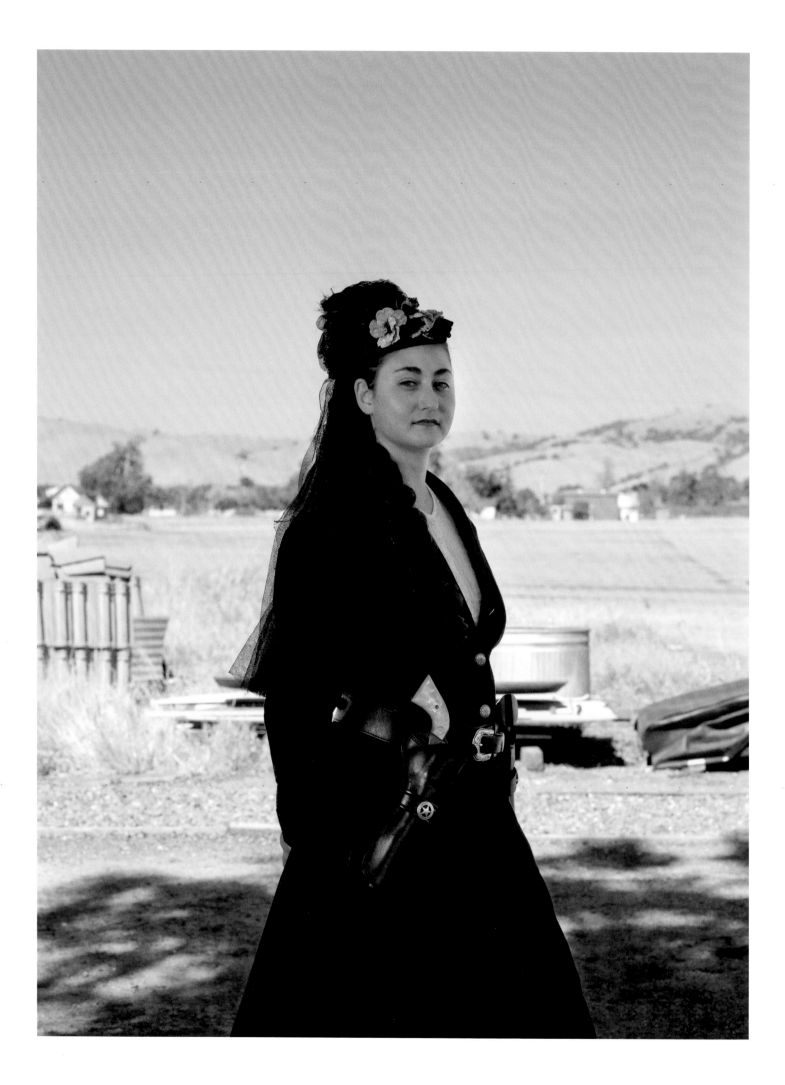

JESSICA
Royal Oaks, CA
Pair of Colt .45 Single Action Army revolvers
with 7 ½" barrels

I first wanted to learn how to shoot just for self-defense. While taking a handgun course, I happened to find out that my instructor was a SASS (Single Action Shooting Society) member. One day he brought out his *Cowboy Chronicle* newsletter to show us, and one of the articles was about a grandfather and his granddaughter who were both top shooters. The granddaughter was a rising shooting star, and I thought to myself, "Wow, how cool is that!" The instructor invited both my mom and me to a local shoot to check it out and mentioned we could join if we were interested. That was the beginning of it all.

Now when I shoot in competitions it is for the love of the sport and the people there, not the prizes or awards. Those things are nice, but to me they cannot compare to the relationships that are created at these shooting events. There are so many wonderful, fun-loving people involved in this sport! When you are at a competition you are truly out there to have a good time—camping, cooking, trading stories, shooting, and making friends. We all get dressed up in 1890s fashion and an Old West town springs up. There is a lone dirt road with tents and wooden stores all along it and everyone is walking around you like you just stepped out of a time machine.

I love shooting. My favorite handgun is the Colt .45; otherwise I love my C. Sharps 38-55 High Wall. It is still a thrill for me to hear that ping of my bullet hitting the target.

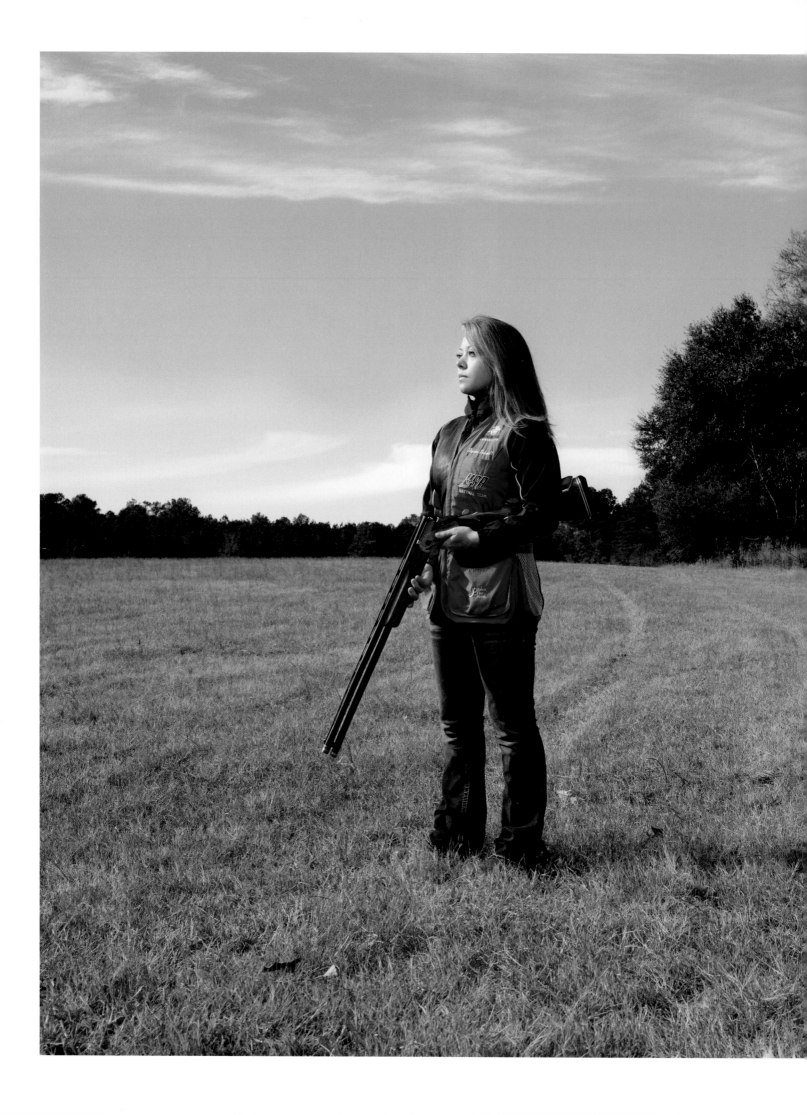

JAIDEN
Colorado Springs, CO
Krieghoff K-80 12-gauge over-and-under

I think everyone wants a special talent. I'm no artist, so I thought that I should look into sports. I tried almost every sport that my school district had to offer, only stopping short of football, and found that conventional sports were not my calling, but thankfully, I always had shooting.

My father had my sister and me shooting guns since I was about six years old. I loved shooting, but I didn't know it would be anything more than a hobby until my dad took me to the shotgun range. When my father was a teenager, both he and my grandfather were competitive trap shooters. So as I started to show potential in marksmanship while I was shooting rifle in 4-H, Dad told me that if I earned good grades in school that year he would take me to the shotgun range for my first shooting lesson. Needless to say, I earned straight A's and we were off to Sunnydell Shooting Grounds! I showed even more potential in shotgun than I did in rifle, so I started taking lessons from Chuck Dryke, and when I began to hone in on International skeet I took lessons from his son, Matt Dryke, who happened to be the 1984 Olympic gold medalist in that very event. As I continued to excel, I decided that skeet was my calling, and I sacrificed school activities to pursue my dream of the Olympic Games. Five years later I find myself on the USA National Shotgun Team for Women's Skeet and living at the Olympic Training Center— and the rest is history! I have finally found my special talent, and I have my father to thank for discovering it, my coach for honing it, and my family for supporting it.

WINDI
Houston, TX
Auguste Francotte 20-gauge sidelock ejector game gun,
made in Belgium

I never wear perfume but I love the smell of cordite.

When I was little, my parents always shot. I remember watching them shoot and loving everything about it. I loved the noise, I loved watching birds fall from the sky or the clays explode in the air. I was constantly saying, "Can I get a BB gun? Can I get a .22?" Plus I grew up on a horse-breeding ranch allergic to horses, so shooting was the one thing I could do that I wasn't allergic to. I just could not wait to have my own gun to shoot. Anytime anybody said anything about my getting to go out and possibly pull a trigger, I was there like a little puppy. I shot cans off the fence with my BB gun and when I got a .22, shot little varmints around the house.

But I think it's interesting that it was my mother who really taught me how to shoot. If I went out with my dad he would want to go bird shooting and he would take the worst dogs, the ones that needed practice. He would yell and whistle at runaway dogs, nothing would be shot, and it would be a terrible, long, boring morning. So in the morning my dad might say, "Do you want to go hunting?" and I would say, "Ugh," but after lunch my mom might say, "Hey, you wanna go hunting?" and I'd say, "Yeah!" and we would end up chasing coyotes, blowing over mesquite bushes, I mean just having the best time. As a consequence, I grew up a rifle shot because it was more fun to go out with my mom and a rifle than do the slowpokey bird dog, bird thing with my dad. That's why I never really learned to shoot a shotgun when I was young. Plus I wasn't physically strong enough; I was a scrawny little kid.

I have a daughter now. She's eight. She hasn't really started shooting, as she doesn't have a lot of arm strength, but when she was about five we got her this little Italian side-by-side cap gun. It's got miniature shotgun shells and you put a little cap on the end of them. It opens and has a safety—it's just like a sidelock. When her dad and I gave it to her she understood that it was not to be taken apart and just thrown in the toy chest, but that it went back in its box and that we kept it in our gun closet, locked and alarmed. The rule was that she had to point it as if it was a loaded gun, in a safe manner, or make sure she opened the action. She grew about two inches when we handed it to her because she got that it was a grown-up thing. I thought it was just so cool, and a very important first step. She asks for a BB gun all the time.

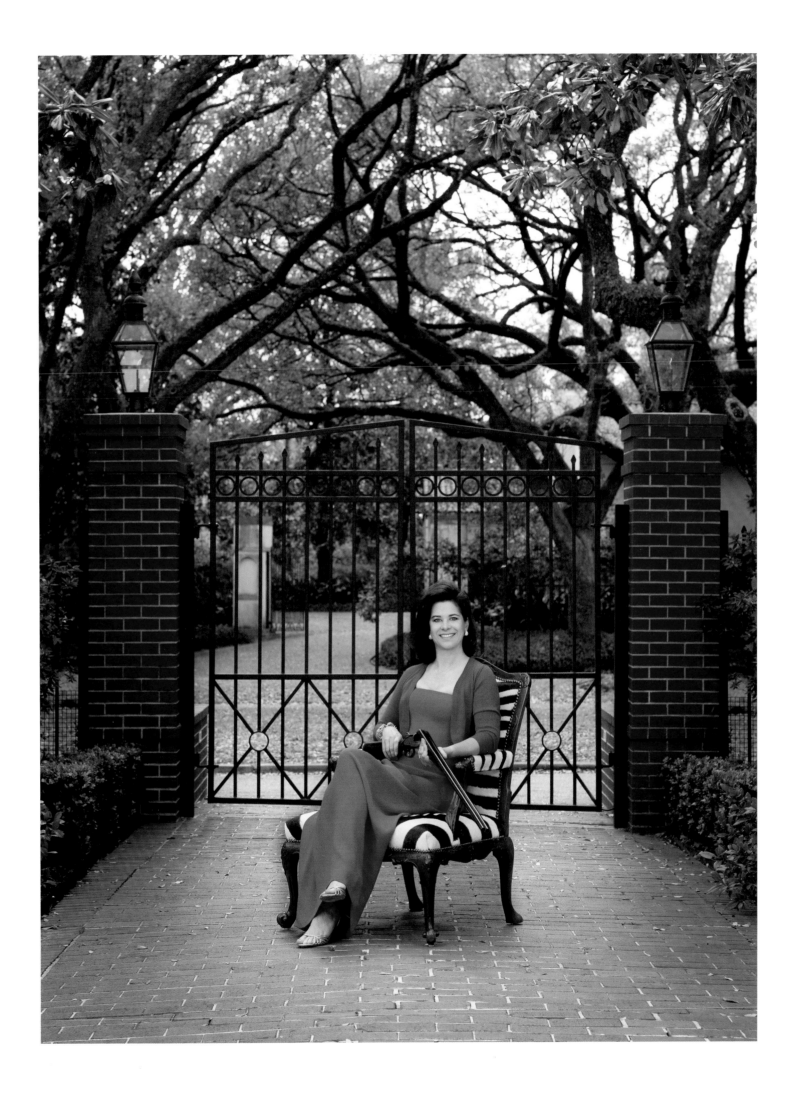

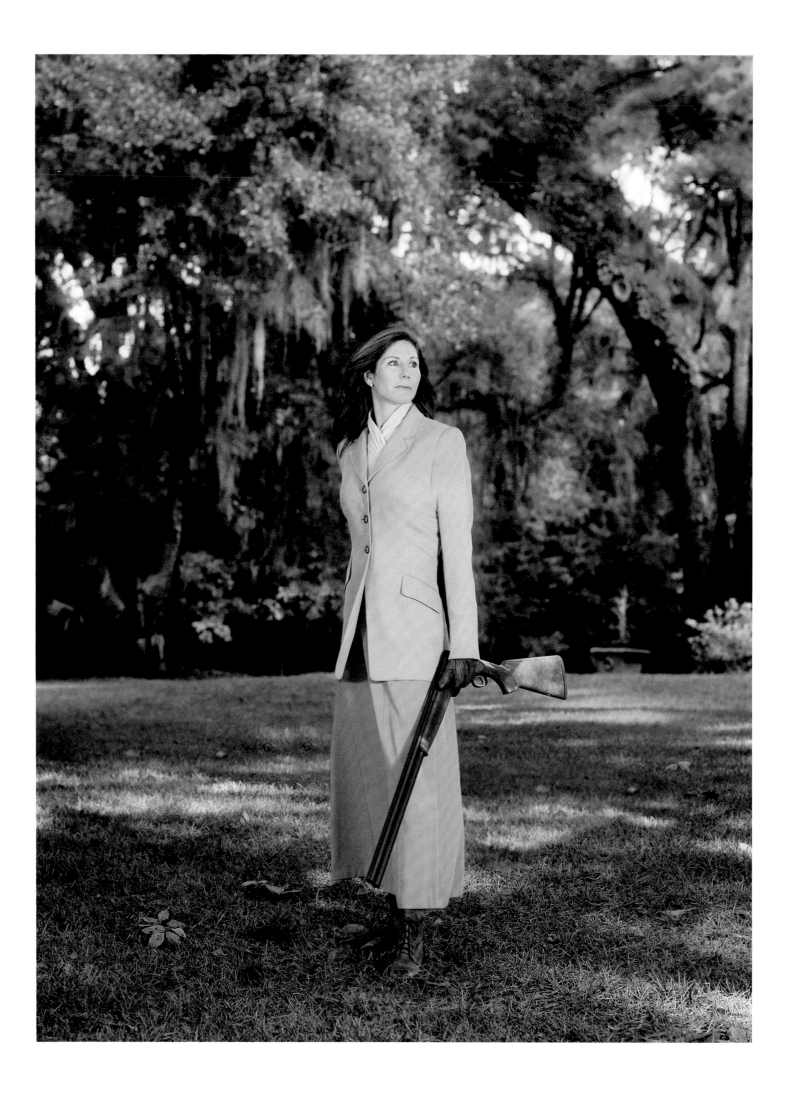

SARAH
Beaufort, SC
Berretta EELL 12-gauge over-and-under

I was raised on a farm—the only girl with three brothers—
where everything we did was a competition. We couldn't
even go to the mailbox at the end of the road without
turning it into a race. I'll never forget when I was about
fifteen, I went to my dad in tears after being slide-tackled
a few too many times during a "fun" sibling soccer game,
explaining that I just couldn't beat my brothers at any-
thing. He seemed positively delighted that I had reached
this point; he had harbored a secret that now would be
ours. He said I had forgotten one thing: I could shoot. No
boy—in fact, nobody—could hit a target harder than any
girl. No boy could hit a target faster than any girl. It was
a level playing field—and if I worked at it, I could wipe
my brothers' eyes over a friendly round of skeet or even
pecking tin cans off fence posts with a .22. He was right.
That was one of the greatest gifts my dad ever gave me.

My daddy is the biggest influence on me because he has been shooting all his life, and he wanted me to try it, and I tried it, and I liked it, and we keep doing it.

When I was eleven, I started shooting on an air rifle team at our local wildlife and conservation club. We shoot twice a week. There are more girls than boys on the team. We have maybe one or two competitions a month with other teams from around the state, I like winning with our team, and when we went to an invitational shoot in October, I was thrilled that we won, and I like knowing that sometimes I can win over somebody bigger and tougher than me.

My favorite guns are the .22 pistols because they don't have as much recoil and they are easy to shoot. Most of the time, nothing goes wrong with them, and the bullets are cheaper.

On Halloween, my dad, a friend, and I went to a shooting match, a Dick Tracy match. My dad dressed up as Magnum PI, and I was a butterfly. I shot a .22 revolver, and when everybody left, the score person told me that I had won the match because I had dressed up in a costume, and most of the others didn't, and that counted as points, so I had the highest score and won first place.

I like my pink gun because I like the color. It shows that it's different. I would have chosen a lime green one, but they didn't have one. When I'm a little older and a little bigger and a little stronger, I'm going to shoot a shotgun. I tried it before, and well, let's just say I went backwards. But I did shoot the clay pigeon.

I don't really consider myself girly or feminine. I enjoy shooting because I can protect myself if any harm comes, or I can just have fun shooting and feel good when I hit the 10 or the X ring or get a good score.

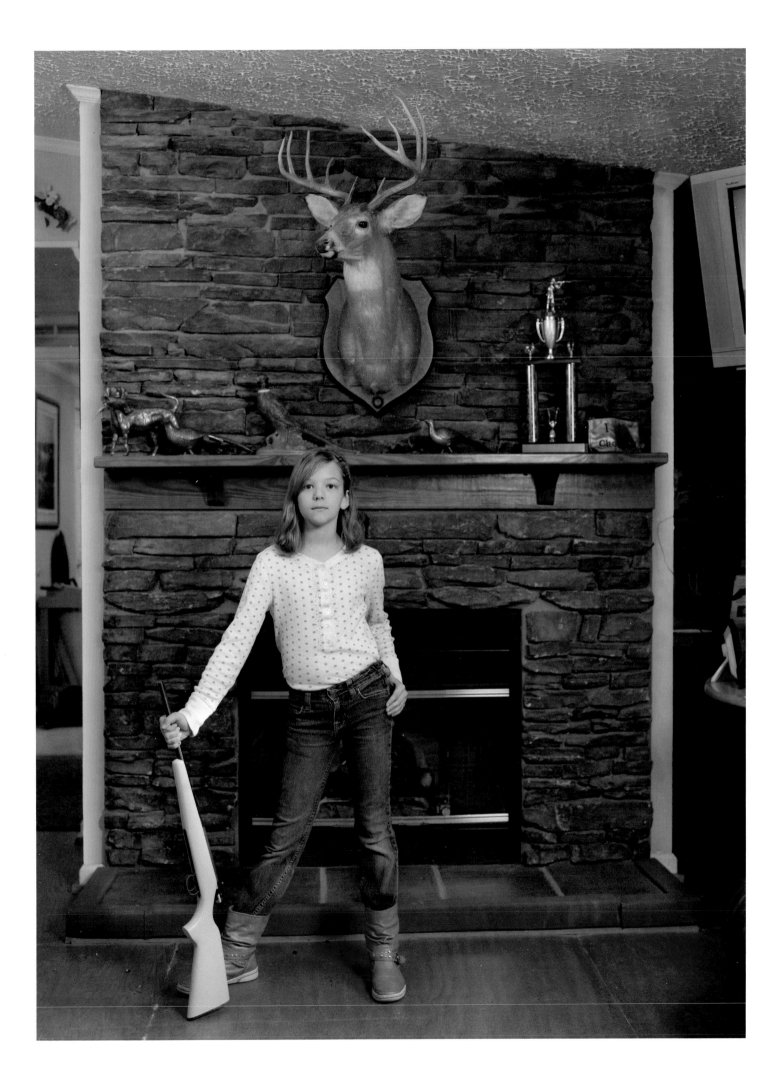

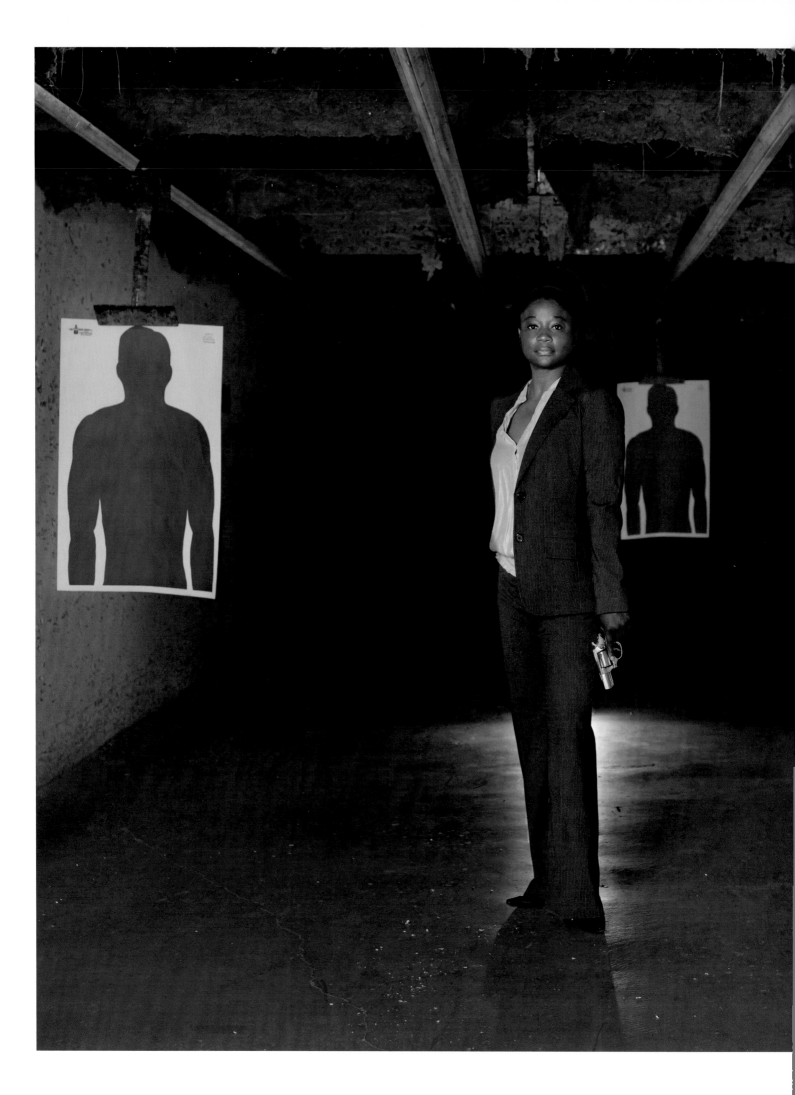

CONNIE
Merced, CA
Ruger SP 101 revolver

I was in high school the first time I ever laid eyes on a gun. It was a rusty old revolver my father owned. The revolver wasn't in working condition and I never actually held it. Back then my focus was athletics; guns really were not a part of my life and honestly didn't hold much interest for me. It would be eighteen years before I saw another gun and actually held one in my hands.

I didn't start shooting until my job required training to carry a firearm. I was trained to carry a .40 Glock to be specific. I was a novice and started out in the classroom learning about the weapon I would carry. I learned how the Glock worked, how to take it apart, and how to clean and properly maintain it. Training always emphasized safety.

I was surprised at how much I enjoyed the training. But it was challenging for me and I had to work hard. It was important to me to improve my skills. So I practice through work but also on my own. I began going to the range on my own time. I like to use different targets, and sometimes I shoot with different weapons. I try to shoot at least twice a month at the range and I really enjoy going because the more I practice, the better I get and the more confident I am with my guns. At home I do an exercise called dry firing, which is basically firing your weapon when it has no ammunition. I put up a target and work on my trigger pull. I practice pulling back the trigger slowly and work with my breathing. The dry firing really helps a lot with my target practice and my aim.

I have developed and maintain a great respect for guns. I am always mindful of the tremendous responsibility that comes with carrying a firearm.

CAITLIN
Minneapolis, MN
Anschütz Fortner rifle with Altius Firearms custom stock

I started shooting with my uncle when I was eleven years old. We would go out on his sheep ranch in Montana and "eliminate" the ground squirrels that were digging dangerous holes for the sheep's legs. I had a lot of fun but never thought shooting would become such a big part of my life.

The next time I picked up a gun was with my ski coach in Minnesota. He knew I was a good skier and was hoping that I had a knack for shooting as well. He was really pleased with my ability and recruited me for the sport of biathlon, which combines cross-country skiing with rifle marksmanship.

I love the juxtaposition of skiing as hard and fast as you can to being completely in control when you enter the shooting range and aim at the targets and then to getting up and skiing as hard and fast as you can again. I don't think people realize that although the black target appears to be the size of a C.D., the truth is, the actual target is the size of a quarter!

In the sport of biathlon we use lots of skis but only one rifle. Our rifles become an extension of ourselves as we carry them with us throughout the racecourse. I love how precise the measurements and angles of each individual's rifle are. My rifle is an Anschütz with a beautiful bird's-eye maple Altius stock. I love it!

CAROLYN
Minneapolis, MN
Anschütz Fortner rifle with Czech custom stock

I started shooting at a biathlon recruiting camp, and until it started I wasn't sure if we'd be shooting bows and arrows, BB guns, or pistols (shows how unfortunately unpopular biathlon is in the U.S., despite its being the #1 most televised winter sport in Europe, with 5.7 million TV viewers in Germany alone for an average World Cup race). I fell in love with the challenge of combining shooting with skiing and was interested in its history in many countries—Russia, Finland, Norway, Sweden—any snowy place where you might have to shoot either to eat or defend yourself.

Biathlon is incredible; you can be shooting in front of 40,000 loud fans with your heart rate at 190 beats/minute, and then skiing around a three-kilometer loop with TV cameras everywhere and spectators five deep the entire way, cheering you on to go faster!

I have enjoyed shooting as part of biathlon because of the unique combination of endurance fitness with fine motor control and concentration. I haven't done any other shooting, because firearms also make me uncomfortable. I appreciate the extensive world traveling that biathlon has allowed me to do, and the lifelong tools the sport has given me to stay fit—skiing, running, biking, kayaking, lifting weights, and rollerskiing.

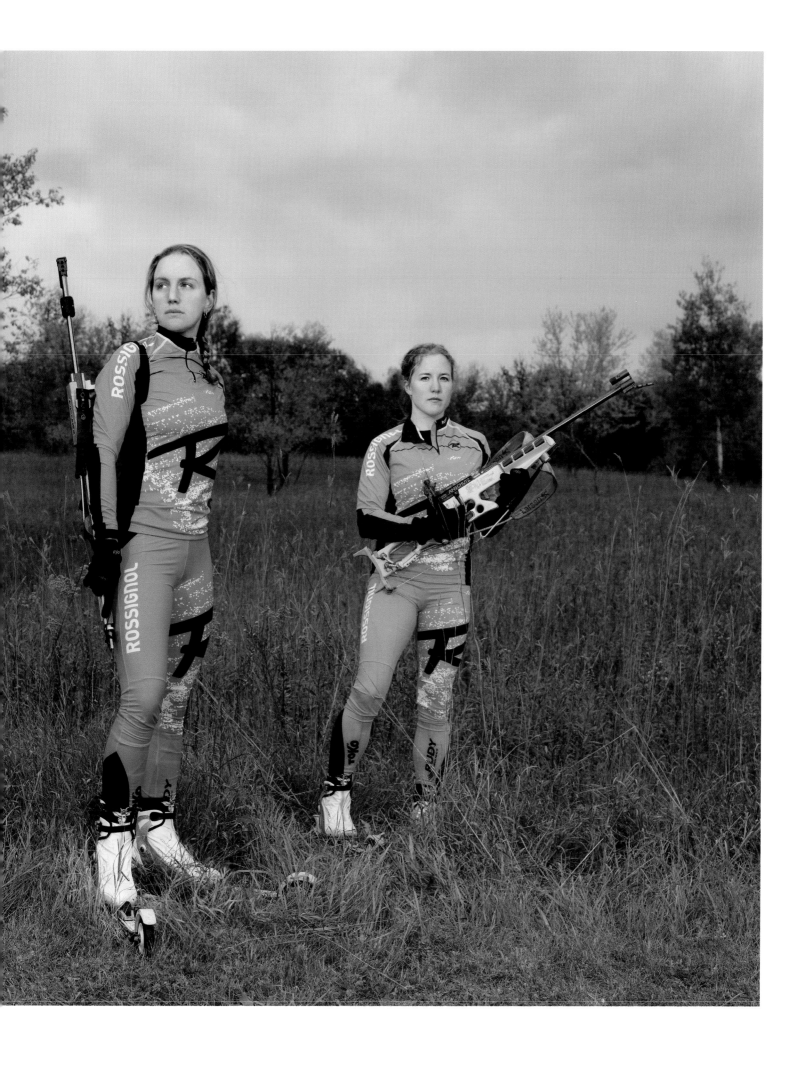

ALICE
Minneapolis, MN
Smith & Wesson 9mm TSW5906 &
Remington Model 870 12-gauge riot gun

I grew up being the only girl in my family. I was given a
title, something like Tomboy Princess. I played rough with
the boys—and had every Barbie accessory imaginable. In
high school I continued to appear very "girly" as a cheer-
leader all four years.

 None of my peers would suspect that I was equipped
with the strength to be a gun-toting Minneapolis police
officer.

 Being raised in the city of Minneapolis, I had heard,
seen, and witnessed the power of many firearms, and lost
very close friends to them. I hated guns, I was afraid of
them, and never wanted to touch them. But in my mid-
twenties I decided to follow through with my childhood
dream of becoming a police officer, which meant I would
be required to handle the dreaded handgun.

 During the past five years I have qualified with long
guns and handguns (my gun of choice being the Smith &
Wesson TSW5906, 9mm), and have had M16 training. The
very first time I took a shot I realized that guns don't kill
people, just like pencils don't misspell words.

 Shooting is an art: everything becomes silent ... get
that sight picture, be mindful of the front sight, target
blurry, squeeze (not pull) the trigger, and BOOM!

 I am a mother of three girls—Carma, Rilet, and
Darah—all of whom will be well versed in the art of shoot-
ing, while having the heart to shoot if necessary.

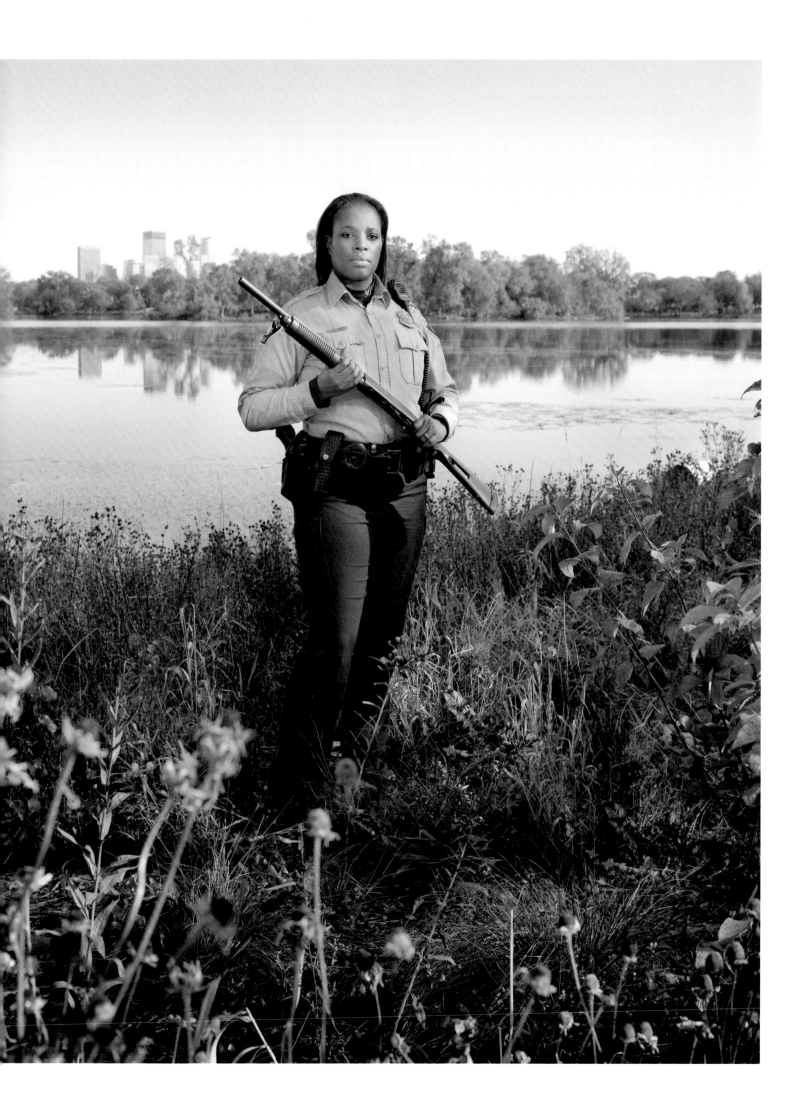

JILLIAN
Ellerbe, NC
Winchester SX3 in Mossy Oak Duck Blind finish

Hunting started for me at a very young age. I was raised on a tobacco farm in Ellerbe, North Carolina, with three adventurous brothers and a dad who was very passionate about hunting. From the time I could walk they would take me out into the field to hunt alongside them. Whether we were hunting for deer, rabbits, birds, or raccoons, I was never left behind. My first gun was a youth model, 20-gauge pump. My daddy spent numerous hours teaching us gun safety and to respect the sport and the wildlife that we hunted. Hunting for us wasn't just about the kill; it was more about spending quality time together outdoors. However, we were taught that if you shoot it, you eat it! So needless to say, we were raised on game.

When I turned twelve, I took hunter safety classes so that I could start hunting alone. When I completed the course, my uncle bought me a Remington .308, which I still use today. I would spend most afternoons sitting in a box stand with my note cards, doing my homework. I remember my friends asking me why I wanted to spend all afternoon in silence waiting for deer. My response was, "The same reason you spend your afternoons practicing tennis—I love it!" Eventually I talked a few of those friends into giving it a try; they are now avid hunters/shooters themselves.

My most adventurous hunt took place the year I graduated college. As graduation grew closer, I started thinking about what I wanted to do or where I wanted to go for graduation. It didn't take me long to settle on a hunting safari instead of a cruise to some tropical island as my graduation gift. At first my family was reluctant to let me go alone, for fear that I wouldn't be safe. But after hours of persuading, I won their support and I hopped on a plane and headed to South Africa to hunt plains game. I had never flown before this trip, so it was definitely an experience for a small town girl. My budget was small, so I was only able to take a kudu, an impala, a blue wildebeest, and a blesbuck. I never imagined I could love hunting any more than I already did, but I was wrong. This trip gave me the opportunity to see, and shoot, wildlife that I only dreamed I'd get a shot at. Since then I've already started planning and saving for my next adventure. To me there is nothing better than a day outdoors in camo with a rifle. What more could a girl ask for?

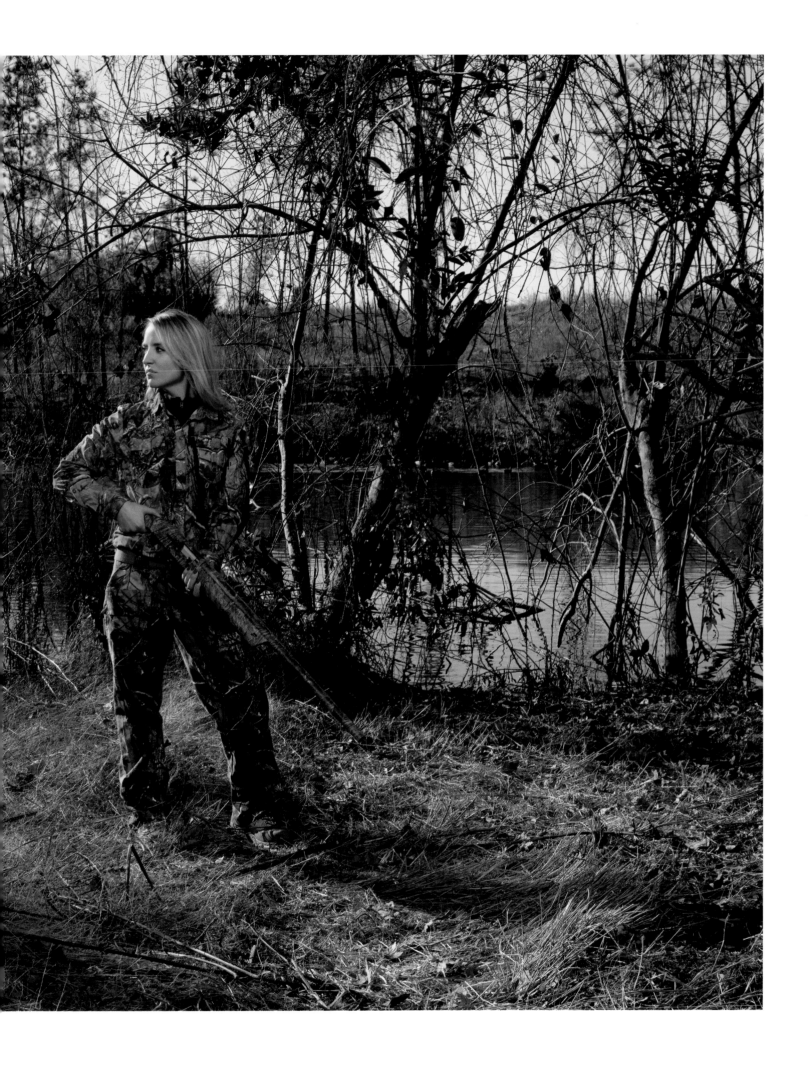

Merced, CA
Taurus Titanium .38

I bought my gun—the one in the photograph—at the local
gun store in Merced, California. It's a .38 titanium revolver
made by Taurus. My hands are not strong enough to pull
certain guns back, so I need a revolver. It's very light-
weight and easy to use. When I want to target practice
at the local range, that's the gun I'll take. I also have a
revolver that's a .22 9-shot. I use both guns for target
practice. I don't go shoot animals or things; I just enjoy
target shooting.

When I was mayor, I couldn't practice as often as
I wanted to, but now that I'm no longer mayor I go a lot
more often. The girls usually go on Tuesday nights. We
go to our local gun range, hook up our targets, and then all
go down and see who's the best shot. Who attends varies
each time. Sometimes you get ladies from the correctional
facilities, sometimes you get realtors, and sometimes you
just get gals who like to practice. The ages range anywhere
from early twenties to women in their seventies.

When my granddaughter was nine, I brought her
and her girlfriend down there and let them both shoot for
the first time. They were both fine with their little .22s
because they go "pop!" Then my granddaughter wanted
to try Grandma's .38, so I let her try. But when it shot and
went "BOOM!"—you know how much louder they are—
Grandma got the .38 back and granddaughter took the
.22! We all had a really good time.

JESSICA
San Antonio, TX
Smith & Wesson Model 60-14 .357 Magnum
double-action revolver with 2 ⅛" barrel

I was born in Laredo, Texas, and spent the first fifteen
years of my life on a ranch thirty miles north of Laredo,
near Encinal. Living on a ranch has many benefits, includ-
ing learning a lot about guns. As a child, I spent much
of my time in the oil fields with my father as well as on
the ranch hunting. My father worked in a gun shop when
he was in high school and college, so he's incredibly
knowledgeable. First he taught me all about cleaning and
caring for our firearms properly, and then he taught me
how to shoot using coke cans in our backyard as targets.
I mastered the handgun and then graduated to my great-
grandfather's 28-gauge Harrington & Richardson single-
barrel shotgun, which I love and still use today.

 I was a hunter at one time but now focus primarily
on target and clay pigeon shooting, skeet and trap mostly.
It is a challenge, a sport where you are competing against
yourself, so you are constantly trying to beat your own
record. As a helicopter pilot, I have heard repeatedly how
women in training proceed faster and are better pilots than
men. We are detail oriented, focused, and able to make
precise, small movements that make all the difference in
shooting and flying. Given the right training and weapon,
a woman will outshoot a man with a similar background
any day.

 Currently, my husband and I enjoy shooting trap
together. We keep several handguns in our home for
protection; when we purchased them, I took them out
to the ranch to make sure I knew how to use them and
was proficient. I have never been to a gun range; all of my
practice has been on the ranch. We go out several times
a year to shoot trap and targets, and hunt white-tailed
deer. I have also been fortunate enough to make two trips
to Africa, where I hunted plains game.

 My favorite gun is a weapon I received as a wedding
gift from a dear friend, a .25-06 Sako rifle. It shoots a very
fast and accurate bullet. If I could have any gun, my wish
would be the Purdey 12-gauge side-by-side shotgun.

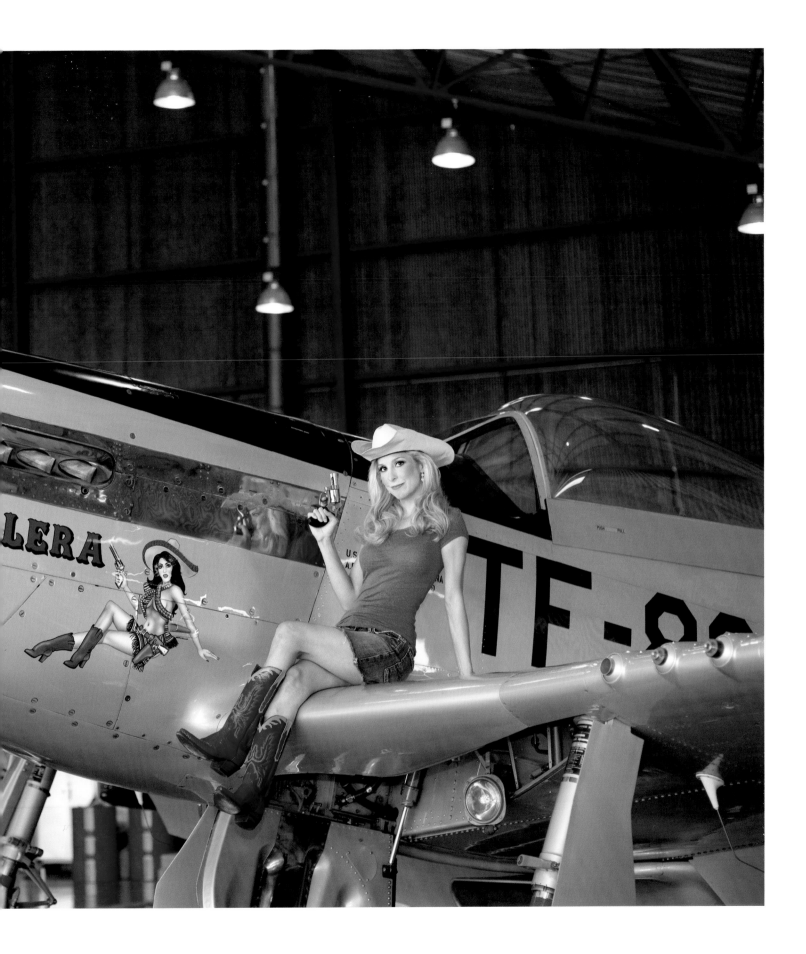

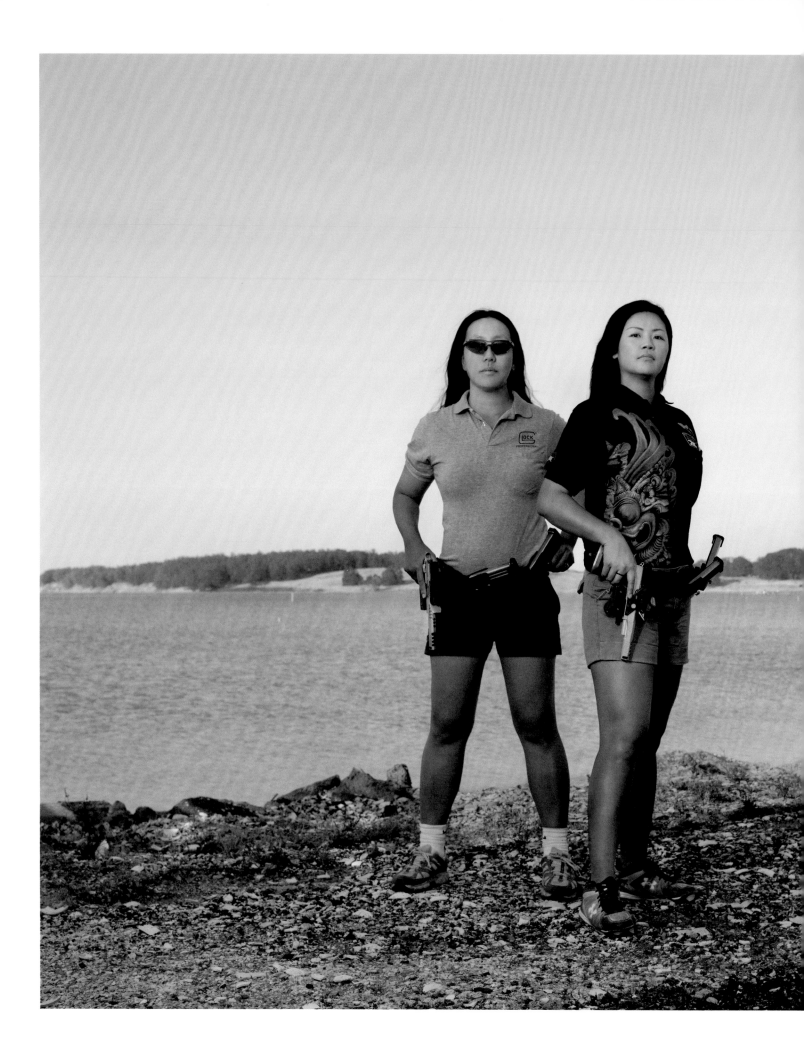

JENNY
Richmond, CA
STI 2011 International pistol

It was not an instant love affair when it came to shooting. Between the goofy rental glasses and loud bang, I wasn't a fan. Initially, gun safety drove me to the range, where I learned the basics. It was important to understand the fundamentals of safe gun handling because there were firearms at home. But once I was introduced to practical shooting at Richmond Rod and Gun Club, I fell in love with the sport.

Today, competitive shooting is my passion. I compete in USPSA (United States Practical Shooting Association) A class, Open division with my 9mm custom pistol (built by Frank Chan, Irvington Arms). I count down the days until the next practice or match. The friends I've made over the years are truly what keeps me active in the shooting sports.

LILY
Richmond, CA
STI 2011 International pistol

The first time I fired a gun was seven years ago. Since I was born and raised in Hong Kong and didn't come to the U.S. until I was eighteen years old, in my mind firearms equaled "dangerous" and only bad people used them. But one day, after being in the U.S. for a while, I did a 180-degree turn and thought, "Why don't I give it a try?" On that day a new journey began for me and my husband. After we learned the basic skills for handling handguns, we started going to an indoor range once or twice a week. After a few weeks, we started to get bored shooting the same target. One of my friends had participated in practical shooting before and he brought us to a gun club where they have local USPSA matches and practice sessions. We were taken with the sport immediately. My first impression of it was, "Wow, it looks so cool to run around and shoot."

Although I am not an excellent shot, I have a lot of fun and continue to improve. Over the past seven years, I have shot matches once a week and try to practice as much as I can. It has become routine for me to wake up early on weekends and go to the range. Maybe one day I'll retire from this sport and try something entirely different, like fishing. However, at the moment, I do enjoy shooting with good friends and traveling around to shooting matches. Meeting new people and shooting with your friends is definitely the reason why I love the sport.

LENA
Atwater, CA
Colt .45 Single Action Army with 7 ½" barrel

I first learned to shoot when I got married forty years ago on the 4th of July. My husband has always been a shooter, so he taught me, and then our children when they came along. He is a sergeant at the police department and also the range master. He teaches all the new officers how to shoot and conducts their monthly training. We are also very active at our local gun range, Gunrunner, in Merced, where we practice shooting and also purchase our guns. If there is a special model I want to surprise my husband with, the owner, Sandy, can always find it for me. Whenever we shoot we practice gun safety to the utmost degree. I feel that is what makes an outstanding shooter.

Shooting is a great hobby for my husband and myself and very relaxing for me, as I am a woman of many hats! I am very involved in community affairs, currently serving as the president of our elementary school district, past president of our Chamber of Commerce, past president of the Women's Club, and a lector at St. Anthony's Catholic Church! I also owned a dress shop for ten years and would always carry a concealed weapon with me when we went to market in the city.

As a family, when the children were young, we always had a great time going out into the country and shooting at cans, collecting the shells, and then relaxing with a picnic lunch afterwards. One year we went on a cruise and all really enjoyed skeet shooting too. We also travel during the summer and truly love stopping at all the various gun museums.

My favorite gun is any Colt, especially one that has some "bling" or sparkle; and I love ivory grips. The gun I would love to have would be a Gatling gun. I would mount it in the front yard for effect!

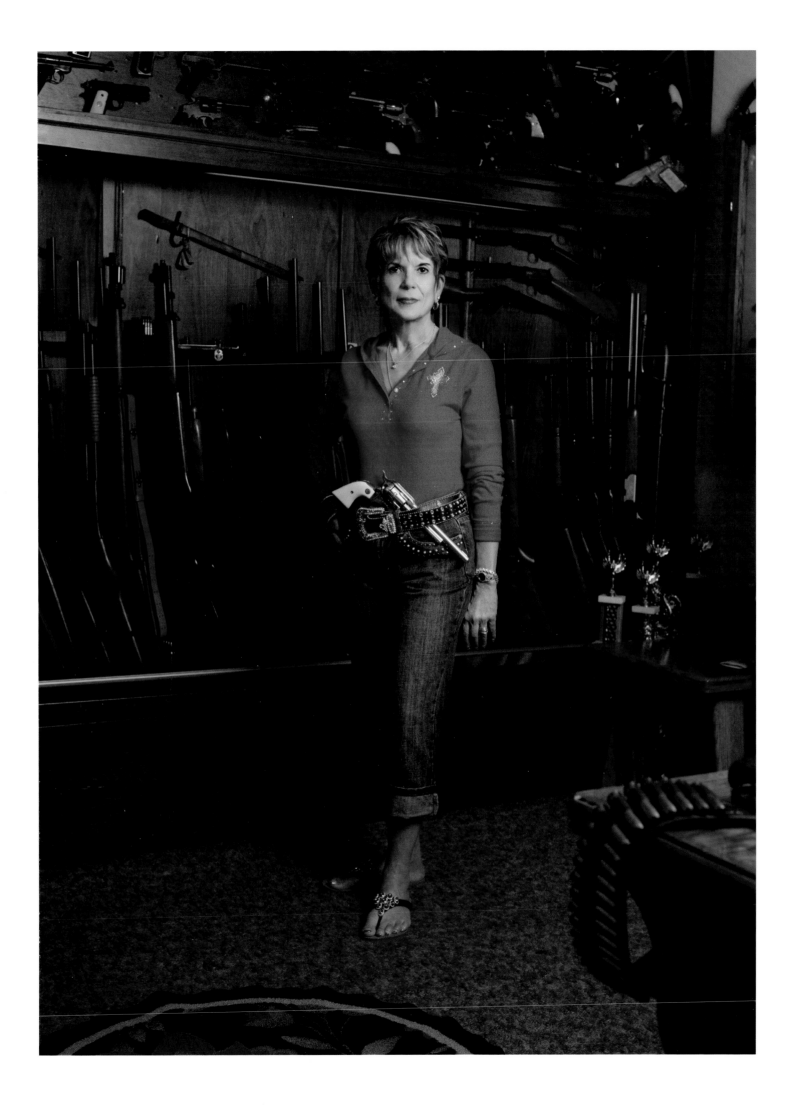

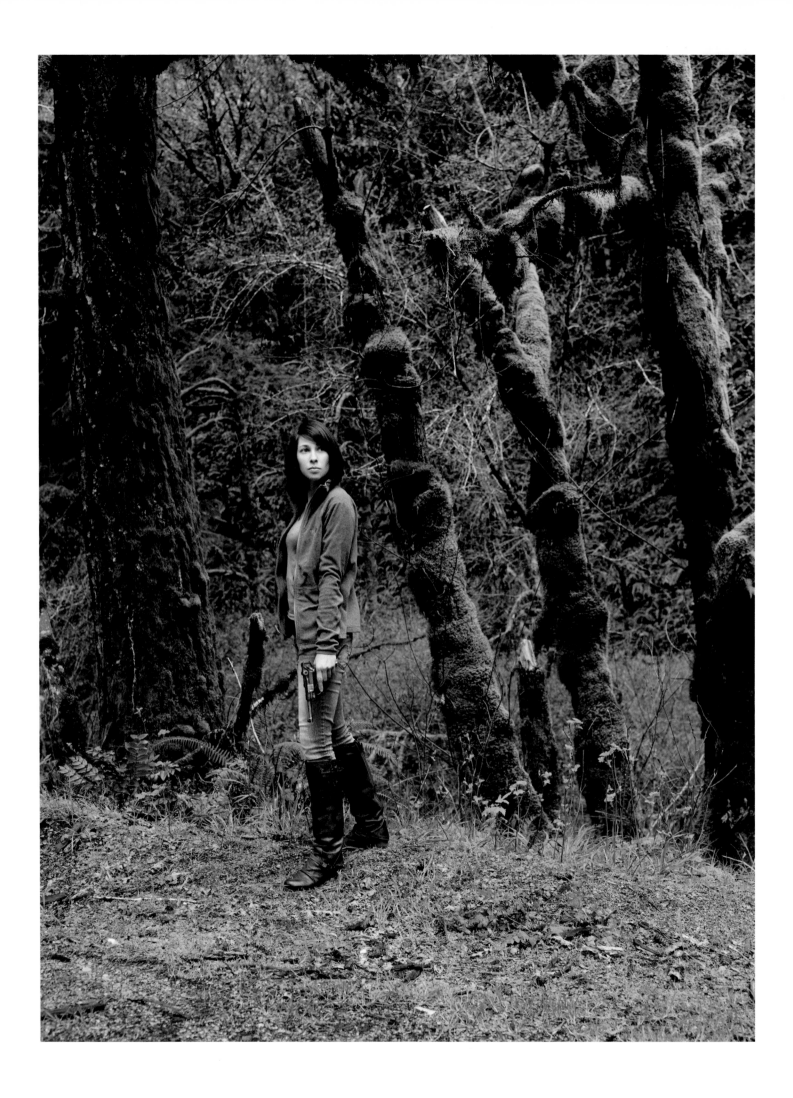

ALLIE
Roseburg, OR
DWM Luger military model of World War I period,
in 9mm Parabellum

I grew up in a town in the heart of southwest Oregon
where the woods abound and nature is ubiquitous. As
a girl, I was afraid of nothing; as an adolescent, I was far
more shy. It was about that time that I began shooting
with my family. I remember shooting for the first time; I
just fell in love with it. Even though shooting was a family
event, it was my dad who was the true marksman. He
taught me the basics, and experience and practice have
done the rest. We'd go out in the woods and I would shoot
my 1914 model Luger at a modest paper bull's-eye target.
Despite the unassuming surroundings for target practice,
I was learning a great deal about confidence. I have found
target practice very liberating. Holding the significant
power of a firearm in your hands can make you feel more
self-assured. The confidence I learned shooting taught
me to be more confident in other areas of my life as well.
Shooting makes one feel powerful, but it requires dedica-
tion, practice, and precision to gain full control. Life can
be unpredictable, so it's good to have control in at least
one aspect of it.

 As I got older, I learned that few people have ever
shot a gun and even fewer women have held one. I think
it's a shame that more people, and especially more women,
have not known the positive impact shooting can have.
This has been the case with a few of my friends. I have
had to dissuade them from their negative views of guns
and show them the power of shooting a firearm and how
meaningful it can be. Guns aren't all about violence. Guns
can be about finding confidence and gaining a sense of
accomplishment. Some of my favorite memories are of
taking my girlfriends shooting with my family. Watching
their faces as they become empowered while learning to
shoot and handle a firearm is an amazing experience.

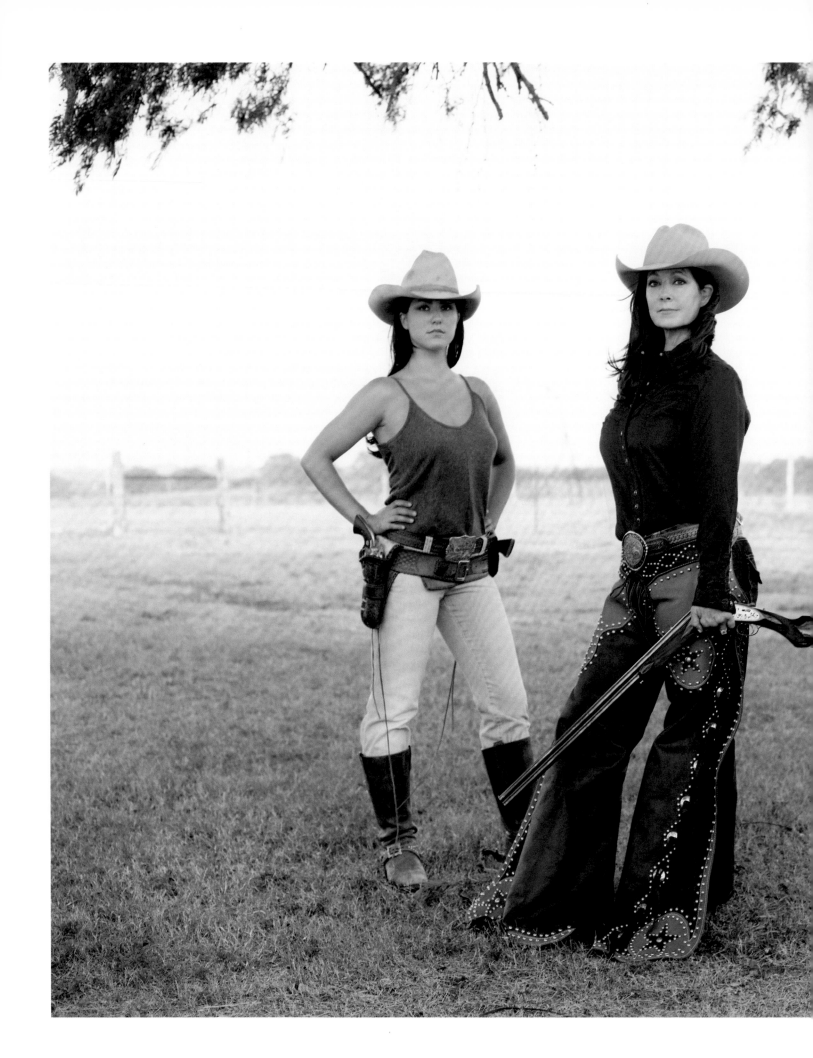

KELLY
Westhoff, TX
Colt .45 Single Action Army revolvers

Quail hunting is one of my favorite Texas rituals. When you're sitting on a quail truck from dawn until sunset you really connect with the people you're with. I love to watch the incredible instinct and athleticism of the pointers as they tear across the pastures. When a dog is on the point there is a rush of excitement and anticipation as you jump off of the truck and pull your gun from the scabbard. The sound of the birds as they flush and rise against the rugged landscape is magical.

As a sixth-generation Texan, I feel an innate resonance with the Texas folklore, and the guns and the birds are definitely a big part of that story.

KAROL
Westhoff, TX
Holland & Holland 28-bore over-and-under

I learned to shoot when I was eight with a German luger my father brought back from World War II. Every summer at camp I was the high point shooter of my tribe and loved it. When I married Paul, guns and hunting continued to be a big part of my life since he is also a hunter. My husband and I taught our children at a very young age with a single-shot .22 rifle, using prickly pair cactus as targets. Shooting is a tradition in our family, and we all enjoy doing it together.

I love to be in the outdoors, and quail hunting in South Texas is a great way to do so, surrounded by family, friends, dogs, and horses. I love to hunt with my favorite 28-gauge Perazzi, which was a special gift from my husband. Some of my favorite moments have taken place on these hunts.

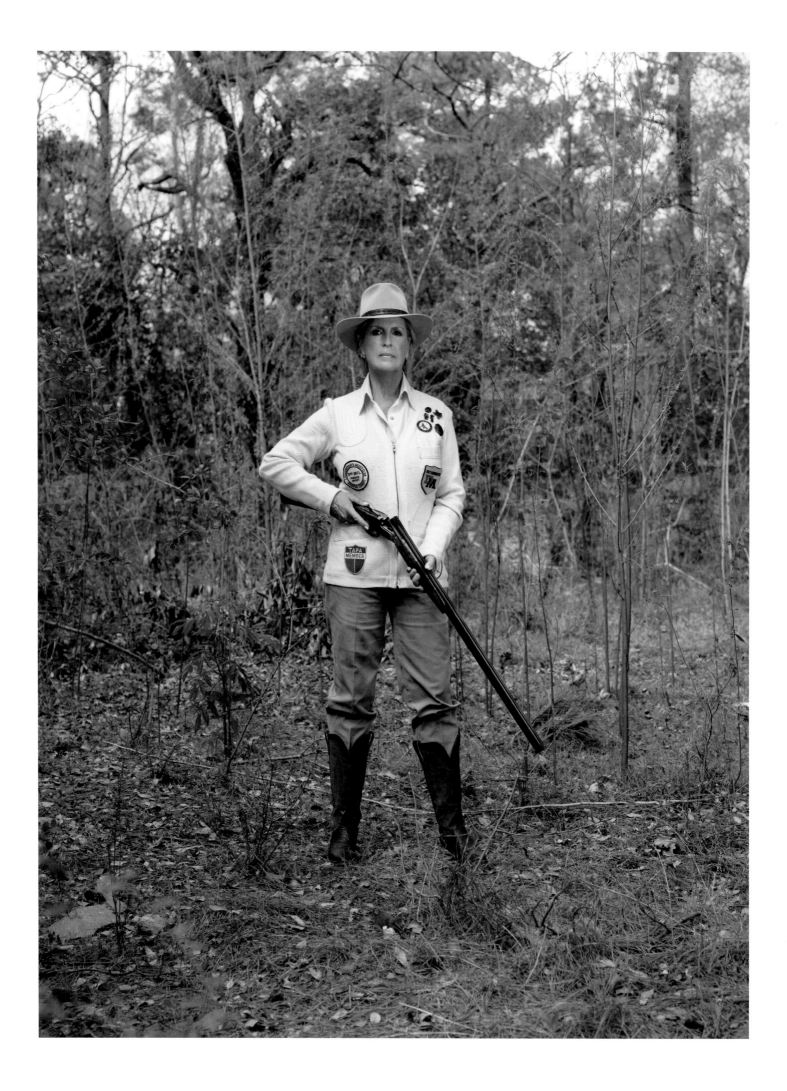

GAYE

Houston, TX

Perazzi 28/410 SCO over-and-under

I grew up in Houston, Texas, and my only sibling was a brother ten years my elder. My father, starting at an early age, had been a State and National Trap Shooting Champion several times over but had given up competitive shooting when I was born. When a new competitive sport filtered into the United States (by way of Spain through Mexico) and landed in Texas, I guess you could say it brought a whole different way of life to competitive shooting—live birds—and my dad was hooked.

My father started participating in this sport when I was fourteen, and my mother and I traveled the circuit on the weekends with him. It took us to various shoots around the country and into Mexico from mid-February to Labor Day—the off months of Texas hunting season. There was an association formed called T.A.P.A., or Tiro Al Pichon, meaning "shooting pigeons." Throughout the year you were rated on your wins, which determined whether or not you were placed on the American team, which would compete with Canada and Mexico. The North American shoot would be held once a year in some exotic location and the Calcutta that preceded the shoot would be separated into bets on the the Men's and Women's divisions. The total purse could easily be in the six-figure range.

When I was seventeen, my father handed me a Remington Model 58 during a practice round the day before a shoot, and said, "Honey, you have watched me shoot for three years and now I want you to have the respect and fun that I have had with guns all my life; I want you to start shooting." After that moment, my life changed forever. The next weekend, there was a shoot in Mexico, 175+ contestants, a 6+-figure Calcutta, and a broken blood vessel in my right cheek, yet I beat all of the men, including my father, and the women, having lost just one bird in the shoot. Three years later, I won The North American Women's Championship.

I shot that wonderful game for many more years and I made it my livelihood, off and on, but the lifelong friendships that I made are my greatest trophies.

I am back living in the great state of Texas, in Houston, where I have met the partner of my dreams, my husband, John. We now shoot sporting clays at our ranch with our family, and various birds in South Texas, England, Italy, France, Spain, and Argentina yearly. I have owned several guns since my 58—over-and-unders, side-by-sides. I have a 28/410 SCO over-and-under that was custom made for me in Italy by Perazzi—a present from my husband. I do love that .410 for doves in Argentina, but my Model 58 will always be my old friend.

Shooting has taught me how to honor firearms, how to focus with patience, how losing builds character, and how winning teaches respect for others. True competition should be within oneself—not against others; that is a good lesson in life, at any age.

JANET
Whispering Pines, NC
Browning .270 Automatic Long Trac

When I was eight, my father handed me my first rifle, a Winchester Model 67 .22 single-shot, which had been in the family for three generations. I still have a crystal-clear memory of that day, one of a thrilled kid and a dad who knew that someday his little girl would hold her own. As I embarked on my first hunt, my way through the wooded trails was guided by my promise to Grandma: "All the rabbits you can eat!" More than once I finished a morning hunt only to inform Grandma that I'd had no luck with rabbits that day. Even though she saw my frustration, Grandma never let on, reassuring me she had faith in her granddaughter. That faith kept me focused and able to tackle the challenge again and again. Little did I know that my Winchester would instill in me a love for the sport of hunting.

Thirty-two years have passed, and after serving in the United States Air Force and traveling the world, I am fortunate and proud to be back in North Carolina— reclaiming my childhood "stomping grounds." My prized possession is my Browning .270 Automatic Long Trac rifle for hunting big game such as whitetails and wild boar. Grandma has long passed, but I stop by Dad's house before each hunt, promising him "the trophy buck." When I return frustrated, and without fulfilling that promise, Dad always smiles and reassures me that the next day will be better. Perseverance is crucial. I dropped my first whitetail deer in its tracks from 210 yards.

The nature of the hunt is very similar to life. You will have thrilling days, boring days, and frustrating days. The key is to stay focused, stay motivated, have faith, and always "aim" for a way to improve and succeed.

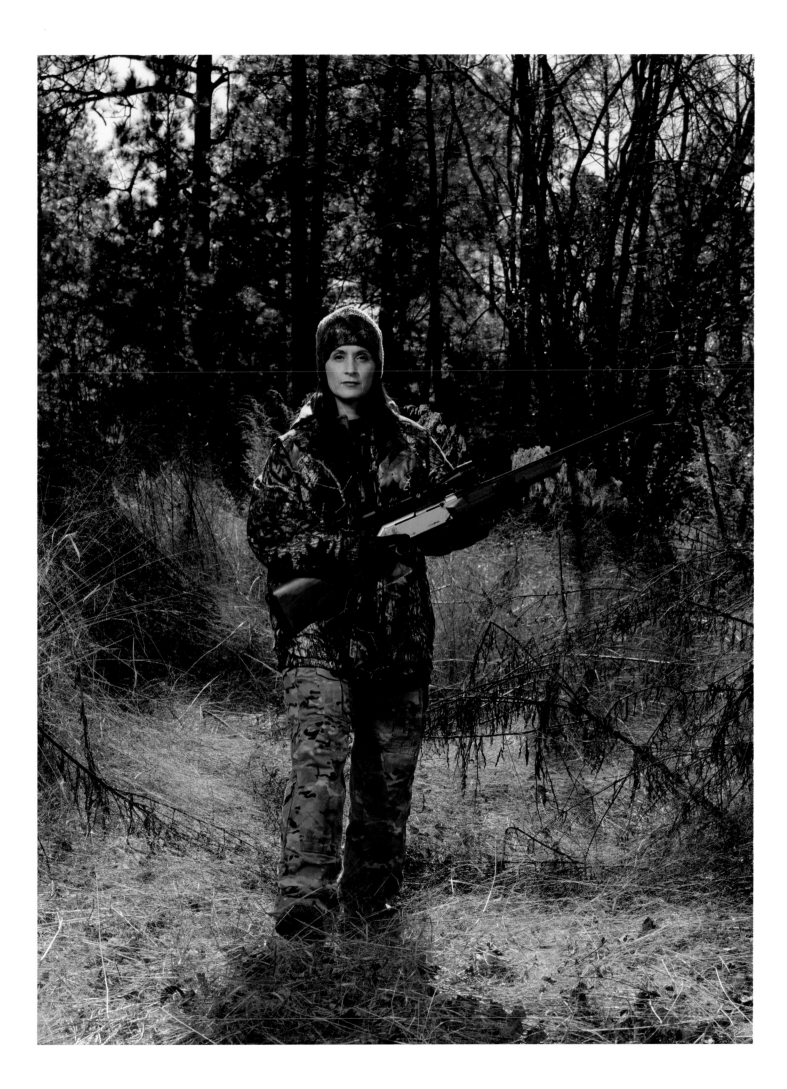

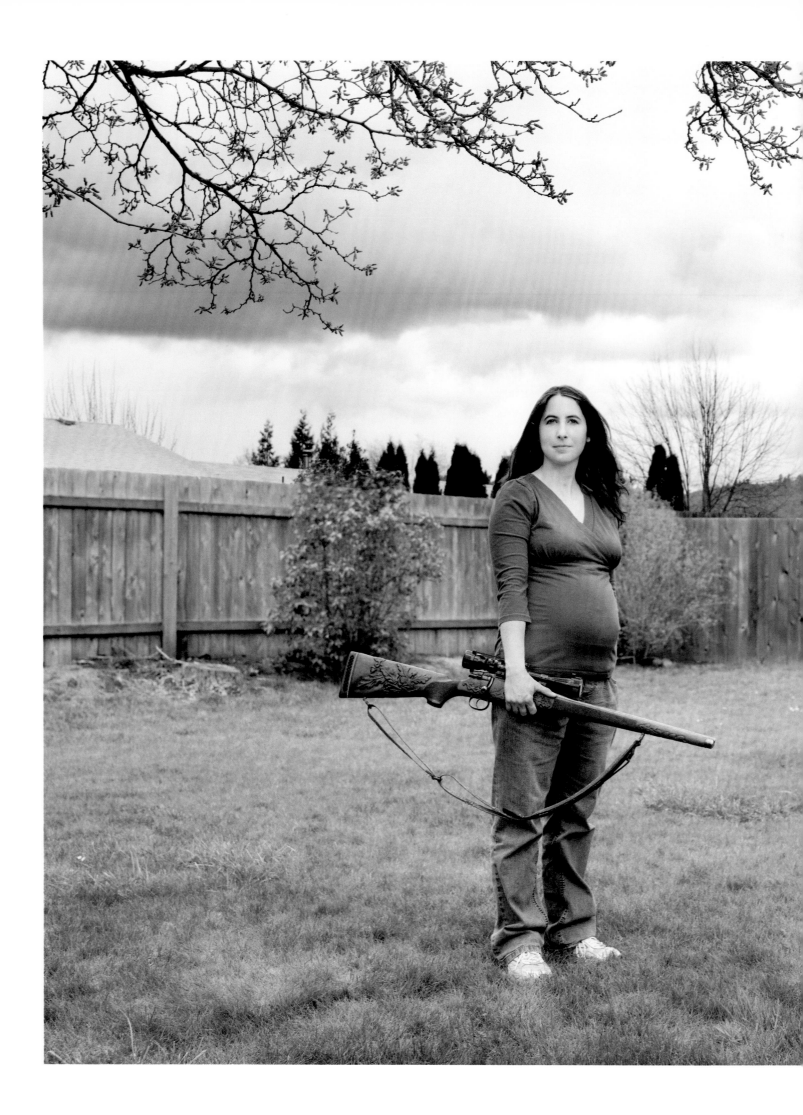

DEANNA
Winston, OR
.257 Roberts rifle with Mauser action

I am thirty-five years old and live in Winston, Oregon. The gun I am holding is a .257 Roberts with a Mauser action. My grandfather handcrafted this gun clear down to the stock. The stock is made out of a piece of black walnut he cut from a tree at his homestead in Missouri, before he moved his family to Oregon back in the 1950s. Oregon white oak leaves and acorns are carved all along the black walnut stock. The trap door, trigger guard, and action have a Roosevelt elk engraved on them. Grandpa was a very talented craftsman and artist. This was just one of his many beautiful pieces. The legacy of this gun and my grandfather will be passed down from generation to generation.

My husband says that it will blow the wings off of a gnat at a hundred yards.

LAURA
Whispering Pines, NC
Nickel-plated Smith & Wesson Hand Ejector model
in .38 caliber

My interest in the use of firearms began in my childhood days, with my father and my brother. Although my brother and I participated in the local BB gun program at the neighboring junior high school, it was my father who gave me my first real opportunity to use a firearm; it was a 12-gauge shotgun he used for trap shooting. My father is a seasoned hunter, as was my grandfather, so hunting has a history in our family.

Today, shooting sports are not solely for men. Women are drawn to these sports and opportunities have increased in the field for them. To date, my twelve-year-old daughter is enjoying the local air rifle programs, has completed the Hunter's Education class, and received a compound bow as a gift. I was delighted when my father passed on to me a Smith & Wesson .38 Special revolver. It is a classic and a joy to shoot. My other favorite handgun is my Glock 26. I am proud to say that when I go out for practice with my family (my husband, son, and daughter) on the "100 acres," the competition starts when Mom makes the first marks on the target! It's all in the technique and a bit of practice. These practice sessions are truly fun and will become treasured family memories. Remembering to be smart and safe at all times when around guns will keep these times memorable. What better way to instill this than through practice?

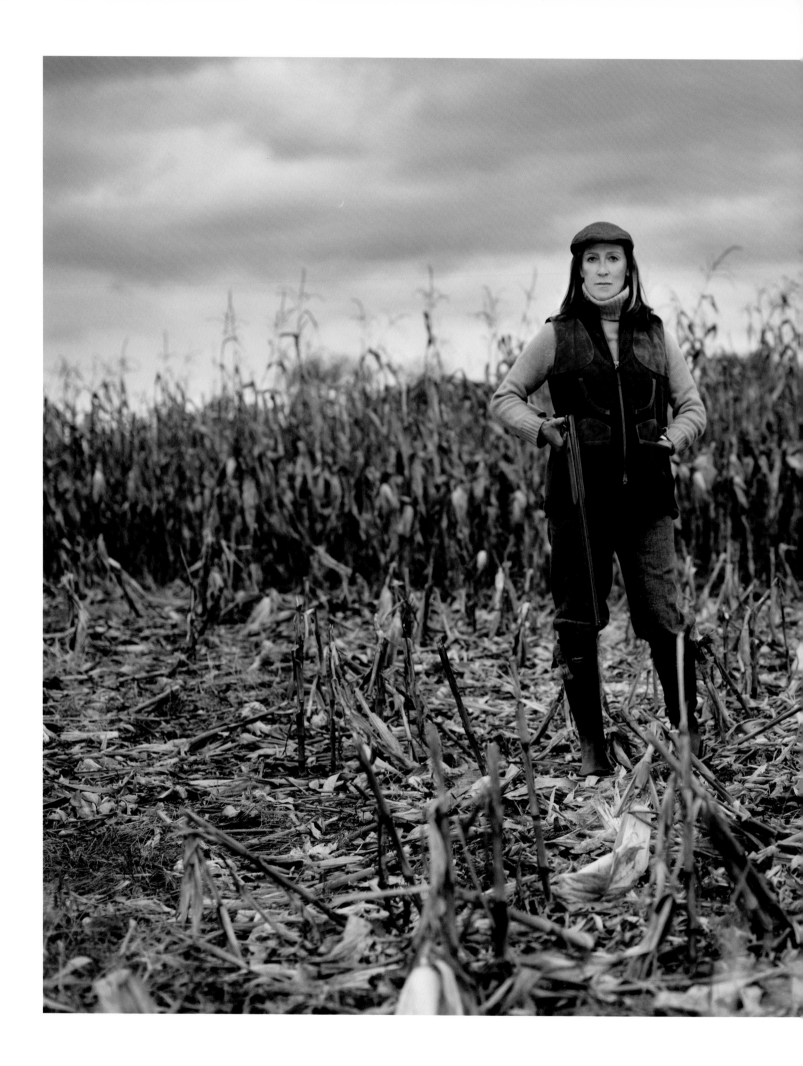

GINNY
Long Island, NY
Sturm, Ruger & Co. 20-bore over-and-under

Shooting, hunting, and guns in general are such an integral part of my personal and professional life that it's hard for me to imagine that I had a life before firearms. The first time I held a gun was in college. Good friends from Atlanta invited me for a weekend of bird shooting. Three days in the field and I never shot one duck, dove, or quail. But I was hooked. With time and practice, I gradually became a decent shot. Admittedly, hunting is a lot more fun when you can hit something!

This weekend pastime evolved into a career when Stanley Harris of Harris Publications asked me to start a hunting magazine. *Sportsman's Hunting Annual* was the first of many titles and the beginning of the Harris Outdoor Group. Fast forward thirty years and we have published over forty gun titles, including *Guns and Hunting*, *Deer Hunting Strategies*, *Combat Handguns*, and *Guns and Weapons for Law Enforcement*.

In conjunction with my position at Harris I have been on numerous bird shoots and big-game hunts in Africa, Alaska, and other parts of North America and received my combat handgun training at Gunsite Ranch. There isn't any aspect of the shooting world that I don't enjoy. I own more guns than shoes. Since my husband isn't interested in hunting, my most memorable experiences in the outdoor field have been those I've shared with other women. Hunting camps and shooting schools are usually in remote areas involving tents and outhouses. Typically, there are days of being cold, wet, and hungry. Sharing the exhilaration of the hunt as well as the camp experience with good friends has transformed every outdoor situation into a great memory and endless laughter.

THERESA
Anoka, MN
Desert Eagle Magnum gold .50-caliber with tiger stripes

I am a person with a lot of passions. I have always had a strong love of animals and the outdoors. As a child, I was playing with the boys and building forts while my sister played with Barbie dolls. Growing up, I always seemed to gravitate toward things most girls wouldn't dare get into, but I still had my girly moments.

Today, I am a woman who lives with the man of her dreams and lives the dream every day. I have the dream job working at a powersports dealership, my own clothing line geared to women of my kind, and I just love the people around me. I have fallen in love with moto-cross, hunting, fishing, shooting, bikes, monster trucks, and muscle cars, spending most of my time up north or outdoors with family and friends, racing, raising wild animals, doing taxidermy, and buying shoes, of course. Most people when they meet me would be surprised to know I own a gold .50-cal Desert Eagle with tiger stripes, one of the largest, most powerful pistols out there. Any girl would understand when I explain it was something I saw and HAD TO HAVE. Some women experience that feeling with clothes, some with jewelry. For me it was with a large firearm.

I bought it with the intention of putting it away for years and never shooting it, so that I could pass it on to my children someday. Well, it was only a matter of time before I was sharing the once-in-a-lifetime experience of shooting that enormous, intimidating pistol with friends and family, who would have probably never gotten the chance otherwise. THAT is a gun you will never stop talking about, and something I only bring out on special occasions.

I have learned through experience and years of being involved in fun and exciting hobbies that hunting is one of my favorites. Like I said, I am in love with animals and hunting is often misunderstood. Words just cannot describe the experience. Sitting up in a deer stand, you are separated from reality and you escape from the busy world called life. It's just the most relaxing and comforting feeling (except for the freezing cold) to sit, just you and the woods, and surround yourself with nothing but nature. You appreciate the silence and time to yourself to just think. You think about the past, present, and future while being entertained by the little squirrel that runs crazy through his daily routine. And the best part? Buck fever, one of the most thrilling experiences I have ever had and a memory that will last a lifetime.

Hunting is about being with family, making memories, taking only what you need and supplying yourself and others with extra meals. It's a good feeling. It's something we look forward to all year long, from deer hunting in November in northern Minnesota and salmon fishing in Alaska to goose hunting in March out in North Dakota. We get to travel and see things most people don't take time to see. It's a lifestyle that was easy for me to fall in love with. These are the things I enjoy the most, memories I will remember forever.

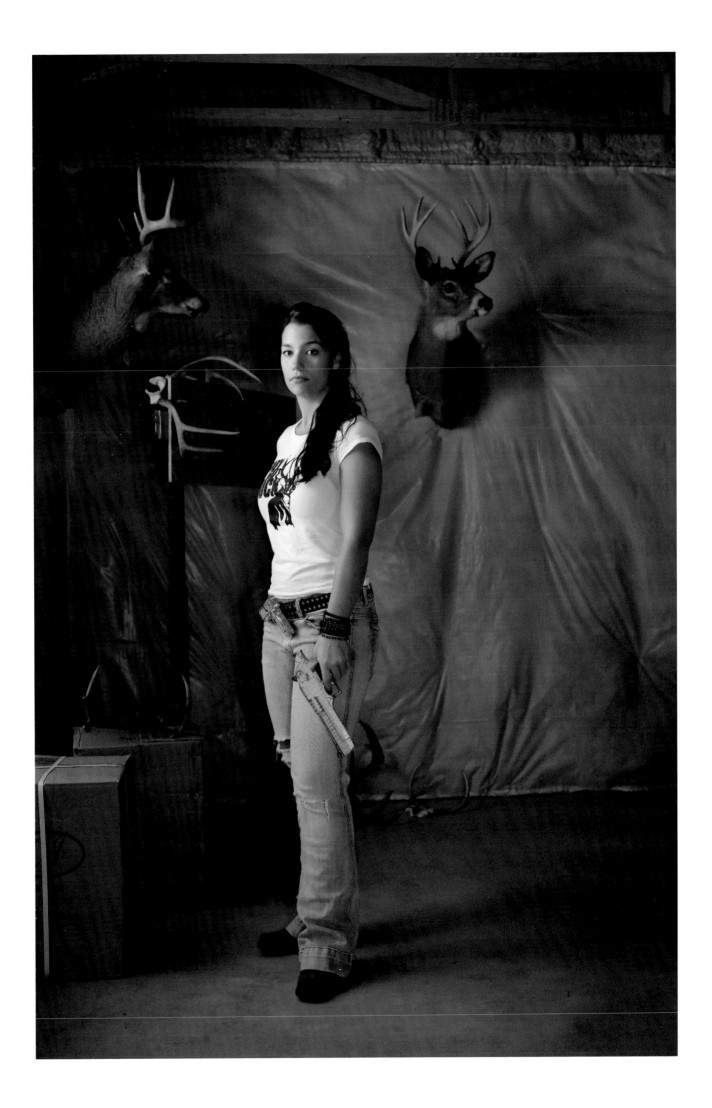

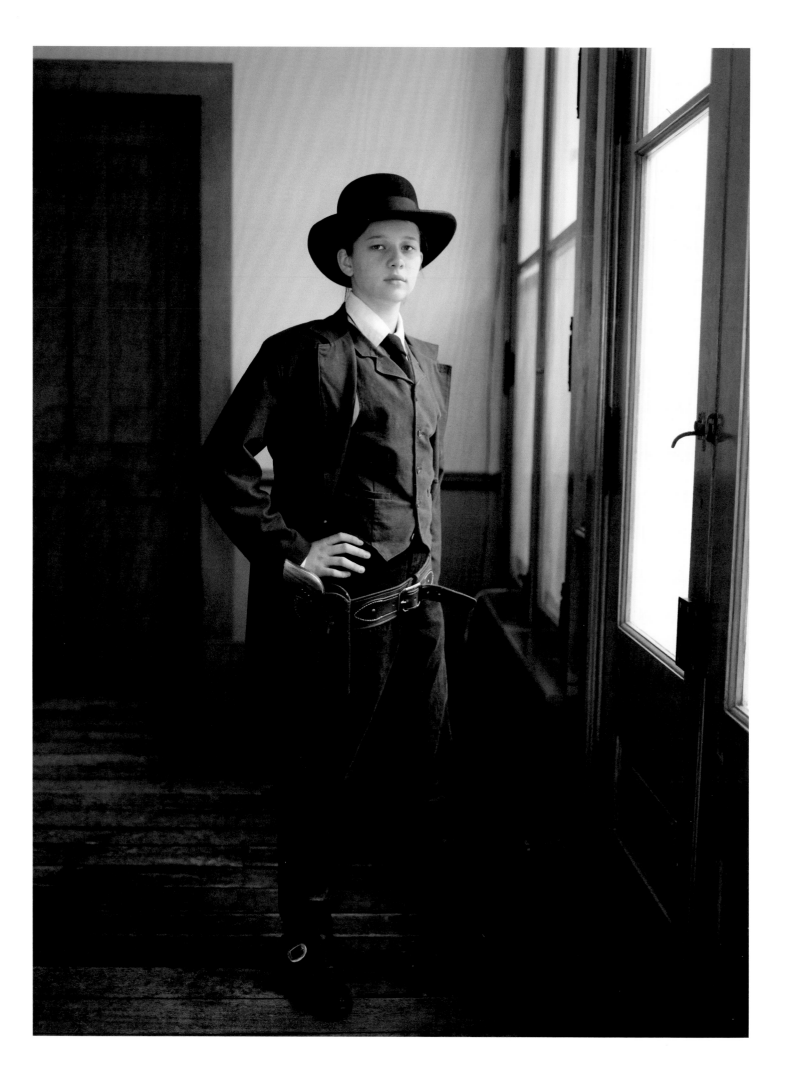

MOLLY
Northfield, MN
Armi Jager Frontier Model single-action in .357 Magnum

Being born into a family of gun enthusiasts made my childhood quite different from other girls my age. Not only because of the guns; performing horseback added to it as well. In 1948 my Grampa and a few of his friends decided it was about time to recognize the historic shootout that took place in Northfield, Minnesota, on September 7, 1876. The battle was between the Northfield citizens and the James and Younger Gang. Three gang members were killed. Cole, Jim, and Bob Younger were captured and put in prison. Frank and Jesse James managed to escape but were never able to put a successful gang together after that.

For the reenactment of the shootout, many of the blank cartridges have to be custom loaded by hand and I've spent many hours knocking out spent primers and sizing .45 casings. My two older brothers and I have always helped out with the celebration, which started as a small-town event and turned into one of the largest celebrations in the Midwest, attracting thousands of spectators every year the weekend after Labor Day. The gang of performers has been handpicked by my dad since 1973, and my mom has been in charge of the reenactment since 1980. The Gang is like my second family and I admired them riding every year, wanting more and more to ride with them and show that I could be the girl in the all-male group.

My brothers started riding with the Gang when they were fifteen and sixteen, and I knew once they started that it would be my turn one day. I wasn't going to let being a girl stop me from achieving one of my biggest goals. Riding a horse over a hard surface while being shot at with 12-gauge shotguns and .50-caliber rifles and shooting a pair of Ruger Vaqueros in the air is one of the biggest thrills of my life.

LORAL I.
Anoka, MN
Perazzi 12-gauge over-and-under

Growing up with a dad who was a dog trainer put me right into the outdoor world. When I was nine, I got a Model 10 Stevens child's hammer gun and, with my cocker spaniel by my side, shot my first flying wood duck. It was a big thrill, and it wasn't long before I graduated to a 20-gauge.

Of course the 12-gauge came into play when the competition bug hit. My second trap shoot was the Minnesota State shoot in 1957, and with a 197 × 200 score I won the Ladies State title. I also won the State Handicap title with 95 × 100; this was all at the age of eighteen,

Before I ever got involved with the Grand American Trap shoot, I would read the program about the Frances Clyde King trophy. You had to win the trophy five times to possess it, but one can dream, can't they?

I attended my first Grand in 1964. Then in 1966 a winning streak began and lasted right through 1970, when I retired the High-Over-All Frances Clyde King trophy five consecutive years. Dreams do come true!

Besides shooting approximately thirty years at the Grand American, I've won over fifty trophies and several State and Zone championships. I had fun with the Olympic Bunker World Championships as one of three in the ladies team events, taking Gold in Canada, Silver in France, Silver in Mexico, and Bronze in Korea. My recent accomplishments include competing in the World Flyer Championships, which are held in Spain, Portugal, and Mexico. I've won the Ladies World Championship four times—all proud moments.

For the women who want to start getting involved in the sport of shooting, many opportunities exist now. Find a good coach and just do it!

When not shooting, my profession is the kennel business, which includes boarding dogs, training gun dogs, and raising nice Labradors. My husband, Chuck, and I live in the house I was born in, right at the Armstrong Ranch Kennels in Anoka, Minnesota. I have been hunting over my dog companions for sixty-four years and have no plans to stop.

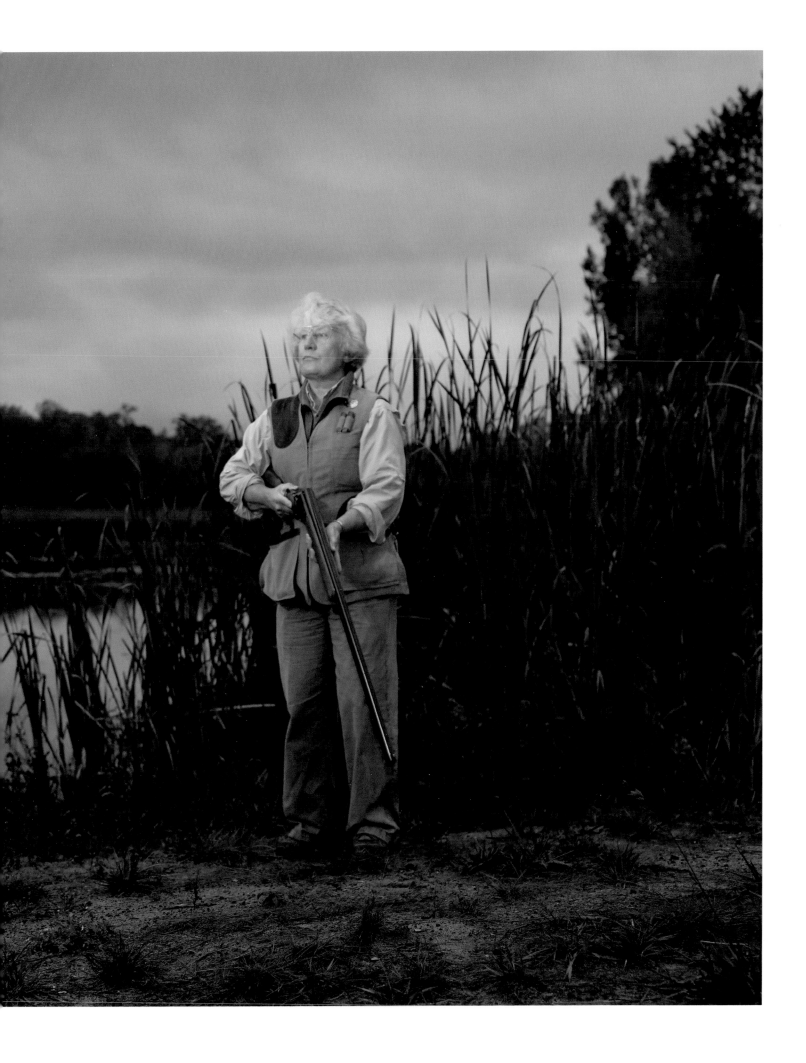

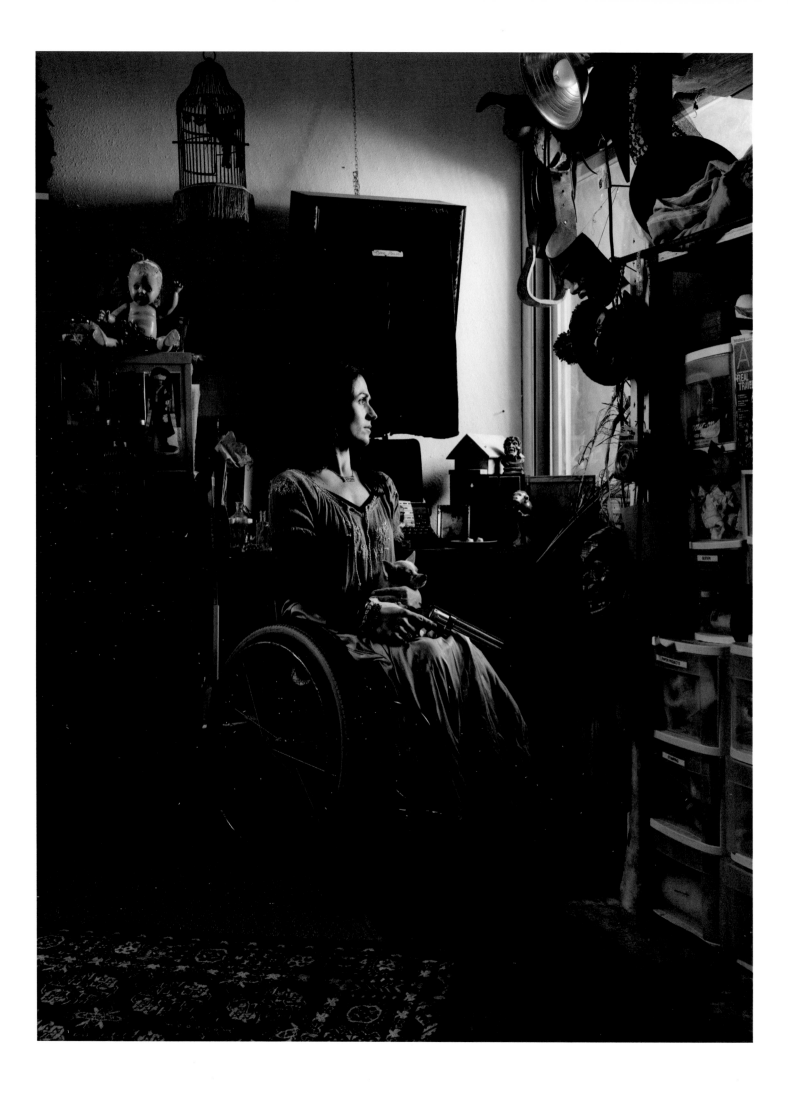

LAKE

Healdsburg, CA
Stainless-steel Smith & Wesson in .357 Magnum
with 6" barrel

I learned how to shoot from my dad. He would walk out on our back deck in South Carolina and just start blasting away. I would invariably be outside reading, and this would scare the hell out of me. He would always ask if I wanted to try, and one time I did. My heart was pounding so hard! My mother and her side of the family were very upset when I began shooting. My mother cried.

But I got seriously interested in guns because of my husband. Our first date was at this house in the mountains, and he was wearing a gun on a holster. I was a little agog at this. He casually explained something about bears and dangerous animals and I thought, "Wow, he's really thinking ahead."

My favorite gun is a 6"-barreled, factory-bored .357 Magnum that my husband bought me. He thought it would be the perfect gun for me. I also like my .44. They are both wonderful. The .357 is my "Shiny Dandy" and the .44 my little "Buck Rogers." All my guns have nicknames.

In addition to my husband's instruction, I had a year of tactical firearms training. I'm in a wheelchair as a result of a childhood accident, so the training was definitely empowering. I loved running through different scenarios with the instructor.

I think it's important to know how to defend yourself. Look, I'd rather die defending myself than be a victim.

SARAH
Livingston, MT
Marlin .30-30 caliber rifle

I got my first gun when I was ten or eleven. My older brother bought both my sister and me Ruger .22 rifles because we helped him haul wood. Until I got old enough to hunt big game I'd mostly shoot gophers with my dad, older brothers, and sister. When I was eleven I took my hunter's safety course but, I had to wait until the last two weeks of hunting season, when I turned twelve, to actually go hunting. I'll never forget the night before my birthday, when my dad took me to get my hunting tags, I don't think I'd ever been so excited. With all the predators where we live, it is vital to own and know how to use a gun.

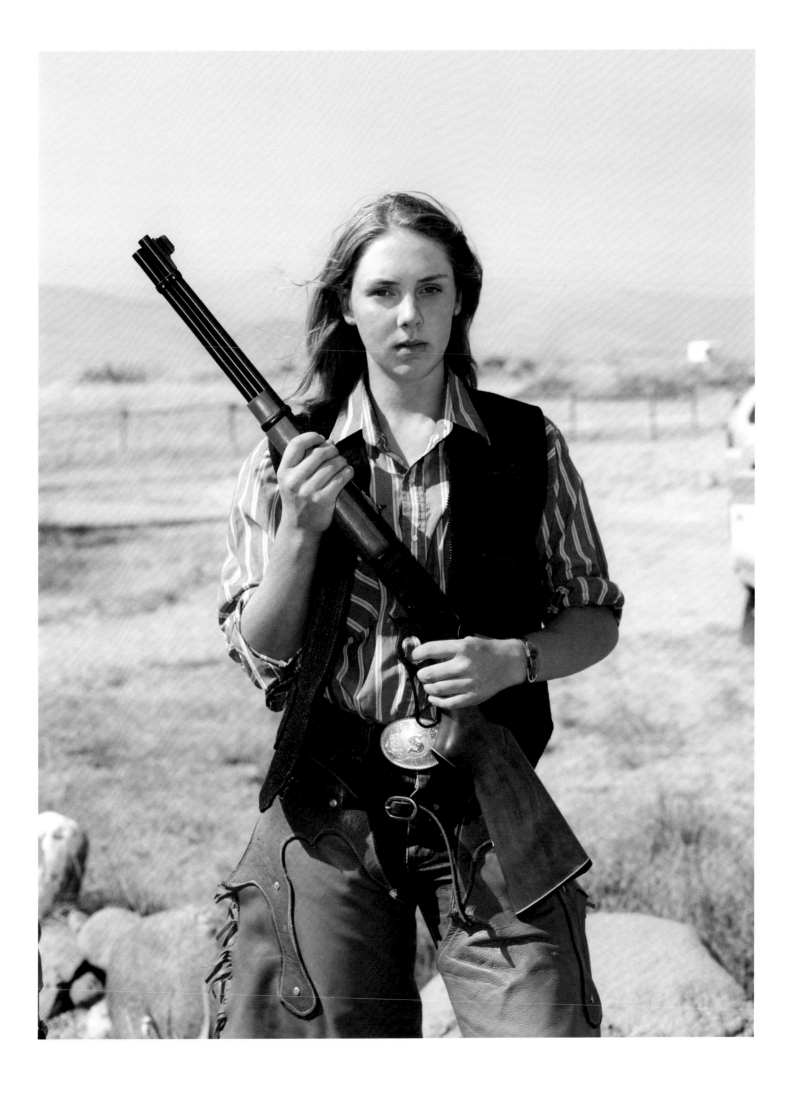

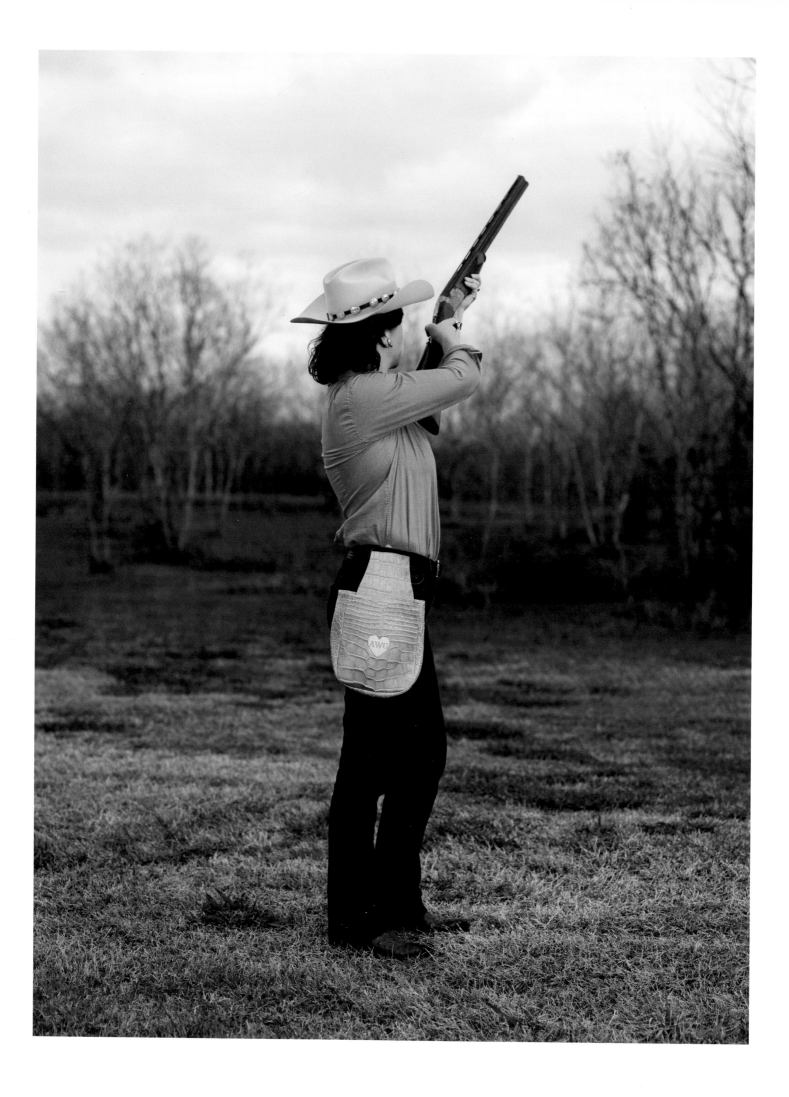